THE SHOT

THE SHOT

GARY RAMAGE

WITH MARK ABERNETHY

HarperCollins*Publishers*

The author and publisher would like to thank Will Stanley, Bill Guthrie and Corporal Jake Sims for the use of their photographs. All reasonable attempts have been made to contact the rights holders of photographs. If you have not been correctly attributed, please contact the publisher so that appropriate changes can be made to any reprint.

HarperCollins*Publishers*

First published in Australia in 2016
by HarperCollins*Publishers* Australia Pty Limited
ABN 36 009 913 517
harpercollins.com.au

HarperCollins*Publishers*
Level 13, 201 Elizabeth Street, Sydney NSW 2000, Australia
Unit D1, 63 Apollo Drive, Rosedale, Auckland 0632, New Zealand
A 53, Sector 57, Noida, UP, India
1 London Bridge Street, London, SE1 9GF, United Kingdom
2 Bloor Street East, 20th floor, Toronto, Ontario M4W 1A8, Canada
195 Broadway, New York NY 10007, USA

National Library of Australia Cataloguing-in-Publication data:

Creator: Ramage, Gary, 1967- author.
 The shot / Gary Ramage, Mark Abernethy.
 ISBN: 978 1 4607 5135 0 (paperback)
 ISBN: 978 1 4607 0604 6 (ebook)
 Subjects: Ramage, Gary, 1967-
 Photographers – Australia – Biography.
 War photographers – Australia – Biography.
 War photography – History.
 Other Creators/Contributors:
 Abernethy, Mark, 1964
779.9355092

Cover design by Hazel Lam, HarperCollins Design Studio
Cover image of Gary Ramage © Will Stanley
Typeset in Bembo Std by Kirby Jones
Printed and bound in Australia by Griffin Press
The papers used by HarperCollins in the manufacture of this book are a natural, recyclable product made from wood grown in sustainable plantation forests. The fibre source and manufacturing processes meet recognised international environmental standards, and carry certification.

For my beautiful wife Ali,
who puts up with my absences,
and for my brave parents Cindy and Joe,
who started me on this adventure.

There are things I have seen
that I cannot un-see.

CONTENTS

PROLOGUE

It's loud, cramped, and I'm face to face with a dying soldier. It's just after ten o'clock in the morning and we're flying at two hundred kilometres an hour and just thirty metres above the ground through the golden-brown valleys of western Helmand Province. I hold my Canon EOS 5D Mark III camera with one hand, and push against the roof of the Black Hawk helicopter with the other, trying to hold my shooting position as we hurtle towards a military hospital in southern Afghanistan. The scene in front of me is one of hopeless injuries and the half-insane, half-profound statements of a man who knows he is dying. I see it in my viewfinder: an American soldier, a bullet through his lung, bleeding out on the floor of this casualty evacuation helicopter. He is half naked, the dirty army fatigues of combat a terrible contrast against the vulnerable, bullet-riddled flesh. The bleeding soldier and I are flying with the US Army and a legendary team of operators known as Dust-Off. A crack unit of US

Army trauma medics and ace pilots, they will fly through anything to rescue, revive and deliver the casualties of war. For many American military personnel, the Dust-Off crews represent the paper-thin difference between living and dying.

The young soldier's wound weeps and dribbles – the bullet has passed through his chest so he has a 'sucking chest wound', a description you don't fully understand until you've seen one. The blood shifts in dark waves across the aluminium floor as the chopper banks and turns around known Taliban outposts, from which a rocket-propelled grenade or surface-to-air missile may be unleashed at any moment. The intensity of the medics who attend to the soldier is inspiring, but not loud. Unlike the movies, where airborne medics scream with urgency, these Dust-Off operators are calm and resolute, their voices almost conversational through the cabin radio system, yet audible above the shriek of the turbine engines and the *thromp* of the rotors. After ten minutes of flying the soldier seems to have accepted his fate. But one medic won't give up. I feel like I'm watching a lesson in hope versus reality as the soldier's chest heaves for pressure in his lungs and the medic encourages him to stay with us.

I wait until the medic has the half-naked soldier in a dignified position and I start shooting. Through the carnage, the blood and the anguished moans, I have been waiting for my chance, moving my body until I have an angle where the shot captures the horror of a soldier's death in Afghanistan but without showing him naked.

The intensity of the medics who attend the soldier is inspiring.

At this point I have been a photographer for twenty years, and my instincts are firmly to record and not to get involved. But that doesn't mean I shoot and damn the consequences. It's my shot, my photograph, and even in a cramped casualty helicopter I don't add the loss of dignity to the loss of life. It has been many years since I stood and watched a young Australian soldier die in Somalia. I was unable to pick up the camera back then, too shocked by what a bullet wound actually looks like and how badly the human body has to fight it. I didn't think of my job first in that instance – I thought about the soldier's family and his unit waiting outside the surgery tent. The first war casualty Australia had suffered since Vietnam, and I didn't take the shot. I vowed not to make that mistake again – that episode stayed with me for many years and can still stir emotions. But now I work

through it. I just keep doing the work, doing what it is I can do: record this mess, put faces to the headlines, let readers see that war's participants and victims are just people like us. They have faces and bodies, they have dreams and fears. And they all fight for life even when torn apart by the flying metal of combat.

The soldier's chest heaves less now, the bubbling reduced to a steady flow of blood. I get my shots and realise that the person most upset by this situation is the medic. Just as I want the shot, this medic wants to save the soldier. He catches my eye and we hold each other's gaze for one second. And I make my decision. I can't be with a hard-core unit like the Dust-Off operators and pretend I'm not there. I am here: I can see the blood, I can see from the medic's eye contact that I'm up. I twist the seatbelt locking handle to the left and unbuckle my four-point harness. Released from the security of the collapsible seat, I move around the medic and drop to my knees on the other side of the injured soldier as ancient irrigation canals flash by below us. Without a word, the medic hands me a plastic CPR mask and I place it over the soldier's face – I've seen it used when I've previously been embedded with the US Army. For ten minutes I puff air into the soldier's useless lungs while the medic performs CPR and tries to keep his heart going. We work in sync, small grunts echoing over our radio systems, punctuated with occasional calls of 'Okay – again'.

The soldier is dead long before we give up, and when we do I am stony-faced and as emotionally drained as I have

ever been. I sit back and look at the padded ceiling of the Black Hawk so I don't have to look at the medic. To let him see what's in my eyes would not help the soldier's family and friends; nor would it give encouragement to a Dust-Off medic who will land at the hospital and be called to another casualty evacuation probably before he's even finished his coffee. For now, I sit back and wait for the pilot to do his job, just as the medic and the soldier have done theirs. We are the various players in war, all trying to do our jobs and to hold it together.

I am a combat photographer who has seen too much death. The first time was too much for me, and yet here I am, back in my comfort zone, where I will try my hardest and never be satisfied with what I have done.

I am hard enough to endure this, yet also too soft. I can get through by reminding myself of the simple rule I live by: in wars where nothing seems to matter, I can take pictures in which every person counts.

1

My Father's Hobby

It's tempting to look back on early life and find the beginnings of what you have become as an adult. That adulthood has seen me taking photographs in some places you would have heard of: Bosnia, Kosovo, East Timor, Iraq, Afghanistan, Somalia, the Solomons and Bougainville. People become their profession – they're not born that way. When I was a kid, growing up in my original home of Edinburgh, I had no inkling of a life that would see me ducking bullets, armed only with a camera.

My most obvious link to photography was that it was my father's hobby. My earliest memories involve Dad carrying his camera bag on all our outings. He had a Super 8 cine camera but I don't remember being given specific lessons on how to use it. What I remember was that a camera was part of everything: Dad shot the film and those reels formed the record of our family. It was a normal part of life and it was

also considered normal that I – and, later, my two sisters, Geraldine and Nicola – could point, focus and shoot on that camera. I still have it, in fact, as well as the films and the projector we used to watch them on.

Dad was a cabbie in Edinburgh, and one night a fare left a 1960s Praktica 35mm camera in the back of his cab. The taxi company tried to track down the customer and let it sit in lost property for the required time. But it was never claimed, and one night Dad came home with this camera. It was a magic piece of machinery and we all loved it.

We lived in a cul-de-sac in Broomiknowe, to the south of the city. Mum was a hairdresser and Dad – as well as being a cabbie – was also a trained mechanic and panel-beater.

PHOTO: GARY RAMAGE COLLECTION

Gary aged 3

My parents tell me I was bit headstrong and inclined to take the initiative even when I had no idea what I was doing – certainly a trait I carried into adulthood. In one incident, I watched Mum and Dad in the small backyard vegie patch and was determined to help them, even if I wasn't big enough. The next morning, while they both slept, I tried to use the pitchfork and put it straight through my foot.

Dad was active in the cabbie world and he and his mates would do charity days at the local hospital, taking sick kids out to the beach dressed as Wombles. As well as a cab he had a purple Jaguar E-Type which he drove in the thriving Scottish rally club scene. When I was seven he made me his co-driver and I spent an afternoon with my head knocking around the cockpit in a too-big helmet.

Of course, Dad was also passionate about football – everyone in Edinburgh was. There were two teams you could support: Dad was a lifelong supporter of Hearts of Midlothian, while I supported Hibernian FC, known as Hibs. I never understood why Dad didn't support Hibs; he was a total Leith boy, from that tough area in the city's north where street gangs roamed the docklands, and Hibs played at Easter Road in Leith. Then again, when you talk football in Scotland, the 'why' has bugger all to do with it. Football is just a fact of life and once you select your team, that's that.

While he was very Scottish, Dad wanted to try another part of the world – maybe Canada, South Africa or Australia. It was the mid-1970s and the colonial countries would book a school hall and show movies extolling their virtues.

My parents were agreed on the fact they wanted more opportunities for their kids, but Mum was less keen to move because she belonged to a large, close-knit family. Finally, when I was eight years old, they decided on Australia. Like all British kids, my only knowledge of the country came by way of *Skippy the Bush Kangaroo*. We thought it was basically a documentary of life there.

After an emotional farewell to my mother's family at Edinburgh's Waverley station, we boarded a sleeper for London. From there we made our way to Heathrow, where we boarded a British Airways 747 bound for Melbourne. We moved in with Auntie Estell from Glasgow, who had a flat in St Kilda, and Geraldine and I started immediately at Caulfield Primary School. In the early days, the teachers couldn't understand what I was saying thanks to my accent. This wasn't the only cultural difference; I remember being surprised by the fact there were no fisticuffs in the playground.

After a year we moved south-east of the city to the bayside suburb of Frankston, where we built a large house on what looked to me like an enormous property, with a big grassy yard and also some sand. I had never seen so much space.

The space wasn't the only way in which Australia was unlike Scotland. There was the weather, of course – the heat and sunlight were startling after the cold, dark afternoons of Edinburgh. But the wildlife was a bit of a worry. I remember playing in the sand with my Action Man – and suddenly I was covered in bull ants! Immigrants to Australia are warned about the snakes, spiders and sharks, but we hadn't been told

about those ants. I ran into the house screaming and Mum whacked all the ants off me. She had no idea what to do with ant bites, though – there was no user manual for Australia. One time Nicola and Geraldine were at the neighbour's house and a red-bellied black snake appeared on their lawn. They fled, screaming. It was frightening for us, our fear magnified rather than relieved by the nonchalance of the Aussies. When you come from a country where not much in the natural world can kill you, Australia is confronting.

And I loved it.

* * *

Mum missed the company of Scottish folks, so after a year in Melbourne we packed up and moved to Mount Gambier, in South Australia. My Auntie Shirley had friends living there and there was a Scottish community and a large population of European migrants. Dad found a job selling cars with a Holden dealership and we lived in a four-bedroom limestone house which backed onto paddocks where the plovers used to roost. The space and freedom of Australia really suited my personality. I loved the outdoors lifestyle. The other great thing about Mount Gambier was the soccer. There were soccer clubs everywhere and we immediately joined the Scots-Irish one, Blue Lake Soccer Club.

I remember how much Dad liked being back in a football club. In Scotland football is a big part of community life. Dad had played for Scottish Taxi Drivers – a tough, high-quality

outfit in the day – and his dad, Joseph Gilliland Ramage, had been an ace goalkeeper. Our first trip back to Scotland, in 1979, featured a special treat: Dad's friends gave us tickets to George Best's last game in the UK, playing for Hibs at home in Leith. Seeing George Best play at Easter Road is one of my great memories.

Mum and Dad both felt more at home in Mount Gambier, but don't think that means we were all friends. The rivalry between those football clubs was intense and we all played the game the way it was played in our home countries, which meant never pulling out of a tackle and never going soft once you've decided to take the ball. So there was hard tackling and bust-ups on the pitch and crowds accusing refs of being on the take and all the clashes you'd expect when you throw Italians, Greeks, Croatians, Scots, Irish and Dutch into the same competition. Soccer allowed us immigrants to express our culture and our passion, and we did that without holding back. And yet if there was any socialising done around those football clubs, it was beer and barbecues. That was Australia back then – a melting pot of cultures but everyone trying to be Aussie.

It was through football that I discovered my temper, probably inherited from Dad. He played the game like a Leith boy, and his temper earned him some red cards. There was a competitive rivalry with the Italian team, Internazionale, who knew how to push his buttons. On a Sunday, when all the grades would play at a club's home park, you'd have these fiery Scots and Irish players who would not be stood over or

taunted and these equally fiery Italians who tried to stand over and taunt us. Not a good mix.

When I finally played in the same A grade team as Dad, it was a proud day for him. Football brought out the beast in me. I played all the way through the grades of Australian soccer and captained the national army team, and I also played a lot of indoor soccer. I once broke another player's leg in a tackle during an indoor game – not my proudest hour. And I could snap: my own players from 6 RAR in Brisbane once dragged me off the field because I lost it at the ref. For me childhood was about soccer and then baseball, and hanging around on pushbikes with my mates. I didn't think of myself as a gifted student until my final year of primary school, when I was named dux – more for my charm and personality than my grades, I fear. And through all of this, there was photography. Dad was taking photos and shooting footage on his Super 8 camera and teaching me how to do it too. It was an old-school way to learn. Back then you had to pull focus and frame your shot. There was no digital point-and-shoot; film had to be developed and that cost money, so you didn't just wave the camera around, take two hundred shots and hope one came out. To this day, even with CF cards that can hold a thousand images, I still frame a shot as if I'm using film.

After four years Dad was made manager of the Holden dealership in Millicent, a much smaller town fifty kilometres down the road. In Millicent I really started to develop my interest in sport. I did karate at the gymnasium, played basketball at school and football with the Blue Lake Soccer

Club, with Dad driving me back to Mount Gambier for practice and games. Millicent was a small, unfashionable town, but boy did we have fun. Craig, Mark and I used to make our own bikes from parts salvaged from the local tip and wrecking yard. I built a pretty flash racing bike, added some cool accessories and painted it metallic green. You'd never know it started life as junk. I did the basketball umpiring course, played golf with Craig and tennis with Mark and when Egan's sports store first stocked a set of aqualungs, Dad went in there, bought two sets, and we went down to the rocks at Cullen's Bay near Southend, teaching ourselves to use this gear and dive on crayfish. We were diving one day when Dad said, 'There's no way we'd be doing this back home.'

Gary aged 12

Once I got the hang of it, I'd grab Craig and Mark and we'd take the scuba sets down to the rocks. We pulled aerials off wrecked cars, made them into hooks and used them to pull crayfish out of rock crevices, which was against the law. We were in our early years of high school, and it was like a giant playground: freezing water, giant crays and white sharks. Only in Australia!

My life felt pretty good: I was even studying photography as one of my elective subjects in Year 8, under Mr Gates, which would set me up for a challenging career later on in life. And then my folks threw a spanner into it. They decided we had to move to Perth.

* * *

Some boys thrive in a city suburb while others need some elbow room and are better suited to small towns where they run until they're exhausted. I thrived in a small Aussie town. The biggest schism in my childhood was not leaving Scotland for Australia; it was being pulled out of rural South Australia and plonked down in the suburbs of Perth. At an earlier time it might have worked out for me, but this happened when I was sixteen: I was tall and strong and sports-mad and I had just discovered Aussie Rules football.

At sixteen, I joined the Hatherleigh Football Club – an Aussie Rules club. I hadn't played the game seriously before then, but because I was in South Australia it was the main game we played at school. So I joined up and pre-season

training went well, so well that Hatherleigh threw me in as their number 13 – a full forward. I took to the game like the proverbial duck to water. I was physically confident, I could kick and I wasn't easily intimidated. I liked the speed and aggression and the skills and fitness. I loved the team culture and it didn't worry me that as full forward I was the target of a lot of attempts to knock me over, make me relinquish my ground. I rose to the challenge and as the year progressed the coaches talked about me playing for an SAFL team in Adelaide. Footy is a huge thing in rural South Australia and the people at that club were excited about the prospect of one of their own going to the big leagues.

I didn't talk about sport to my parents, though, and by the time I asked them to come and see a game – I think because I was being mentioned in the country newspapers – my folks had already decided to move to Western Australia.

My dad had little appreciation of Aussie Rules football and he tells me he only knew how good I was because the first time he watched me play there were two supporters in front of him, crowing about something I'd done. And then one said, 'That piece of pelican shit is our biggest scorer and his bastard father is taking him to Perth.'

That game was so Australian: big open spaces, physically demanding, highly competitive and a bit of biffo to go with all that sledging. And then you have a can of drink with the other team after the match, and there's no hard feelings.

The hard feelings were all mine, towards my parents. My coach even approached them and asked if I could stay behind

and board at his house. He planned to have me playing in the bush for one more season and then he was sure an SAFL team would pick me up. But my folks were worried that there were no opportunities in a small town and I was drifting. I was a larrikin who loved sport and I didn't care about school. Dad encouraged me towards a trade – I could be a motor mechanic, he suggested – but I resisted, something I would regret in later life.

So it was off to Perth, where I had to learn the hard way that I was more suited to small-town Australia than to being an anonymous kid in the suburbs. I did Year 11 at Lynwood Senior High School in the southern suburbs of Perth. I made no friends and I became a bit of a recluse. I wouldn't talk to my parents, I'd stay up until 2 am watching TV and I never touched a footy again. I was bitter, disappointed and cut off from what I thought was my real life.

During Year 11 I applied to join the air force, largely because my friend from Millicent, Andrew, had always talked about doing so. But the RAAF wouldn't take me because my maths and science grades weren't good enough. My parents, meanwhile, had bought a block of land in Kelmscott, south of the city, and built a house there. Because I couldn't join the air force I went to Kelmscott Senior High School. I actually made some good mates in Kelmscott but at school I lasted two months before I abused a teacher and never went back.

Like most teenage boys of that age I was rebelling against the world and my parents. I knew what was best for me, or so I thought then. How wrong I was. Moving to Perth was

actually the best thing my parents could have done for me and my two little sisters.

I got a job detailing cars for eight months then went to a job in Kenwick making fibreglass water tanks. It was hot, exhausting work but the two owners of the company were veterans of the Vietnam War and at smoko they'd tell their war stories. I worked hard, earned a promotion and a pay rise. But I enjoyed those war stories more than anything, so I started to think about the army.

I went down to the recruiting office and the army gave me a date to sit my aptitude test. I was determined not to screw this up, so I got a mate of mine, Dave Simmonds, to tutor me. And when I went into that office and sat the tests with all these other young men, I was actually excited. It was the best I'd felt for a while, which I suppose was a good omen.

I received a letter of offer ten days later, and that was it. I was off to a place called Wagga Wagga on the other side of the continent. I was eighteen and jumping out of my skin with excitement. I needn't have been, really.

2

Becoming Ramo

The Australian Army had a really good antidote to enthusiasm: it was called bastardisation. From the moment me and my fellow new recruits poured off the bus at Kapooka Army Base, the culture shock was brutal. Bastardisation basically means being reduced to nothingness, without identity or the ability to think, so you can be reconstructed into a form the army finds useful.

There were twenty-five of us in 15 Platoon Bravo company. This was my recruit training unit at the Kapooka barracks where we were housed alphabetically in cubicles in which a divider wall separates four beds. The first lessons were when to sleep and when to wake up. Then we learned to eat, lining up three times a day to have food thrown on a plate, and then bolting it down as fast as we could. We were taught how to wash, dress and shave. We had to fold our underwear in a certain way and fold our socks with a 'smiley face' and

Gary, Kapooka Army Base, 1985

the face had to be right way up and facing the instructor so it always appeared they were smiling back at the bastards. Every cubicle had a locker with a place to hang jackets, shirts and pants, a rack for boots and shelves for clothes and toiletries. The bed had to be made with hospital corners and the green sheet had to be a bayonet's length – no more, no less – over the counterpane that featured the orange 'Rising Sun'. And yes, they measured.

We had spot inspections and routine inspections. A corporal or sergeant would come into the hallway and scream, 'Hallway 15!' and we'd have to drop everything and present ourselves at attention outside our cubicles. Then the non-commissioned officers (NCOs) would go over our cubes, and

if anyone's bed or locker was slack or out of line, they'd have to stand there and watch as the rest of the unit was punished. For the recruits who couldn't get their act together, this was a tough time: ostracised by the unit and abused and humiliated by the NCOs.

Lollies, chocolates and cigarettes were banned in the barracks. One time, Wayne, my cube mate, didn't hide his smokes very well and the instructor threw everything in his cubicle out the window onto the lawn below.

The dress code was harsh. There were several types of dress, from full ceremonial (known as 'A1') down to our greens. Anything black had to be very black and very shiny; anything brass had to be mirror-like; anything made of fabric had to be clean and pressed flat. There were fifteen-eyelet general purpose (GP) boots, and you had to spit-polish them and polish the laces with black Nugget to ensure they matched the boot leather. There were ankle boots (AB) which went with gaiters on several formats of dress. Spit-polishing in the movies is done with a piece of rag; in the Australian Army you have to use your finger and a cloth or you can't get the depth of shine required by the instructors. If you couldn't get the shine to the level they wanted, they'd destroy your locker and throw your shit out into the hall or out the window. And you couldn't leave Brasso residue on the buckle. That was lazy and disrespectful – they'd destroy your locker for that, too.

We'd iron our shirts to the army standard and stack them the army way, and the pants would have to be ironed with

the creases in precisely the right line, and then hung in such a way that the crease stayed in place. Nothing could be tatty, so we were issued sewing kits and they taught us to sew. You couldn't present for inspection with any fuzz on your face, so we had an old-school screw-down razor, a box of double-edged blades, a brush and a stick of shave soap. And they taught us the army way to shave, but the instructor had no blade in the razor when he showed us. When I tried his technique myself I almost tore off half my face and was loudly abused for the gash it left on my cheek.

I avoided any big mistakes and stayed out of fights (of which there were a few) and bashings (of which there were many). In our sister platoon, which had arrived at the same time, there was an attempted suicide and some of their guys didn't fare so well. Our instructors were hard bastards. Really hard. This especially showed itself when it came to the physical stuff, such as the obstacle course, ten-kilometre fitness run and push-ups. And, of course, the marching. Lots and lots of marching with a pack on your back. The guys who couldn't hack it were back-squadded to a later intake, to see if they could get the times on the obstacle course.

Still, I got through and then we did the passing-out parade, got the rank of private and were going to be allocated to our employments. It had been an agonising four months, but I was happy. After being cut adrift in Perth and feeling alienated, in the army I had a new group of mates. Most important, I felt like I was good at something.

* * *

When I look back on those four months at Kapooka, I see a young man who needed to spend some time in a structured environment before he pushed out again and developed his own personality. This may sound self-contradictory for a person who goes out and does a job like photojournalism in conflict zones. But actually a lot of young men go into the army and find that they can subsequently thrive because they were first broken down and rebuilt. I don't claim to understand exactly how it works, but it might be that if you take a youth who's a bit directionless and lacking in confidence, and remake him with a core of discipline, you might be giving him the foundation to develop his own self-confidence. In my case, the daily acts of being properly presented, having to overcome physical pain and follow simple rules was actually liberating. In the army, the phrase 'get your shit together' is a specific and urgent requirement of everyone in the unit. It has stayed with me all my life and has given me the ability to operate in some very dangerous environments. Whether I wake up in a forward operating base in Uruzgan or in my house before I go to Parliament, I get my shit together. The army gave me that habit and focus.

But basic training is just the beginning in the army. Once you've completed basic, you're assigned an 'initial employment' and sent to a base to learn it, be it engineering, hospitality, communications or whatever else the army needs. When I left Kapooka they were lacking infantry soldiers, so

I went with the flow. We were supposed to be bussed up to a base in Singleton in the Hunter Valley to undergo IET – Infantry Employment Training – but just before we were due to leave they told us, 'Change of plans, lads,' and we embarked on a much longer bus ride to Enoggera Barracks in Brisbane. It seemed the famous 6 RAR battalion, which fought the battle of Long Tan in Vietnam, needed men in boots. So we'd skipped the notoriously brutal IET at Singleton and were in an express lane straight into a battalion. It was a lucky break of the kind that would follow me for the rest of my life. As the old NCOs would say, 'Ramage, you were kissed on the dick.'

* * *

Enoggera was a great score. The barracks were in good nick, and the kitchens and gyms were too. And we did our infantry training in three months, within 6 RAR. It was battalion life, so there was none of the bastardisation we would have received as trainees at Singleton.

I was six foot one and strong and fit by the time I got to Enoggera, so they made me the machine gunner. I was trained on a Vietnam-era general purpose machine gun (GPMG) called the M60, also known as the Widow Maker. Because of my surname and the fact I was carrying around this belt-fed weapon, my nickname was obviously Rambo. Everyone in the army gets a nickname and you just have to wear it. Gradually I managed to get people to drop the 'b' until I became Ramo, a name that stuck with me for the rest

24

of my army days (along with a few other names I'd rather not go into).

We did a lot of exercises in the bush, one of which lasted six weeks. Being the machine gunner is exhausting. The GPMG ammo alone was so heavy that I had a 'second' assigned to carry it. The heavy ammo belts were carried in bags by the second and in big canvas pouches on the gunner's webbing. The pouches were World War II era and the straps on them were designed so you couldn't close or open them with one hand – incredibly inconvenient when doing exercises. We had to carry surplus rounds because a GPMG on full throttle goes through a hundred rounds every few seconds. And as for the movies, when Rambo struts around with the ammo belts in bandoliers across his chest? That doesn't work. That just gets dirt and other crap in the breech and then the weapon jams. And in the army the machine gun always has to work. That meant I had to be able to fix any jam, any malfunction in the field under any circumstance. I learned to break down and rebuild a GPMG and then I learned to do it blindfolded. This isn't a macho army trick, it's so you can fix a machine gun in the dark with a minimum of noise. When we got to the end of a day in the field and harboured up, the other soldiers went into the nightly routine, while I had to strip, oil and maintain the machine gun. It wasn't a wasted skill: as a photographer I would follow the same discipline, cleaning and checking my camera gear thoroughly every night before I packed it away, and I could break it down and rebuild it with my eyes

shut. That sounds a bit over the top, until you have to unjam a film camera on a moonless night on patrol in Afghanistan.

After eighteen months of being the gunner in a Queensland infantry unit, I was in better shape than I'd ever be again. I was twenty, and lucked in again when I was chosen to be part of a small group sent down to Singleton to do the Pioneer course. This was essentially construction engineering for battalion HQ. It got me out of infantry exercises with that dammed machine gun and into building bridges, setting up bunkers, using flamethrowers and chopping down trees. It was a great time with fantastic people. A couple of years ago someone from those old days put up a photo of us on Facebook, at an exercise site. We're built like professional athletes and we all have six-packs. My wife jokes that she missed out on my good years because now rather than a six pack she gets to look at the keg!

The Pioneers opened up amazing opportunities. In 1988, for the Bicentenary, there was a program to have Aussie soldiers stand as the Royal Guard in front of Buckingham Palace. They sent one hundred of us down to HMAS *Albatross* in Nowra, on the south coast of New South Wales, and brought in a Welsh regimental sergeant major (RSM) to teach us. He spent a month with us, and I can tell you that the Aussie digger sense of humour had virtually no translation into Welsh. We got off on a bad start because this Welsh RSM arrived with the Royal Guard kit: the full crimson dress uniform along with highly polished hobnail boots.

'Wonderful,' we said, picking up the boots. 'We gonna wear these things or put them in a museum?'

The Welshman didn't see the funny side, and told us that even the soles of the boots had to be polished. And the thing about showing no emotion, remaining absolutely blank-faced while you stand at your post? That's real and, yes, we were trained for it.

Anyway, we had a great trip to the UK, which included a small reception at Windsor Castle for the Aussies, where we were introduced to the Queen and the Queen Mother.

The stirrer side of me was quite evident even in the army. Me and my Pioneer buddies had made a few informal comments about the fact we were made to wear the crimson coat and busby hat, when it was the Australian bicentenary. The Army RSM Lofty Wendt must have agreed because when we finally stood guard over Her Royal Highness, we were dressed in slouch hats and Australian Army uniforms (including boots). And there was not a Welsh RSM in sight. Sometimes the digger has the last laugh.

3

Learning the Trade

The thing about being kissed on the dick? The way lucky breaks work for me really showed through in how I got into photography. While in the Pioneers, I needed to have an operation on my toes. I wasn't very mobile for a month after the procedure and, being a bit restless and pushy, I started gravitating towards the intelligence section of the battalion. One of my mates worked in intelligence as the battalion photographer, and photography happened to be something I enjoyed and I knew about. It also struck me that a career in infantry could easily be undone by a small physical problem, and then what? Photography and intel work, on the other hand, didn't seem to put the same strain on the body.

So here I was, twenty-two years old with almost three years left on my army contract of six years, and keen to retrain. They knew I was handy with a camera − not professional, but handy − and my mate was moving on. The

intelligence section needed a replacement for him and after a bit of needling and persuasion they accepted me and sent me to the Army School of Military Survey in Albury-Wodonga.

The army's photography course at Albury-Wodonga was much deeper than anything I'd learned before. By the end of that course I could have bluffed my way into a job as a photographer, darkroom technician or even something in basic graphic design. The army can't have photographers in the field with gaps in their ability, so they teach you everything and test for proficiency. I learned how to frame a shot, about focus, shutter speed, aperture, focal depth and light; I learned how to break down a camera and rebuild it; how to develop film, process it, crop it and print it. From portraiture to action; from night shots to time-lapse. I learned photo cataloguing and subject indexing – which is important in the battalion intelligence role so you can find any print or negative with a subject search.

After six weeks in Albury, I went to the battalion's intelligence cell as an intelligence duty man, and the commanding officer of the battalion – Lieutenant Colonel Jim Molan – signed off on my secondment to the PR section for twelve months. I was placed under unit photographer Warrant Officer Class Two Terry Dex, at the Defence Centre in Brisbane. Terry changed my life and he's a shining example of why certain types of people – like me – can thrive under a mentor.

The section itself was a dungeon, a little office and darkroom under the Victoria Barracks just down the road

from Lang Park. Terry's rank (WO2) the highest NCO position short of regimental sergeant major and he was in his early thirties when I started under him. He stood around six feet tall and was a very good water-skier, so he always had that tanned, outdoorsy Aussie look about him, which was a funny contrast to the dark cellar we were based in. He was not only my mentor, showing me all the tricks of the photographer's trade, but he was my employment trainer: he set my exams and marked me for proficiency.

These were special days, when I worked harder than I ever had before, trying to soak up everything about this amazing profession right down to how you hold the camera. I had my first photograph published in 1991. It was of an army officer with a plaque, for the army newspaper; a standard PR shot, but it got a run. I did it the way Terry told me to: know the story you're trying to tell, frame the shot in your head before you take it, take control of your picture. I would do it differently now, but I see in that shot the basic elements of the young professional. So, no Walkley, but I was happy. I'd got my start.

When you're starting in this business, a camera is a camera – they don't seem that different from one another. But I saw that Terry stayed current with technology. He read all the literature and kept up with the suppliers, and I carried that outlook through my own career. The gear we used was pretty indicative of kit in the early 1990s. Our 35mm SLR was the Nikon FM2, with an MD-12 motor drive. We used Ilford FP4 and HP5 film, on thirty-six-frame rolls. During my time

in the army, the SLRs were only ever Nikons. For portraiture we had a Hasselblad 500mm CM camera, with the 6x6 square negative, and we had to be handy with a Linhof Technika 4x5 field camera used for aerial photography, landscapes and army marketing shoots. And our flash units were the Metz.

Terry taught me how to make pictures, about depth of field, the 'thirds' composition rule and lens selection. And then you add the variables of light, time of day, movement and so on. The beautiful pictures that readers take for granted are a result of many decisions and I loved learning what those decisions were, even if it took me a while to master all the nuances.

One of the things I had to get out of my system was my love of a wide-angle lens. Every photographer has a comfort zone that they have to push out of if they want to be a professional, and mine was a close-cropped picture with a wide-angle lens. Some photographers like a bit of distance but I liked to be in people's faces and talking to my subjects. That instinct would serve me well in another career, with the Sydney tabloids, but as a young journeyman I had to vary my repertoire and Terry got me shooting the same scene in different ways. That's how I developed a career-long habit of going into a gig with at least two camera bodies over my shoulders. One would have the 28mm Nikkor wide-angle lens, and the other would have a 70–200mm zoom lens (the strength of that zoom depending on the shoot and the set-up). Terry would say, 'Get in and do your close-ups but then make sure you get me a variety of pics.' He taught me to

always get a saver picture – the set-up picture you take first-up so if everything else goes wrong you have that one saver pic. That trick saved my hide on more than a few occasions.

When Terry got the new Nikkor 20mm lens in the office, he knew he had to hide it from me. I loved that 20mm – it was the most close-up and personal lens a photographer could use at the time and it totally suited my style. Yep, I was developing a style.

* * *

Terry tried to encourage my energy and confidence while developing me as an all-round photographer. I can't have been easy – my energy levels were very high in my early twenties. One of the best things Terry did was calm me down a bit and insist I frame a picture in my mind before I took it. I didn't know what he was on about when he first said it, but as I became more aware and practised I understood that this was probably the main difference between a professional and a hobbyist. When you shoot for a readership – not for yourself – you have to capture an image that tells a story, so the image has to have context and information relevant to a person who simply turns the page and looks at the picture. When the photographer's picture and the journalist's words work together, there's nothing better. Just as the writer has to include everything that's relevant to the story, so does the picture. It isn't enough to be pretty or whimsical or arty, even though all of these things are great in their own ways. When

you take photographs for a readership, you have to know what you're shooting before you shoot it, which means you have to frame it in your mind. The habit Terry got me into has become a part of my life, and these days I see the shot before I've taken it; I know the shutter speed and the aperture, and the lens, the foreground, the background and where the subject is composed in the frame and how the subject interacts with light, environment and other subjects. But that's all just technical detail. Mostly, I've got a clear idea of what story the picture will tell. This is something you learn.

Don't let anyone tell you they're a natural photographer. It takes a lot of work and many mistakes, not to mention good teachers, to get you going. At least, it did for me. Terry Dex worked me hard and held me to a high standard – he didn't want crappy work being sent from his darkrooms. I really picked up that ethic: every time you send out your work, it's a chance for someone to say you're great or you're shit. It's up to the photographer. You're only as good as your last picture.

I was lucky to be a photographer in the army. Each arm of the ADF trains its photographers for a specific task. Back in the 1990s, the Royal Australian Navy (RAN) and the Royal Australian Air Force (RAAF) used imagery as analytics, but the army needed all-rounders and news-gatherers. An army photographer can be out and about with a patrol, sent up in a plane or taken out in a boat. But the images – once cleared by the hierarchy – might also be sent to newspapers as a PR tool. So army PR organised internships with media outlets to ensure the photographers not only had the technical ability

to take imagery for the generals, but knew how to shoot material that could be printed on a front page.

At the PR section I was taught videography on the old – but high-quality – Betacam SP systems. We worked to the same standards as television network crews, and we were also trained as sound technicians. We were trained as video editors, able to 'cut and crunch' footage and sound together, with titles, and make basic programming. We practised with the PR officers, interviewing them, taping them and then cutting it into a package that might be supplied to a television network. Again, the focus was on the story, not simply the images and sound.

In these early days at Victoria Barracks I had the enthusiasm of a big puppy and the dexterity to go with it. I was hard on my gear. Really hard. To this day, I'm no better. I get engrossed in what I'm doing, I act quickly and I see my gear more as a tool than as something to be worshipped. Terry used to wince at the dings I'd put in the bodies and lenses. He was talking with a sales rep from Nikon one afternoon, and the rep was boasting about how tough the new camera bodies were. Terry said, 'We'll see how tough it is. If it can survive Ramage, it'll survive anything.'

I started to wrap a lot of my gear in duct tape, to keep Terry happy. Mainly the edges of the bodies and lenses. This doesn't avoid damage from a major whack, but it does stop all the nicks and scrapes. It was a good habit to get into because as I amassed my own kit over the years, I'd always duct-tape it. That not only keeps it working in harsh environments, the

fact that it's in good nick also enhances the resale value when I'm ready to trade in. Here's another tip for young players: for some reason, customs officers the world over barely look twice at camera gear that's plastered in duct tape. It probably doesn't look valuable enough – the same reason duct tape keeps the thieves away.

* * *

During my time in Brisbane, I was madly in love with Sheree, a very pretty brunette who worked in the jewellery trade. She was the younger sister of my neighbour in Brisbane and right from the get-go, when we first met in 1988, we just hit it off. After eighteen months of dating we moved in together in Toowong and then, after living together for a while, we married in 1991 in a church in Maryborough – her family were Queensland cane farmers. She was twenty-one and I was twenty-three, and using the income from her job and my lance corporal's wage we bought a plot of land in the Brisbane suburbs and built an AV Jennings home on it. Twenty-three is considered a bit young to marry these days, but it was a straightforward decision for us. I had a profession and a woman I loved, I had a job and a house. Life was pretty good.

4

Out and About

Luck stepped in again in 1992, when I'd been a photographer for less than two years. The Australian Defence Force had its Kangaroo 92 (K92) exercise coming up and I was given the chance to photograph it with a crack outfit organised from Canberra, the Media Support Unit (MSU). K92 was a joint Australia/US ground-air-land simulation of an invasion of the Northern Territory, the largest exercise Australia had been engaged in since World War II.

Terry and I and another photographer, Warrant Officer Barry Buckley, went to Darwin and covered K92 with the navy and air force guys, and a large contingent of army PR people flown in from Canberra. I'd been a little sheltered in Brisbane and I hadn't seen the defence system as a class structure until we were all together like that. There were twenty-five people in the Media Support Unit and it became very clear that the journalists were the officers (captains and

majors) while the photographers and videographers were NCOs (corporals and sergeants). I was struck by how some journalist officers took their rank to mean that they were superior people, whereas others used their rank to drive people to get the best stories and coverage. It was an eye-opener: for some people in this amazing business called the media, it was all about their status and their perceived place in a class structure. For me it was about the work.

There were other officers in my new media world who were driven by excellence. One was Brigadier Adrian d'Hagé – then head of Defence PR – who raised the Media Support Unit with the ultimate goal of it becoming a permanent unit. With d'Hagé in charge, it was an exciting time. As we prepped for K92, the word came down that d'Hagé had a million-dollar budget for the exercises, and he had to spend it tomorrow. Who cares if that story was true? What it meant for us was lots of requisitions to make sure we had all the gear for the job. The budget was well used, and Barry Buckley came to the fore. Buck, as he was known, had been in Vietnam and as a WO1 was the highest-ranking photographer in the Australian Army. He was a classic grey-haired warrant officer who took shit from no one, especially not a bright-eyed mischief-maker like me. But beneath his stroppy demeanour was a tolerant, encouraging person who covered my arse more times than I deserved.

Buck was great on the tools and he built three mobile workrooms for K92, converted from large caravans. The mobile darkroom was a dual-axle, air-conditioned caravan

for the photographic crews. It contained three beds, fridges, cooking facilities, chemical storage, a wet process area for Jobo colour processing of negative and transparency, and processing for black-and-white negatives. The doors were sealed, so the whole caravan became the darkroom, and it had a five-hundred-litre water tank on the back so we were self-sufficient. Another, camouflaged, caravan contained the video editing desks, and a third – the MTV – had all the satellite communications gear, so our images and packages could be transmitted.

The three caravans were driven to Larrakeyah Barracks in Darwin by the army's transport corps, while four of us in the media support team travelled in a Land Rover with a trailer on the back. It took us a week to make that drive from the freezing cold of Canberra to the tropical warmth of Darwin.

For a couple of weeks we followed the forces around the Top End in our Land Rover, our stores and tents in the trailer on the back. It was rough going, and by the time K92 was over, I didn't need to see the inside of a Land Rover ever again in my life. But it was an ongoing education, learning how to get the shots when there was so much dust around and the light could be very harsh. When a convoy of vehicles comes through, you have a small window before the dust shrouds everything; same with a helicopter exercise. And if you get on the wrong side of the sun while the dust is rising, you could be shooting a whole roll of nothing. This was an invaluable experience when you consider that I ended up doing so much work in combat situations.

In those days, shooting on negative and transparency, there was no way to check. There was no 'review' button – a convenience that a whole generation has grown up with. I also developed my 'anticipation' style of action photography that would serve me very well in newspapers. When you're photographing groups of soldiers and they're getting on and off choppers, in and out of Land Rovers and talking on radios, you don't get to ask them to 'walk this way', or 'can you do that again, mate?' Not only can they not hear you, but they're tired and thirsty and they might just tell you to fuck off. So I'd have to think it through, be where the soldiers were going to be. I made it a mission to second-guess their movements, to work out in which direction they'd be running when they got off a helicopter and just make sure Corporal Ramage was waiting with his camera.

I was also developing an instinct for what photographers call the set-up, which is a picture that tells the story. If you do a proper set-up, no one picks that it was actually staged. During those two weeks in the north of Australia covering K92, I was on the lookout for a set-up picture that would hopefully get a good run because it encapsulated what K92 was all about: a picture that told the rest of the army that soldiers were on exercises in the Top End. I had noticed the tanks as they crossed the numerous rivers and I thought that setting would provide the first part of the picture. But I wanted something else: a human dimension that put the soldier's life in the forefront. I managed to talk a tank crew into stopping their vehicle mid-river, and then I grabbed one

of the soldiers. I got him to take off his boots, and one of them we filled with water. The picture I made – which got a really good run in the army newspaper – featured the soldier sitting on the front of the tank, pouring water from his boot. It was all staged, of course, right down to the look on the soldier's face. If you look at the picture you see a spontaneous antic during a military exercise, but it was all in my head long before I sourced the tank, the soldier or the boot.

This is another tip for young photographers: you must communicate with people. You have to earn their trust and take control. The soldier in my tank picture wasn't just sitting there holding a boot filled with water; I had to find him, prep him, get him onside and make him understand that this would make him look good (which it did – his unit loved it). It took some talking and selling and it never would have happened without the spiel. Some of my better-known pictures are set-ups: the picture of the digger walking with a young local in Somalia, and a similar picture from East Timor which ran on the front page of *The Daily Telegraph*. Both are set-ups with the added bonus of looking spontaneous. A big mistake made by hobbyist photographers is to think that the job is about passive observation of a found object. It's not. Hang around with a pack of newspaper photographers for one day and you'll notice them constantly talking to their subjects, cajoling them, corralling them into a better position, calling out to them so they look at the camera.

I really developed this skill while covering K92. If you don't engage with soldiers, get in their faces and let them

know what you want to do, they just ignore you and get on with their jobs. So it was an exhausting couple of weeks with long days out in the dust and heat, catching rides on helicopters, Land Rovers and tanks. But the hardest work was all the cataloguing and filing, which dragged on for weeks after K92. The army needs every negative and print, and every SP tape, catalogued, and it's the photographers who have to do it. It's not so bad when you go out for a half-hour gig. But we had hundreds of rolls of film shot at K92, most of them on the brand-new F4 cameras supplied by Nikon before the exercises started. They were a nice bit of gear and notable for the in-built motor drive and a few bits and pieces that made for easier shooting.

As the youngest, I was assigned most of the filing work when we got back to Brisbane. And while I was sorting these hundreds of rolls of film, I had this idea: *There's so much material here — someone should make a book out of it.*

That idea would have its day, but right then I had to slow down a bit.

* * *

Some of the best advances in my career occurred out of the blue. For instance, why I was tapped for the mission in Somalia.

During a phase of my life when I'd discovered my profession and calling, a dynamic duo in Canberra were remaking the way Defence did public relations and media.

They were Brigadier Adrian d'Hagé, who would succeed in having PR become its own corps, and his star recruit, Ms Lisa Keen.

Lisa was a very smart, very confident woman who was perhaps seven or eight years my senior. She'd been brought in from the private sector by d'Hagé to shake up Defence PR, and direct its work towards mainstream media needs. She was in charge of the Media Support Unit out of Darwin at K92, and I guess you could say our stars aligned: she was having to deal with all these sexist old photographers and officers, many of whom were resentful not only of a woman being in charge over them but a woman who was really good at her job. At the same time, I was enthusiastic, hard-working and open to any new idea or suggestion. I'd work fourteen-hour days, I'd take any job, I was developing my own ideas and I'd contribute to her briefings, not just sit there and roll my eyes. And because of the way Terry Dex ran things at Brisbane, I was already accustomed to anticipating commercial media needs and sending them our pics.

So Lisa noticed me and threw me the challenging gigs at K92, and she got me thinking about the media, trying to anticipate what they wanted and getting it to them quickly. I went from being happy to have my pictures in the army's publications to seeing them in metro newspapers and having my footage get a really good run on Nine's *A Current Affair*.

One afternoon in December, after K92 had ended, we were standing around a TV set at the PR section in Brisbane. A United States action had just started with a dramatic landing

on a beach near Mogadishu, the capital of war-torn Somalia. The US was sending troops to Somalia and Australia would also contribute to the humanitarian mission.

It was all a bit of a chuckle. But two days later I got a call from Lisa Keen.

'Do you want to go to Somalia?' she asked, just like that.

'Shit, yeah,' I said, without even pausing to think – or to ask Sheree!

5

To Mogadishu and Beyond

Kissed on the dick again. It turned out I wasn't just going to join the Media Support Unit in Somalia – I was the advance party. Along with Major David Tyler, a PR officer, we were going to be on the first plane into Somalia, where we'd find a base for our operations and set up in anticipation of the media arriving.

No one explained why I'd got the gig, but they did tell me something about where I was going. Somalia was on the north-east coast of Africa – the Horn of Africa, just south of the Arabian Gulf. Years of civil war had resulted in a breakdown of the normal operation of market agriculture and then famine had set in because opposing warlords kept stealing humanitarian aid donated by the West. Even the United Nations had been unable to bring order to the famine-relief program. We Aussies, along with the Americans, were going to secure the supply lines so the women and children got the food, and the doctors got the

medicines. It was called Operation Solace and the Australian Army's 1 RAR – also known as the 1st Battalion – would be part of a UN mission called UNITAF.

The capital, Mogadishu, was known to be a hellish mix of bandits, warlords, poverty and the rampant abuse of a drug called khat, and considering the role I was expected to play, I told my own commanding officer that I'd have to throw my weight around and be a bit demanding to get the PR base set up. I'd have to requisition supplies and divert men, and I didn't fancy my chances as a lance corporal. Acknowledging the problem, they made me up to full corporal and said, 'Do your worst.'

Our first stop was Townsville, where the MTV and the other two caravans were being loaded onto the HMAS *Tobruk*. We needed them in Somalia, but the commanding officer of 1 RAR, Lieutenant Colonel David Hurley – later to become Chief of Defence Force and then the Governor of NSW – was furious. He was the army's first combat commander since the Vietnam War and he did not appreciate his precious logistics space being taken up by not one but *three* of these caravans. Worse, *Tobruk* had already been fully loaded and all of Hurley's vehicles, stores and munitions were ready to sail for Africa. Then we turn up, these smartarses from PR, and we want some caravans on board. He had to take his own vehicles off the ship to accommodate us and he and his officers were hostile about it.

Once we'd jumped through this hoop, my photographic style got me into the shit, and not for the last time in my

career. I'd watched the local media mill around and take their shots of the dignitaries on the docks. It seemed like classic 'going to war' photography. But because I'm always pushing for something a little different – or better – I waited for a more candid moment. I waited, and crept in, and I shot the Minister for Defence, Robert Ray, standing on the wharf while he smoked a pipe. It was a good shot. But Ray went quite mad at me. He demanded to know who I answered to and made me promise that the photograph wouldn't see the light of day. Apparently he didn't like the public to know he was a smoker, which I guess was why he was standing on a wharf in Townsville, puffing away. I was in the army back then, and my chain of command led all the way to Robert Ray, so I had no choice but to obey. But I distinctly remember thinking, 'Screw you, that's a good shot.'

So, not a good start. With the caravans bound for Mogadishu, in January 1993 we were flown in a C-130 Hercules to Darwin and then to Port Hedland. I hadn't been into a combat zone before and I was pumped – in fact, the entire Australian military was amped. This wasn't blood lust, but it was the first foreign combat mission since Vietnam and it's not unlike a footy team: they train for years, and all they want to do is get on the field and play the game. I was no different, even if I wouldn't be firing a gun. I hadn't been in a war before, and this was a big deal.

It took us three or four days to reach Diego Garcia, which is a US–British military base on an island in the Indian Ocean. We were packed like sardines in that plane and it

Defence Minister Robert Ray. This shot of Ray smoking was not supposed to see the light of day.

was uncomfortable travel, sitting on the fold–down hammock chairs that are fixed to the inside of the fuselage. We finally fell out of the plane at Diego Garcia and spent two days of R&R in the accommodations at this massive military base. Diego Garcia is an atoll which looks like the island Robinson Crusoe would have washed up on, except it is dominated by a massive air base and runways and a large military port. So it's lots of squared–off concrete in a tropical paradise. The battalion guys called us 'pogues' – a Vietnam-era term used by grunts for non-infantry types – because of the dispute in

Townsville with the caravans. And because of our rejection by them we befriended the military police guys. This meant that while the 1 RAR battalion boys had to stay sober, we went out and enjoyed a few too many beers with the MPs.

The next morning, first thing, the spectre of war really loomed. Our first stop was the hangar, where we loaded rounds into magazines for our Steyr assault rifles – we may have been PR but we were going into a combat zone and we had to be armed. One of the MPs was still half-cut. It had been a big night and we had to be very careful because in the Australian Army mixing alcohol and firearms is a big no-no. We got through that and then it was off to meet the media contingent, who had flown in that morning. The contingent included people like Hugh Riminton, from the Nine Network, and Palani Mohan, a photographer from Fairfax. We'd be supporting them for two weeks in Somalia, so it was a meet-and-greet. Prior to the media deploying they were shown the basics of living in the field. They were shown how to eat the issue ration packs, use the sleeping and toileting systems, work on operations with the military, and stay safe and not get in the way when certain things are going on.

Tyler and I flew into Mogadishu with the Battalion's advance party the next day, on an RAAF C-130. From my window, the city – a former Italian colonial outpost which had been rent by civil war since 1990 – looked like someone's vision of hell: burnt-out, filled with rubble, shrouded in smoke. If there was a paint job in that city less than ten years old, I couldn't see it.

As we landed and taxied to the terminal, I could see the entire airport precinct was secured and controlled by the Americans. There were soldiers everywhere, military vehicles, helicopters and big stacks of shipping containers.

From the airport, we were bussed, with a heavily armed American escort, to the university campus where the Australian commander, Bill Mellor, was based. From here he'd oversee the Australian operations. Our home was a section of tents inside the campus, which had a secured perimeter but also boasted smashed-up university buildings, pockmarked with bullet holes. As we found our tents and had something to eat, I noticed there was no Aussie flag in place. I got the authorisation and then climbed the scaffolding on a burnt-out building and attached the flag. It was the first Aussie flag to be flown in Somalia, and that felt good.

The general atmosphere, though, was slightly confused: all the Aussies in that place were excited but also on edge. For most of us, war meant a clear fight between two sides, but in Mogadishu nothing felt clear. Every night we heard the sound of gunfire – sometimes in the distance, at other times a few suburbs away. At one point, there was an almighty crashing and shaking somewhere in the city, the result of a rocket attack. The fighting came nowhere near the university, but it was reassuring to have our flag flying while all this was going on.

We spent a week in Mogadishu before shipping out, and once the initial excitement had faded I was struck by a sense of hopelessness. The civic infrastructure we take for granted just

wasn't there. The more we explored and got out and about, the more we saw the scale of the destruction. The city was a total mess. I felt like I was in a scene from *Apocalypse Now*. Just anarchy, chaos, violence, danger and sick and scared children. The only law and order I could see was the US military. The fact that there were families living in this smouldering, dirty, broken and bombed-out place was astonishing to me. And the smell! Mogadishu smelled like an open sewer.

Alongside the desolation of the city was the quite awesome might of the American war machine. There was an enormous hangar at the Mogadishu airport, and in it and around it was the biggest collection of military hardware I'd ever seen in one place. The US Marines were camped there and there were C5 Galaxy cargo planes, Black Hawk helicopters, Cobra gunships and munitions and stores stacked to the sky. They had tent cities and massive messes churning out steaks and mashed spuds. The contrast between the overflowing bounty of the Americans and the less-than-zero subsistence of the Somalis was too much to bear. After a week in that place, I had to switch off my sense of fair play and make a conscious effort not to think about starving children eating garbage. I had to focus on my job.

Near the end of our week in Mogadishu, Major Tyler went off to a meeting. When he returned, he told me that *Tobruk* was about to dock and we were to grab our caravans and head to our ultimate destination: Baidoa.

Yes. Baidoa. The Australian contingent would be based in the city 240 kilometres inland from Mogadishu. It had

been called the City of Death by aid agencies because of the particularly savage wars fought between the clan militias and the lack of all laws and infrastructure.

We went down to the Mogadishu docks at the appointed time. The Americans had taken over the wharves and equipment while the local kids scurried around like rats, looking for whatever the foreigners might drop that could keep them alive. The 1 RAR boys were far more friendly getting those caravans off the ship than when they had to load them on. We hitched them to Land Rovers, and they were taken in the Aussie armed convoy to Baidoa while Tyler and I flew up to the City of Death in a C-130.

We flew over Baidoa on the way to the secured airport and it was worse than Mog. There were bullet holes in everything and every structure was somehow affected by war. It looked like a city of arsonists. Pretty much the only thing working in Baidoa was the airport: the US Marines had initially taken and secured the city, with the airport as their base, and the engineers had got in there and fixed up some power, lights and an air traffic control system. This was going to be our base, and even though much of it had been destroyed by gunfire and artillery shells, it had some feeling of security about it. I found an old Soviet-era concrete bunker, built for the MiG fighters stationed there in the 1980s, and it seemed to fit the bill for our media centre, so we grabbed it and made it ours.

Once the caravans arrived, a day and a half after us, we hooked ourselves up to the power supply and Tyler liaised

with the battalion commanders at the air base. The camp consisted of our caravans, some demountable office blocks and about twelve large army tents, in an area about fifty metres wide, some of it covered with camo netting. When we were secured and everything worked, we called the media scrum in from Mogadishu and they arrived a day later.

Channel Nine arrived with their own SNG — a satellite uplink that you tow behind a car — and that unit was going to be used by everyone under agreement. We processed their photos and gave them time on the editing desks for their TV footage, although the TV crews found it easier to send their footage and voiceovers back to Sydney over the SNG and let the production people do it back there. For the photographers, we developed and printed their shots, and pictogrammed them back to the pictures desks in Australia over the INMARSAT satellite phone system. Back in the day, the INMARSAT was so big you had to carry it around in a large suitcase. The pictogram was a rolling drum about twelve centimetres across and twenty-five centimetres long. You pressed the photograph to the drum until it was flush all the way around, and once you'd established a phone connection back to the picture desk at your newspaper, you hit 'send' and the drum started spinning. Back at the picture desk the picture would be printed and then the picture desk could use it.

Each morning, Tyler would go down to see the battalion HQ, pick up a sense of what was happening and come back to the media camp. We'd design a day trip for the media,

working out what could make for good images and who the journalists could interview. It was a really good media camp, and we worked incredibly hard helping journos and photographers get access to patrols and army people. I also learned a few tricks and picked up a few things about what makes a story and what is worth giving a miss. The photographers talked about a good 'get' and they constantly referred to the difference between 'news' and 'colour'. Until this point, I'd assumed that news photography – that goes with daily reportage – ranked above 'colour', which is the more magazine-like picture that brings alive a person's humanity rather than their place in the day's news. But in conflict zones, the colour shots often get the big run on the front page of the major newspapers, especially the weekend papers. It was a tip I filed away and would use when I went into conflict zones: the personal picture can tell the biggest story.

6

Inside or Outside the Wire?

Operation Solace was a dry gig for the Australian Army; this meant not one drop of alcohol was to be drunk on operations. But before we'd left Australia, Barry 'Buck' Buckley had stacked slabs of beer in the mobile darkroom. I'd previously learned on K92 that an empty box of 8x10 photographic paper could hold four cans of Tooheys New. But we were busted and Buck was ordered to dispose of the beer.

One night, Hugh Riminton was interviewing David Hurley, doing a live cross to the newsroom in Sydney. As the interview got going, an inebriated radio journalist from Townsville crawled out of his tent and wandered towards Riminton. For some reason, the radio journo was wearing a shirt but no pants or underwear – and he was hung like a donkey. As we realised what was happening, we tried to get his attention, but he wouldn't respond to our whispered calls. He was making a beeline for Riminton, but luckily someone

saw him and tackled him before he was within range of the camera.

Getting rid of the secret beer cache left us with only army-issue food and drink. These were the US MREs – Meals Ready to Eat – and our own rat-packs, which back then were quite terrible. Some of the meals came on aluminium trays with a lid you had to tear off, and there was a range of four or five food options. Most of them looked and tasted like slop, and the only one we found edible was the bolognaise, though even that had to be heated so you could get it down. The Italians, French and Americans who were also camped in the airport compound had much better food. We were always trying to trade, and it was the Americans who were most generous. I was particularly thankful for the American generosity because I'm not a small fella and the wooden Aussie Army field cots were too cramped for me to get a good night's sleep. I managed to trade Aussie rat-packs and a bunch of our Rising Sun pins for a steel US Army field cot, which was bigger than the Aussie-issue cot. For any Aussie who's going to spend some time in-country with an American contingent, always take Rising Sun badges and pins: the Americans love them.

Other than the booze bust, it was a really solid two weeks. And when we said goodbye to our media guests, I'd basically spent a fortnight finding the best stories, building rapport with the patrol leaders and getting a lot of good ideas for how to cover Operation Solace. I also had with me Tim Bowden's biography of Neil Davis, *One Crowded Hour*, and it became

my bible. Neil Davis was the Australian photojournalist and cameraman who became famous for his coverage of the Vietnam War, especially his gritty combat footage that always looked a little close for comfort. I picked up a lot of ideas from that book, in particular the idea that informed people make for better democracies.

While in Baidoa I got the seed of an idea going – I thought there could be a book in this gig. We had a modern new leader in Canberra and a newly centralised set-up. I figured Lisa Keen might go for the book idea. But before I pitched it I needed a lot of good photographs and some solid notes. And I didn't want to talk about it too much over there. I thought I should wait until I got back to Canberra where I could pitch to Lisa.

Once the media contingent was gone I kept the momentum going with the patrol leaders and commanders, letting them know I still wanted to go out with them, reminding them that now we could relax because I was shooting for Defence PR. Most of the companies were uncooperative; they saw media as a nuisance. The exception was Major Mick Moon and his Charlie company. He was proud of his guys and liked the idea of there being a record of their service.

Major Tyler gave me a driver and Land Rover and my job was to range around getting the shots that would form the media packages. Packages are photographs and press releases that are sent to newspapers in the hope they'll get a run and publicise what we're doing. But I had creative differences with Tyler. He was an officer and former journalist who'd been

brought in from mainstream media. He was a well-presented man in his thirties, around six foot three. He had thin blond hair and wore glasses, which gave him an intellectual air, but while he had a smooth exterior he wasn't exactly a dynamic news-gatherer, and he certainly didn't see his job as operating outside the secured perimeter. On the other hand, I was an NCO who'd been in the infantry and then trained as a photographer. So I saw a once-only opportunity to document our guys in combat in Africa, and I had one patrol leader who was totally positive about my goals and was prepared to assist me.

So it was a clash of outlooks. At first Tyler was prepared to let me go my way and do my thing, but on the second day of me roaming around while he stayed behind in the office, tempers flared. He had written a story supplied by HQ but it didn't match with the actual pictures from outside the wire. He wanted me inside the compound taking staged shots of the brass visiting the diggers, while I wanted to make pictures of the operational reality of our deployment.

For the next four months, Tyler and I played a cat-and-mouse game: me trying to get outside the wire and document our guys in action, Tyler preferring to get the story from the commanders once the patrols had returned to the compound. He wanted the story, I wanted the shots; I thought the story was where the action was, he thought the shots could be taken when the soldiers returned and could pose for the camera. Both of these approaches are legitimate, by the way. In my current role as News Corp's chief photographer at Parliament

House, I can tell you there are journalists who stay in the Press Gallery newsroom all day, and there are journos who are out and about. Same with photographers: some look at their list of photo calls for the day and attend them; others like to roam and scheme. We had different styles, Tyler and I, but we produced some good work, and because the only output for the Australia media was coming from us, we got some good runs in the major metro newspapers. It felt good being able to inform the public about what was going on and it felt even better to think there was an entertainment factor too. It doesn't matter how seriously we take ourselves in the media, we love to know that someone gets a kick out of what we produce.

In the end we compromised. Tyler allowed me to go outside the wire as long as I photographed his jobs as a priority. Which, in my mind at least, translated to: 'Go for it.'

7

Bleak City

In Baidoa meat markets, the morning heat was just starting to take hold. Around me was a dirt-paved town square, bullet-pocked walls and scorched colonial buildings overlooking a market where, somehow, there was still livestock for sale. This was my first patrol with Charlie company, and we were in the meat markets because the locals had been attacked a few hours previously by a dangerous militia. The clan militias were known to congregate around food-distribution areas like flies on you-know-what. It was their way of controlling the population, and some of the people at the market that morning had been killed and others injured.

By the time we turned up mid-morning it was business as usual. The patrol unit had insisted I dress in the Vietnam-era, US-issue flak vest. These things were not suited to the African climate because they're heavy and thick and you just run with sweat under them. I had to wear a Nikon

photographer's vest over my flak vest, so within five minutes of our hour-long walk to the markets, my shirt was dripping wet. The meat markets had a smell about them which will never leave me. At African meat markets you choose your beast and you either lead it away or they slaughter it on the spot. So there was blood and guts and flies, and traders trying to make their sales even as the soldiers milled around working out where the militias were. Beside a butcher's stall stood a camel, covered in flies. They were crawling into the animal's nose and mouth while the butcher hacked into a carcass on his wooden bench.

I walked with Charlie company further into Baidoa, a place that made Mogadishu look like a thriving metropolis. These dirty, decrepit streets were, according to the aid agencies and NGOs, the centre of the famine crisis and the hub of the worst, most violent militias. The bullet holes and burnt-out buildings were the obvious features, but I could also tell that the buildings – most dating from the 1860s or 1880s – had barely been touched in 150 years. No improvements or renovations, just slowly crumbling structures that hinted at a society that had given up long before the civil wars.

I kept my camera up and I got some great material. But the scene wasn't something I wanted to remember, and I had to remind myself that it is only through seeing confronting images that the rest of the world might be encouraged to give a damn. The streets were full of starving children and emaciated women and very few men. This was perhaps the only thing that enabled me to relax. The absence of

fighting age males was really obvious in Baidoa, but it made me reflect on where they were: either dead or fighting for some warlord was the consensus among the Aussie soldiers. Popular places, such as the meat market and street markets, were dominated by women and old men. Interestingly, while Somalia is officially a Muslim country, the women back then did not wear the hijab. The rural women wore long scarves over their shoulders and hair, but the scarves were colourful and featured shiny bits of bling. They didn't look religious. The city women – the ones running markets stalls and shops – had no head covering at all.

The orphanages were overflowing, their beds set up in courtyards and side alleys, but with no food or water for the kids. Completely dejected, hopeless eyes stared back at me, and as I got my shots I wondered if they would still be alive in two weeks. It was as bleak a place as I've ever seen – Somalia felt like someone had actively set out to ensure that no civil society could survive there.

After that first patrol in Baidoa, I thought to myself, *We can't help these people – there's too many of them, we can't help them.*

I hate to say this, but the only way you can do your job in the face of such wretched conditions is to put it out of your mind. I know it sounds callous, but it was the only way through. All the Aussies and Westerners did the same thing. You take a few days to adjust to the shock of it, and then, by unspoken agreement, you don't talk about it. Can you help anyone by moaning about the awfulness? No you can't, but you can do your job.

The disgusting state of Baidoa and its people was one thing. The other concern I had was that we could so easily have been attacked – 'contact' in military-speak. Even with a flak vest and there being so few males around, I always felt exposed. The patrols with Charlie company into the city itself were bad enough – the streets were narrow, lots of eyes peering out of the darkness of burnt-out buildings, strangely taciturn locals and the threat of attack looming over our every step. But there were also bush patrols into the surrounding countryside, where our infantry guys would assert their presence and keep the militias on the run – or so the theory went. The landscape was all camel thorn and hard-packed dirt. You'd be hard pressed to find pasture for the very few goats or sheep to graze on. As soon as it rained, the dirt turned to ankle-deep mud and splattered everywhere. The countryside was largely emptied out, not only of people but of livestock and crops. Farmers had clearly once lived there, and a few hung on: occasionally we'd happen upon child goat herders with two or three animals to tend. But Somalia's agricultural base was very small, hence the famine.

The bush patrols I joined were mostly on foot and sometimes in Land Rover convoys for wider sweeps. We'd take a route to a well or a village before circling back to the airport. Mostly the diggers would be dealing with women and children and some of the rare old folks who hadn't succumbed to the lack of food. Every now and then we'd bump into young men driving Toyota utes, with a load of other young men riding in the back tray. They were aged

in their teens and twenties, typically, and they carried an assortment of weapons, the most common being the AK-47. But they'd have a collection of random weapons too: I saw shotguns, M16s and the old FN machine gun. The uniforms were often military fatigue pants, and perhaps a pair of boots. But their shirts followed a sporting theme: the New York Giants, Manchester United, FC Barcelona. The first time I saw one of these militia vehicles, it didn't slow or stop – it kept on going down the dirt road, the seven or eight occupants barely glancing in our direction. Generally, these people would avoid the diggers, driving straight past without stopping or driving off if we found them parked. As I became used to their presence, I realised what was different about them compared to the rest of the populace: the militias looked healthy and strong. They were eating, and quite well by the look of it.

It was rewarding getting the pictures of these Australian patrols. This was the soldier's 'office' and I thought it was worth documenting. I used my two-camera system: one Nikon with a wide-angle lens for close-ups and the other camera with a zoom lens. I started carrying a lot of kit in my Nikon camera vest, too, so I'd always have the lenses I needed and back-up batteries. I was also taking video footage on Betacam SP, much of which was turned into a documentary on the Somalia campaign about two years later. When that doco came out it featured mostly Mick Moon's Charlie company on patrol around Baidoa, and the Alpha and Delta companies whined long and hard about their exclusion.

Of course, they hadn't been excluded – their bosses told me very clearly they weren't interested.

The patrols weren't physically easy because of the heat and rough ground. But they got progressively harder because the militias slowly learned our movements and instead of passively avoiding us, started seeking contact with our infantry companies. I wasn't present when Charlie company had a stand-off with one militia group, but the fact that the fighters were becoming emboldened worried the commanders. So they introduced a rule that I couldn't go out on patrol with the Quick Reaction Force (QRF) guys until after they'd been in a contact. This annoyed me at the time because I wanted the drama and action – but in war zones you should be careful what you wish for.

The militias were probably all around us when we went into town, and I always had the sense we were being watched, even if they held off. They did, on the other hand, attack the Americans, using rocket-propelled grenades (RPGs) and assault rifles. In 1993 one of the militias took on the Americans in Mogadishu, in a battle that would be immortalised in the book and movie *Black Hawk Down*. But during my deployment, it was early days and very few open hostilities occurred.

It was a dusty, dirty grind, but our own discomfort was nothing in comparison to the plight of the locals. In one trip to the city we drove past a normally quiet well that was unexpectedly crowded. We stopped and the interpreter came back and said the militias had poisoned the other wells in the area and so hundreds of people were trying to get drinkable

water out of a well that usually supported twenty or thirty. Their desperation was palpable. I saw this girl, about ten years old, who was crying. Just sobbing, inconsolable.

She'd been sent down by her mother to get water as usual and all these interlopers were crowding her out, not letting her near the well. I pulled out my own water bottles and was going to hand them to her when Major Tyler stopped me.

'If you give one water, you have to give them all water,' he said.

I was in the mood to argue, but I didn't. He was right. One person can't stand there playing Santa Claus. It would create expectation and violence and it would be the girl who'd be hurt because of it.

The real problem was not the way we distributed aid, but warlords using starvation to hurt one another. In Africa, you take away food and water from the villages so the men will join the militia, where they eat and drink as much as they want. The women and children are screwed, basically. So the only way to distribute food and water was in a mass, organised way so women – who may have three or four children to care for as well as elderly parents – can get something to eat. We attended a few of these food drops, usually run by the Americans or Aussies, in a field adjacent to a village or well. At a memorable one, in which I took one of my best conflict zone pictures, the supply trucks pulled up in a field outside a small village. The Aussie soldiers stood on the back of the flat-bed trucks and tried to hand out the rice and maize meal according to need. The grains came in

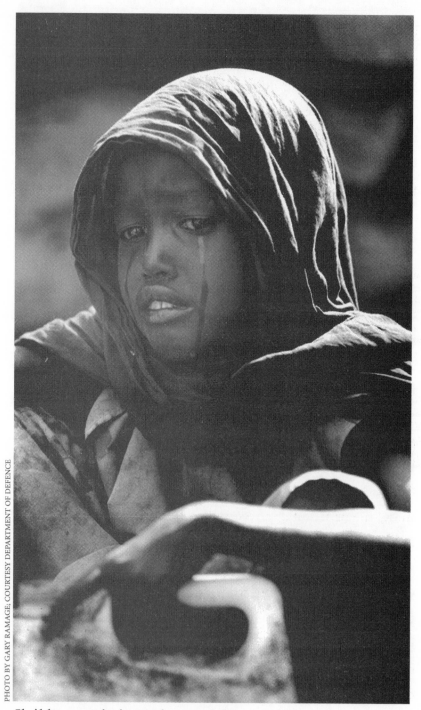

She'd been sent by her mother to get water as usual.

large sacks and the idea was a person would hand their plastic bowl to the soldier, the soldier would fill it with grain, and then serve the next person. But it didn't work the way it was supposed to: too many people, too much hunger, too much desperation. And, frankly, too many men thrusting themselves forward and crowding out the women, most of whom were in no physical state to assert themselves. You can just imagine what happens to a full bowl of rice or maize when you're being pushed and shoved from all sides. Not much stays in the bowl.

This particular distribution was heartbreaking and led to one of the most disturbing photo sequences I took in Somalia. It was the look on the faces of the women when the food distribution trucks were empty and readying to pull out. This was a stressful time for the women because some didn't have enough grain to feed their kids and others didn't want to be left at the mercy of the thugs and militias who would appear and take the food as soon as the Aussie soldiers had gone. One of those photos, which later made it into a book on Somalia, shows the panic on a mother's face as we pulled out, and it's a haunting image. What the picture doesn't show is the sound these women made that day: high-pitched shrieks of fear. If you were at one of those food distributions, you don't forget that sound.

The food drops could be depressing and the diggers really had to keep up one another's spirits. It was during one food drop that I struck up a conversation with a friendly soldier named Private Shannon McAliney – a chance meeting and

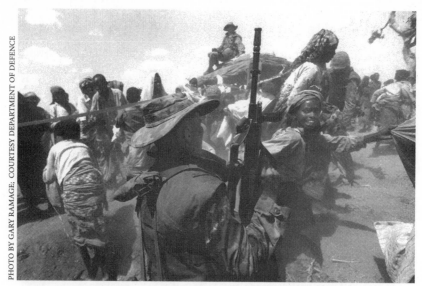

PHOTO BY GARY RAMAGE; COURTESY DEPARTMENT OF DEFENCE

What the picture doesn't show is the sound the women made.

one that would be repeated before we left Somalia, although in very different circumstances.

* * *

One of the highlights of the mission was Charlton Heston. I was a big fan of Chuck's from the *Ben-Hur* days and I really liked his company and his humour. He knew exactly how to talk to military people and with him I organised a system of souvenirs. I'd take a series of shots of Charlton shaking hands with an Aussie soldier, and when I'd filled a couple of rolls I whipped down to my darkroom van where Terry developed and printed them. Then I sought out Charlton and had him sign the photograph with a message to the soldier in the pic. Charlton thought it was hilarious and it gave the boys a lift.

My enduring memory of Charlton Heston? Him telling me how to take a photograph (with a great deal of humour). Funny on one level, but I got a great insight into how movies stars like it to be done.

* * *

About two months after the media contingent had flown out I started hanging around with the Médecins Sans Frontières (MSF) crew in the city. They had a makeshift camp in a bombed-out building, just off one of the main 'streets'. They had essentially stretched plastic sheeting between the internal walls of a colonial building and created a plastic 'ceiling'. There were partitioned rooms for the patients, fold-out cots, medicines and dressings stacked in sealed plastic storage bins and a generator to give them power. They were quite inspirational: volunteer doctors and nurses trying to make a difference in a place where even the most optimistic person wilted in the face of the task. I don't mean to be negative about the mission in Somalia. I think rich nations should assist the poor nations, especially when it comes to basic civic infrastructure like water, food, shelter and safety. But in Somalia, the people with all the resources just wanted to fight and destroy, and the rebuilding was being done by outsiders. It was a commendable mission, but it was like fighting a bushfire with a garden hose: you can't stop the fire but you can die trying.

There was a morbidly overweight woman in her forties who came into the MSF clinic one morning when I was

there with my camera. The blisters on her feet had become infected and they'd been covered over by the folds of skin that fell around her ankles. They'd ulcerated and caused a gangrenous infection in the lower leg. So the doctor cut off her foot with a bone saw. I watched him saw back and forth and the foot was off in a few quick minutes, discarded in a bin. Seeing the internal parts of another human being is a memory that has stayed with me, but while the sight of it was grisly enough, the smell was on another planet.

I got over that, and after they got her off the operating table, they brought in a little girl, maybe five or six years old. She had an infected blister the size of a fist on her lower leg, and the doctor decided her leg also needed to come off. Later in my career, colleagues would remark that I had a cast-iron stomach when it came to what I had to shoot. But right then, in that MSF clinic, I couldn't watch what that little girl was about to go through. That was it for me – I walked out. In Baidoa, at that point in history, I didn't fancy the chances of a one-legged young girl against famine, militias and the lack of sanitation. My heart was breaking.

* * *

The pictures I took with MSF drew me to the work of our own army medical centre in the Australian compound. I knew the staff there because the camp all socialised, but for the first time I started going down to their hangar, about a kilometre away, to see what they were up to. One series

of shots I took of them got a run in a newspaper back in Australia, so the doctors and nurses were accepting of me and liked that they were being recognised. That's where I first met Kym Felmingham, a young female army medic. We continued to bump into one another throughout our army careers and even after I left the army. Kym was the first female RSM at Australia's Headquarters Joint Task Force 633 in the Middle East, as I'd discover years later when I was doing a portrait project for the Australian War Memorial.

One evening I got an urgent call from the medics over the radio system; an armoured personnel carrier (APC) was on its way to the hospital with an unknown casualty – would I like to come down to film? I rushed down there and set up my tripod for the video camera in the inflatable field hospital where they did their surgery. Almost immediately I could hear the rumble and rattle of an APC outside the tent. Before I could get to the door, the screaming and yelling started. It was an anguished sound, one I hadn't heard before and which I won't forget. I pulled back from the door as they carried the soldier inside and then he was on the operating table in front of me: Shannon McAliney, now a lance corporal. He was still alive and in a lot of pain. He'd taken a bullet – it had gone straight through the useless American flak jacket into the upper left side of his chest and out the other side. When I realised he was one of ours, I switched off the video camera and just observed the attempts to save him. David Hurley and the regimental sergeant major were standing next to me as the doctors and medics tried to save this boy's life, him

yelling that he didn't want to die and the commanding officer telling him to hang on.

Years later, when I went to see the Tom Hanks movie *Saving Private Ryan* with Lisa Keen and her partner Bruce 'Johno' Johnson in Canberra, it hit me right between the eyes. There's a scene where a young medic gets hit while assaulting a German machine gun post and his friends are trying to save him from bleeding out. He is crying and screaming for his mum – he doesn't want to die. I must have flinched in that movie theatre, because Lisa looked over at me and could see I wasn't there. She tapped me on the knee and asked if I was all right. Of course I was all right – nothing wrong here! But the fact is, in that moment I was back in the hospital tent in Somalia …

The senior doctor suddenly stood up, looked at us and said, 'Okay, everybody out!'

Shannon died a few seconds later. I wandered out of the surgery tent into a crowd of Shannon's platoon, milling around, eyeballing me expectantly – some of the of young diggers were yelling and crying. I couldn't look them in the eye.

I left the medical centre, camera in hand, tripod over my shoulder, and went back to my darkroom. Then I sat on the blast-mound that surrounded the van. It started to rain. I took a few deep breaths and then started to cry. I was overcome with sadness. We were in this dangerous place and someone had died. Major Tyler found me and asked if I was okay.

'Yep,' I lied.

'Good,' said Tyler. 'In that case you can photograph the body for the internal investigation.' The regimental photographer was not up to it, apparently, and the battalion had requested I take the photographs.

I grimaced and nodded, but my mind was saying, *Are you fucking kidding me?*

I knew I had no choice; the battalion investigation into Shannon's death would require pictures in the file. That's just the way it works — that's what photographers in the military do. So I collected my gear and met one of the battalion guys in the field morgue, which was the battalion quartermaster's store. There were only two air-conditioned places on base: the darkroom van and the Q store, and they needed a cold place to keep Shannon's body before repatriation. I made small talk with the doctor to take my mind off the task. We agreed that the whole thing was difficult and sad, that Shannon had just got really unlucky, and then we got down to work. Shannon was lying naked on his back, in a black body bag, in a pool of his own blood. I remember noticing that his eyes were still open. The guy just directed me to take the shots that were required for his report and we kept it very calm and professional. One of the shots required was a front-on picture of the bullet wound and I couldn't get the shot by standing beside him. Trying to remain as respectful as I could during this bloody awful task, I had to straddle him and take the shot. As I looked down on Shannon, he was looking straight back at me and I didn't have the courage to shut his eyes. I had nightmares about that moment for years, and in my dreams I was lying in the body

bag and Shannon was photographing me. I realised that while I'm fairly gung-ho and action-oriented on the surface, I'm not made of stone. Shannon's death upset me greatly.

The shot that killed Shannon McAliney was friendly fire. It cast a pall over the Aussie mission and I can tell you to this day no one has discussed Shannon's death with me. No one talks about it. Why was I so affected by his death? I had a strange, fleeting bond with Shannon. He was a popular, well-liked bloke. He was twenty-two and I was twenty-four. We were both young army guys, in a violent and dangerous part of Africa, doing our bit. I'd photographed him helping an old lady carry some food bags at a distribution point. A few days later he was dead. At the Australian War Memorial they honour a fallen soldier each day. When they honoured Shannon, they used the shot I took of him in Somalia.

The episode stuck with me for many years, giving me nightmares. The problem with being a photographer is that you're paid to see things – you open up your eyes and see it all. And then you can't unsee it. And so it was with Shannon's death. In the documentary on Operation Solace, Lisa Keen cut the first two months of life in Somalia to the tune of Queen's 'Under Pressure'. It's only been in the last couple of years that I've been able to listen to any Queen at all. I used to turn off the radio when it came on in the car, even if it wasn't my car.

The photographer who goes out looking for action? He should be careful what he wishes for.

8

Through Aussie Eyes

One hot morning the order came to ship out. The operation was over.

I didn't respond well to this and argued with the person who passed on the order: Major Tyler. I was disappointed because I thought we should be on the last plane out so we could document everyone else leaving. My regimental sergeant major – Barry Buckley – had been among the last to leave Vietnam, with the PR teams, during the withdrawal and I wanted to emulate his commitment. It wasn't to be. I was on the very first plane out of there, having disassembled the entire darkroom canvas annexe by myself.

It was a disappointing way to end the operation. By now I'd finished reading Tim Bowden's biography of combat cameraman Neil Davis, and I'd recognised the power of the images and storytelling when a photojournalist is fully committed. Davis had gone *into* Saigon in 1975, to shoot

footage of the approaching North Vietnamese, even as every other Westerner was trying to get out of the city. And, after all, anyone in the storytelling business has to cover the end as surely as they cover the beginning and middle of the story.

Still, I learned a valuable lesson from that deployment in Baidoa and having to work with a journalist who preferred not to go outside the wire. It really struck me that journos can actually get away with putting stories together at their keyboard, relying on meetings, phone calls, faxes and emails. The writer can cobble together something from the past, freshen it up and make it seem like news. But the photographer can't take a picture of the past, or get their shot by asking someone on the phone to describe it. We have to be there – there's no other way. Far from weighing on me, this realisation energised me. If it's my responsibility to get the shot, then I'll do what it takes and no excuses. That attitude now defines me.

Once back at Victoria Barracks in Brisbane, I had to catalogue and file the negatives and prints that had come out of Baidoa. There were thousands. This was when my broader ambitions, and my ideas above my station, started to come through. There was so much material, and so many stories that went with the shots, that I couldn't consign them to a drawer where they'd never be seen again. Operation Solace was a short combat operation, lasting not more than five months – but it was Australia's first combat operation since Vietnam, we'd lost one person and we'd operated in Africa. I didn't want it to pass without honouring our people.

I started lobbying Lisa Keen to do something more lasting. Lisa was a civilian with an Executive Level 1 rank, equivalent to a lieutenant colonel, which meant she outranked a lot of pissed-off army PR officers who believed they should have been given the command of the MSU in Somalia and not some curly-haired blonde chick.

Lisa also had the support of her boss, Brigadier d'Hagé, with whom she shared a vision. Lisa wanted to produce a short film from Solace, which was why she'd commissioned me to shoot so much video. She would eventually produce several films, some as in-house docos and one for commercial television called *Solace: Everyone's Mother Can Be Proud*.

But I thought there was also a book in it. Okay, yes, the photographer's ego always thinks there's a whole book in his or her pictures. Guilty as charged. Lisa was fair about the potential project. She said the stories had to be as strong as the pictures, and she wanted it to be a publication capable of commercial distribution so the public could see what we'd done in Somalia. She found Bob Breen, a writer and military historian, to do the research. Bob also interviewed me to get the real stories behind the pictures.

I loved the process of selecting the pictures, and doing it in collaboration with Lisa and others. I'd never done something like this before and I liked working with people who were passionate about getting the best out of a project. I also liked that with these pictures I got to drive the narrative because I had been out there, on the ground, and my pictures set the agenda. It was from this process of assembling the

narrative of pictures that I vowed to always keep my own notes on my photo shoots and never rely on a journalist to do it. In Somalia, I'd pushed to go on patrols and get beyond that corporate PR level and do something extra and more human. It had been a confronting time but the work I produced vindicated my instincts. Somalia was a culmination of learning and experience, and Lisa Keen capped it off by going for great rather than just settling for a few press releases and some staged photographs. She was really something, that Lisa; no wonder Barry Buckley nicknamed her 'Queeny'.

The resulting book, *Through Aussie Eyes*, was published in 1994 by Defence Public Relations and I'm still proud of it as a team effort. When I look back on it, I see a pattern and approach to my profession that would become more entrenched as the years went by. I see someone who works very hard, covers a lot of ground and wants to document the human reaction in every frame. I also see a book that tells me that the photographer's instinct has to count for something. If I'd sat back and done what the journalist had told me to do, we'd have produced a steady stream of staged shots of the brass pretending to talk to the enlisted men, with press releases telling the Australian public how great the army was. But that book has pictures of David Hurley actually out with the soldiers, wearing his flak vest; there are the 'difficult' shots of a digger standing guard on a food distribution point, handgun at the ready while the hungry villagers wait behind him; we even included the shot of Robert Ray smoking his pipe, and I kept my job!

Mostly, we created a record of service, with the soldiers captured in their environment. My own grandfather served in the British Army in World War I and the only record I have of his service is an old picture of him in uniform, which I carry in my wallet. All his records were destroyed in a fire when the archive building in London was bombed during the Blitz. So pushing for that book had a lot to do with my own wish that someone had bothered to tell my grandfather's story. In truth, every family of a person who serves wants there to be a record and some recognition of what their loved ones did. I was lucky that I was in the right place at the right time to do something about it.

* * *

I settled back into life with Sheree, enjoying our new home, but I was not well. I'd picked up a dose of combat fatigue in Somalia and was a little remote from my wife and drinking way too much. Ever since we first became a couple, we'd been close friends, but now I was distant from her, and this distance was not helped by my work on the book.

Life after a deployment can be like that. You have to decompress, get used to a life in which you eat normal food, walk around without a firearm and aren't constantly on the lookout for people who want to fire an RPG into your vehicle. I was lucky to have an engrossing project like the book to keep me focused, but I wasn't one hundred per cent. Shannon McAliney's death and the subsequent autopsy photo

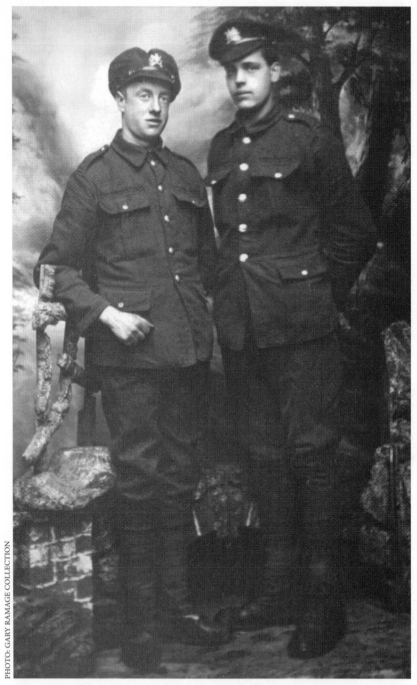

An old picture of my grandfather, Joseph Gilland Ramage (R), which I carry in my wallet.

shoot had hit me pretty hard and I had terrible flashbacks and night terrors about it for months after my return to Brisbane.

At work I was demoted to lance corporal, as the full corporal promotion had only been short term – a small fact they'd neglected to tell me when I was promoted for the Somalia trip. Before I could change my insignia from corporal, a person with a higher rank accused me of being inappropriately dressed. It was done publicly, for full effect, with an immature level of glee. After my deployment, and knowing that a book featuring my pictures could be on the cards, I was feeling pretty good about how my photography was going and I felt embarrassed for these people. Essentially, there were ten photographers in my corps and the lowly lance corporal had been sent, putting some – but not all – higher-ranked noses out of joint. They'd even started calling me 'Petal' because I was allegedly Lisa Keen's favourite. Lisa took great joy in calling me Petal and years later she told me she backed me because I always said 'yes'. She'd ask other photographers to go on jobs at short notice but was always met with some excuse. So her next port of call would be her Petal, knowing I would say yes.

Terry Dex retired from the media unit at Victoria Barracks. I now had Mal Lancaster above me. He was a civilian photographer with the air force, and he'd won a Nikon press photographer award in his earlier career, which is the best accolade you can get as a press photographer. He was a real professional and he became my new mentor, and that was one of the luckiest breaks in my life. Whereas Terry

had drilled me on the technical components of photography, Mal worked me much harder on the storytelling. He'd send me back to do reshoots if he thought I'd missed the 'story' and this approach worked very well for me. In Somalia, I'd really discovered the role of photographer-as-storyteller, largely because I had to pursue my own story ideas and make the pictures tell the story. I had limited note-taking skills so my shots had to speak for themselves.

I became more refined under Mal. He insisted I do my homework and not rely on the journalist for research. 'You have to know what you're trying to say, before you hit the shutter,' he told me. My good mate Mark Dowling then came across from the battalion and was trained by Mal in the early 1990s.

Meanwhile, the publication date of *Through Aussie Eyes* was approaching. Because the project had Brigadier d'Hagé's weight behind it, the sniping I took from my colleagues faded. A launch party was arranged at Victoria Barracks in Sydney and the invitations started going out. The problem was the function would be held in the officers' mess, and Land Commander General Blake's chief of staff wasn't keen on having a lance corporal and his wife in there (you never knew – maybe we'd steal the cutlery or something).

Apparently, Brigadier d'Hagé had a running argument with the chief of staff over the issue, and eventually it was agreed I could attend the launch with Sheree, but only if we entered the mess via the kitchen. It seems D'Hagé hit the roof and yelled down the phone at the chief of staff,

eventually telling him to get fucked and slamming down the phone.

The deal was eventually done, because Brigadier d'Hagé told the officers' mess that there wasn't going to be a launch of the book without Ramage and his wife. We flew down from Brisbane on the day of the launch, and d'Hagé had arranged for a limousine to bring us to the officers' mess at Victoria Barracks. It's a famously flash place, and because we were slightly delayed, proceedings were held up to wait for us. We walked in to find a room full of people all looking at us. David Hurley and his wife immediately took Sheree under their wing so I could go and do all my launch duties. They made her feel like a princess at the ball, and it was a classic example of the Australian Army: while it contains people who cling to their jumped-up colonial class system, it also contains smart, excellent leaders like d'Hagé and Hurley, who don't have the time for all that crap.

The book was widely promoted and well received. And I got my first taste of the spotlight, doing interviews on Channel 7 with Rob Brough and on Channel Nine's *Today* with Steve Liebmann and Liz Hayes. I was proud of that book. It was a good road test for my style and technique and the way I use my equipment. Mostly, it made me realise my instincts about photography were pretty good – heading in the right direction, at least.

Through Aussie Eyes marked the birth of my knack for conflict photography. I was hooked. This was what I wanted to do.

My career was taking off with the launch of the book and my first combat assignment, but it spelled the beginning of the end for my marriage. At the end of 1994 I was posted to the Electronic Media Unit (EMU) in Canberra, which centralised all the photographers and video units in one place. It was a chance to work with Lisa Keen and a range of quality people and I was promoted to sergeant. We all worked very hard in that unit, and were regularly sent around the country and offshore to do our gigs. But between all the travel and my emotional distance from my wife, Sheree and I lasted less than a year in Canberra and split in 1995.

It has only been in hindsight that I have come to understand the depth of my personal problems after returning from Somalia. Sleeping poorly, drinking too much, quick tempered, morose and isolated: that's what Sheree got from me for two years. She did not deserve it. She didn't even have the satisfaction of dumping me: I took the coward's approach. I walked out one afternoon, stayed with a friend, and that was that. A bastard act and one I don't expect forgiveness for – to this day I am still ashamed. About the only thing I can say about that time is that if Sheree felt she lost me, I was also quite lost to myself. Looking back, I can see I used hard work, a few drinks and a lot of fatigue to simply push through and keep going.

The EMU was all hard work and exhausting assignments. Aside from a few portraits of generals and admirals and

official shoots at Royal Military College, Duntroon, most photographic work was outside Canberra. It meant a lot of travelling, which makes you tired and a little self-focused, but I made good connections during my time there. I became good mates with Trevor Bailey, who was working out at the helicopter school at RAAF Fairbairn in the Q store. Trev is my best mate outside of the photographic industry and was a great support to me when I needed it. Another connection from Canberra would become a lifelong friend. Giles Penfound was a brilliant British Army photographer on exchange with the Australian Army, who introduced me to the Leica camera. He was also a burly former Royal Green Jackets sniper who had transferred to PR, as I had done. He'd covered a few combat gigs, he'd been posted around the world, and I liked his company and his technical abilities. We became close mates and he said I should apply for one of these exchanges myself. So in late 1997 I suggested to my bosses that they send me on exchange to the British Army and didn't think much more of it.

A few days later I was sent to Bougainville for six months, and was based at a place called Loloho Jetty. It was probably – technically – a time when I should have been recharging my batteries and not pushing the fatigue too hard, but I really enjoyed myself. We shared the space with the Kiwi air force and their Iroquois helicopters, and I made friends with those Kiwi fliers during the deployment. Once the warring parties in Bougainville – which was actually a region of Papua New Guinea but ethnically aligned with the Solomons – had

agreed to independence talks in Christchurch, the drama all died down and there wasn't much going on. So I sunbathed a lot and ventured out to take shots of visiting dignitaries, but most of the time I was doing what I loved: being out and about with soldiers, joining their patrols and taking lots of good shots and footage.

For the most part, I accompanied the Kiwi lads on their aerial reconnaissance routes or their foot patrols into certain areas where the independence movement had spawned militias that didn't want to make a treaty in Christchurch. The agreement was that visiting soldiers could not carry firearms, so it wasn't a dangerous environment in the strict sense of it, but there were remnants of violence around. My lasting memory of those months is flying low over the incredible scenery of Bougainville, listening to Cat Stevens on the headphones. We had a Kiwi pilot called Crazy, and one day we were flying recon and he pointed to a mountain in the distance and said, 'There's an old volcano.' Next thing we know, we're hovering over this volcano crater, way up in the highlands.

'What's that?' says Crazy, and before anyone can answer he's flying up to this massive cave in the side of the volcano, with waterfalls coming out of it.

'Don't film this,' says Crazy, and suddenly everyone on that helicopter is yelling their Hail Marys because Crazy is flying into the cave. We went all the way in and I was shitting myself. I mean, really, really scared. These days I can't hear 'Where Do the Children Play?' without shuddering at the

memory of that cave. I didn't film it, but the loadmaster did. When we got back to base – and I have no idea how we got out of that cave – he plugged his video camera into the TV and played it for all of the guys. The Kiwi commanding officer came over to see what the whooping and laughter was about, saw what we'd been up to, and sent Crazy and his crew back to New Zealand.

I wasn't far behind. It was a very tough sell, getting Bougainville into Australian newspapers: the nature of the conflict was unclear and the stakes didn't seem that high. Soon after the deployment finished, I was back in Canberra for Christmas and then off to Irian Jaya, where the Townsville-based 5th Aviation Regiment was delivering aid and supplies to the drought-stricken countryside.

By now I was getting tired again. When you're a photographer on deployment or just on assignment, all you do is work. There might be a shoot at 6 am and one at midday and another shoot that evening, and you cover them all. And on the overseas deployments, I'd be travelling most of the day, looking for something worth photographing. I was head down, tail up for months, and at the end of 1998 I got a surprise. The brass agreed I should do an exchange with the British.

9

Germany and Kosovo

I'd had visions of what a British exchange would look like: nice English countryside with a cosy pub down the road. But it wasn't going to be cosy. I was going to Herford in Germany, headquarters of the British Army's 1st Armoured Division, and a serious combat-footing base that served as the British jump-off point for its NATO and Middle East commitments. I arrived in March 1999, and was struck by Herford. It was very big and very well appointed. Rather than the institutional military design we had in Australia, the base consisted of scaled-down suburbs and cottage-style housing with leafy streets and rose gardens and what have you. Of course, it had all the military buildings too, but there'd been a real effort to make it a little patch of England.

Herford also had a big operation for the British Forces Broadcasting Service, which had its own TV and radio studios and welcomed fellow media operators warmly. I befriended

BFBS cameraman Nigel Beaumont and Alison England, a beautiful red-haired Scottish journalist from Glasgow. We all got on very well and a group of us would have drinks together during my time in Germany.

Prior to arriving in Herford, I was aware that the British were involved in peacekeeping operations in Bosnia and the surrounding territories. The Bosnian War between the Serbs, Croats and Bosnian Muslims (Bosniaks) had ended in 1995 with a political settlement, but it required a military presence to uphold various agreements. The British had a big presence in Bosnia-Herzegovina and I wrote letters to every operation they were involved in. Just before they deployed in May 1999 I got the okay to go. I joined the British Psy-Ops (Psychological Operations) unit, which contained a military PR cell. We were based in a compound in Banja Luka, a city in the north of what is now Bosnia and Herzegovina. It was a lightly militarised city by the time I arrived and I instantly had the impression that the highly publicised Dayton Accords – sponsored by President Clinton – were really only held together by the presence of NATO's armies. Communist Yugoslavia had fallen apart and now the various tribes of the Balkans were putting it back together, but on their own sometimes-ugly terms. Banja Luka was the centre of the new Republika Srpska, one of two legal and political entities in Bosnia and Herzegovina, and a lot of mosques in the city had been demolished and Muslims persecuted.

Actually, my first impression of Banja Luka wasn't military: it seemed to be teeming with hot Bosnian girls,

trying to sell pirated CDs to foreign soldiers. And it was awash in alcohol; the British units all had their own bars so you could get drunk with the Commandos or the Gurkhas. Our compound was in an abandoned factory, probably selected because it was surrounded by a wall, and they planted the media unit people beside the Gurkhas' base. They put us media types in these Corimex dorms that were essentially shipping containers with two beds in them. I got lucky and had one to myself.

I was quite impressed with the beauty of Eastern Europe; even a place like Banja Luka, which had seen some fighting and had a few machine-gunned facades, had a really nice proportion to its buildings and streets. While I wouldn't go so far as to say it was business as usual, Banja Luka was basically operating as a city again, albeit one filled with soldiers and military vehicles. I threw myself into work for a month – taking any and all photographic assignments.

After four weeks I was rotated back to Germany and in Herford I hit a couple of interesting crossroads. First, the Kodak company had released a bunch of cameras for trial in the British Army. They were called the Kodak DCS620 and they didn't use film – apparently the images were all digital and were saved to a storage disc inside the camera that you later plugged into a computer and 'downloaded'. Because of the size difference between 35mm film and the charge-coupled device (the CCD, one of the main components of the digital camera), you had to multiply the focal length of a lens by a focal length multiplier, in the case of the 620

this was 1.6. So they were a bit fiddly and the cameras were slightly awkward compared to our SLR Nikons.

'Never work,' we agreed, having had a play with them.

I needed rest after Banja Luka – I'd worked too hard, trying to impress. I probably needed a week off. But the British media ops unit was very busy, and it was going into a charming part of the world called Pristina. We were going to trial our digital cameras in a genocidal shithole called Kosovo.

* * *

Our convoy of forty British Army Land Rovers and trucks set off from the base in Sarajevo at around 6 am, and crossed the border into Kosovo just as the sun came up. We were bound for Pristina, the main city in Kosovo and a site of ethnic cleansing. It was summer in Europe, so the grass was long in the roadside ditches, with wildflowers springing out of the greenery. I was in a Land Rover with three other media unit people, feeling safe because we were travelling with the Paras (the British Army's Parachute Regiment) when suddenly the bullets started coming in. There was yelling up and down the column, a crackle of radio traffic, and the vehicles slid to a halt as gunfire sounded and bullets pinged into metal and whacked off the asphalt. High on a hillside above, snipers were shooting at us from a complex of townhouses, so we were all out of the Land Rovers, throwing ourselves into those pretty roadside ditches.

Welcome to Kosovo.

I ducked into the clay bank, bullets flying over my head, thinking that both the camera in my hand and the British Army pistol on my hip were totally useless: the pistol is like a pea-shooter against the sniper rifles, and the digital camera? I still wasn't convinced.

The Para soldiers formed up very quickly and promptly got rid of the snipers, but I was ducking along that ditch, looking for pictures and wondering what kind of mad shooters would open up on a convoy of British Paras. The Parachute Regiment is not known for being namby-pamby when fired upon.

We were on our way again about half an hour later, once the soldiers had secured the area, but it put me on my guard and set the scene for a lot of paranoia in that unfortunate place.

I worked in the G3 Media Operations Pristina, tasked with covering 1 and 3 Para Regiment, who were in Kosovo as a part of NATO's Kosovo Force. I was partnered with a British Army photographer, Shaun Lewis, who was shooting video footage for G3. Shaun was a great bloke and became a good mate. And aside from the top work he produced, he was also a total ladies' man. Of average height with dark hair, Shaun had a soldier's build and two heavily tattooed forearms. He also had a pierced tongue, which he assured me gave him an edge with the ladies. He hardly needed an edge – in our visits to some of the wonderful military watering holes around Pristina, I was reduced to the role of bystander while Shaun gave a master class in how to get the ladies laughing.

Along with writers and other photographers, we moved around Pristina and rural Kosovo in a Land Rover, news-gathering both for specific assignments and on general tip-offs that something was going down – for instance, the mass graves. Kosovo's civil war between the Federal Republic of Yugoslavia (Serbs) and the separatist Kosovo Liberation Army had only been going for three months when we arrived in June 1999. Wherever you looked that summer there were buildings with massive holes, burnt-out tanks on the side of the road, army trucks burned to the axles and the obligatory spray of machine gun bullets through everything from a school's wall to a statue in the town square. And all amid the idyllic rolling meadows, babbling brooks and medieval villages this part of the world is known for. The people may have been crazy but the Balkans in summer is beautiful.

Nevertheless, Kosovo had about it the same unpredictability I'd seen in Somalia. It was prettier and greener, sure, but it had that same aura of lawlessness: random acts of massive violence, calculated cruelty, school teachers turning into psychopaths, entire towns herded onto trains and transported to the border – that sort of thing. Somali warlords used food to control people, while the Serb forces used artillery. But both used pickup trucks filled with murderous militias, inciting terror on a random basis.

I'd now been in four conflict zones in six years: Somalia, Bougainville, Bosnia and Kosovo. Each was dangerous in its own way, and all the more so for an outsider who enters for a limited amount of time and has to learn the ropes from the ground up, very quickly. While Somalia had felt hopeless,

Kosovo had a manic energy about it. For a start, their cities looked like ours; you wouldn't drive into Pristina and immediately decide this was failed state. It was a pretty city of around 150,000, with a mix of old and new buildings. When we were there it had seen some violence and gunfire, but now the civil war was being fought predominantly in other towns. So Pristina was still basically operating, under a cloud of paranoia and confusion, and most of the bars and restaurants were open for business. It was only in patches that you could see the savagery of the fight: apartment buildings in ruins, a cemetery blown up, bridges taken out and freeways with massive craters in them. Interestingly, the locals claimed the biggest destruction came from NATO bombing, not Serbian artillery. These were the days when generals were talking about 'smart bombs' and 'clinical strikes' with straight faces.

The situation in Kosovo all came down to brute power and ethnic politics. The Serbs (who, under Slobodan Milŏsević, controlled Kosovo as a part of the Federal Republic of Yugoslavia) were trying to drive the Albanians out of Kosovo. The Albanians, in turn, had formed the Kosovo Liberation Army and fought back. The ethnic part of it was quite serious: at one point the Serbs had forced the inhabitants of a whole Albanian village from their homes, pushed them into trains and taken them to the Macedonian border.

The uprising by the ethnic Albanians was being waged outside the main city but the battle for Pristina airport a few weeks earlier, on the outskirts of the city, was deemed crucial. The airport was being held by the Serbs – or their paramilitaries

– while the SAS and the Norwegian commandos had been in a race against the Russians to take it. A part of that airport was a massive complex under a mountain that used to contain Soviet-era fighter planes. The NATO planes had bombed the complex, leaving this big hole in the side of a mountain – the kind of lair Dr Evil would favour.

The Russians' reputation for 'misunderstandings' in Kosovo was still fresh after the airport incident. In one episode, within my first three days of being in Kosovo, I was out and about with the Paras and we suddenly found ourselves on a secondary road clogged with Russian tanks as far as you could see. They'd been moving into a town to take up peacekeeping duties – but they'd neglected to inform the locals. Now they were in a tank traffic jam as the brass tried to sort it out.

Somehow, as we navigated around Pristina and into the surrounding countryside, we managed to stay safe while gathering the pictures required. There were some photographers in Kosovo shooting for newspaper groups and Reuters and AP, but not many: Kosovo, like Somalia, was not a big attraction for the freelance crowd. It was quite unstable and even the American posturing and NATO bombing didn't seem to deter the combatants. Bosnia and Herzegovina had gone through its meltdown phase and come to a more or less stable conclusion – at least, that's how it was in 1999. You could see the remnants of war, but civil society was making a comeback. Kosovo, on the other hand, was 'live' and unresolved.

The British PR units gave me a real insight into how to control information, not holding it back – as was the culture in the ADF – but moulding the way the media reported the sensitive stuff. The British media officers didn't try to cover up a mass grave of Muslims. We would gather the news and the pics, and their crack media teams would trim it the way they wanted it to play, and send these very professional packages off to newspapers in the UK every day, timed to hit the deadlines. Regional and smaller metro papers in the UK would run the stories and the photographs straight into their news sections. It was an eye-opener: not military PR like an advertising brochure, but PR as an extension of military intelligence, where you alter the perception rather than hide the reality.

The Brits were smart and confident with this stuff and they needed a constant stream of images and stories to make it work. They needed to be at least on the same page as the mainstream media. So I was busy, with my days starting at 5.30 am and going into the night. I was lucky to be in bed before midnight during my Kosovo deployment, but it was worth it, because the work I was doing was good-quality news-gathering that ended up in British papers. It was exhilarating. And because Shaun and I were both sergeants, we were left to our own devices so long as we were filing material for the army PR machine. We made our camp in the Pristina compound with the Paras, which gave us good access to information.

But it didn't pay to get too confident. Businesses may have been open but nerves were frayed. One morning we were following a story and tracking the Paras in the city

outskirts. I realised I'd dropped a lens cap and I told Shaun I was going back to where I thought I'd dropped it. I walked back up an alley and saw the cap on the cobblestones. As I bent to pick it up, I heard the unmistakable sound of a machine gun being cocked. It was only a young Para, and it was all over in a few seconds once he realised I was an Aussie and not a Serb, but my heart was thumping like a hammer. As I say to people before they go into these environments, it's the silly moments when you lose concentration and drop your guard — that's when the shit happens.

I felt stupid about this incident. My spatial awareness is always very good in the combat environment. But that's how you end up dead — wandering up an alley, so focused on a five-dollar lens cap that you don't see the shooters. It turned out that my Aussie Army cam fatigues were the same camouflage pattern as that being worn by the Serbs.

A similar thing happened with a bunch of angry Albanians who surrounded me in the city one afternoon. They thought they'd found a murdering Serbian soldier. Luckily, Shaun leaped into the fray and rescued me before anything bad happened.

Due to this major safety concern I was given a set of British fatigues; they were second hand and sporting a few rips. I spent an evening stitching up the holes and changing over all my Aussie insignia to the British shirt ... with sewing skills they taught me at Kapooka.

* * *

We would often go out with the army MPs because they could move around relatively safely and they always knew where the action was. One day, while on a foot patrol, we heard screaming. We followed the noise through the streets and found an apartment building on fire. The MPs tried to find out what was happening. I followed one MP into the burning building, running up the stairs to where the screams were emanating from. Someone had nailed the bloody door shut from the outside. Unbelievable! There was so much smoke, but the MP broke down the door and rescued the two old ladies inside. I managed to fire off a few frames of the MP carrying one of the old ladies down the stairs. According to the bystanders, the people in the house were Serbian collaborators, but when we got them out, they were old ladies. They were grandmothers!

Another time, we were out with the MPs and the radio call came in that shots had been fired in one of the housing estates. We went out there to find an old lady in hysterics outside one of the huge concrete towers. At her feet was an old man, lying face down in a pool of spreading blood, his walking cane beside his hand. I took the shots and asked one of the MPs what had happened. The interpreter said the woman's husband had left the apartment, and the moment he'd stepped outside an Albanian gunman walked up behind him and shot him in the back of the head. Albanian vengeance.

Some of the jobs involved inspections. One afternoon we were driven into the countryside to a secret ammunition

dump that had been discovered by a farmer. It was a shallow depression filled with uranium tailings and other toxic nasties. But when one of the engineers tried to take a closer look, we realised the entire area was booby-trapped with jumping jack mines – the kind that leap up on detonation to inflict the worst injuries. Mines were a widespread problem in Kosovo. Both sides had laid them and the engineers from various nations spent a lot of their time fencing off football fields and family parks, and putting up the skull-and-crossbones signs.

On one job, the MPs were going to arrest someone who'd been shooting people. They'd recce'd the area, and knew where the guy was. Shaun and I followed the MPs in convoy to an area outside the city, along a dirt road, where some of the paramilitaries were known to hole up in farmhouses. But when we arrived, we found the place eerily abandoned. The person we were looking for wasn't there and the house in question was empty. But there was a blown-up car on the side of the track where there hadn't been one before.

There was a terrible silence while everyone looked around to work out what had happened. And then the voice over our army radio: 'You're probably on a mine field now,' said one of the MPs. We reversed back down the road, taking care not to veer off the tracks we'd come in on. It was an agonisingly slow process, and we were so tense we ended up slapping one another to try to keep our sense of humour.

* * *

Of course, there were lighter moments in the job. I was with Shaun one morning early on in the trip, and I was giving him heaps because a warrant officer had lined up a bunch of men and women that morning at the base camp, and blasted them for ignoring the British Army's standing orders on fraternisation. The HQ unit had as many women as men, and apparently there'd been some very friendly behaviour after a few pints. I was joking with Shaun that the Poms wouldn't have dreamed of banning the drinking, yet they called a halt to the shagging.

'You Poms can sure sniff out a drink,' I said to him jokingly.

Later, we were in a rundown industrial area of Pristina with a whole lot of shipping containers among the weeds. Out of nowhere, Shaun said, 'What the fuck is that?'

I couldn't see or hear a thing, but I followed Shaun and we found a rave party going on in a bloody shipping container. He could smell beer through steel walls!

* * *

Something that no amount of high spirits or bravado could prepare me for was the mass graves. The British Army investigated mass graves with its criminal investigations teams, which meant detailed photography. There was no chance of a few quick snaps and then taking off. My job was to see everything and record it for the investigators' files.

The first time I had to photograph a mass grave, the call had come in while we were on another job, and we joined a

convoy of Land Rovers headed east to follow up the report. We arrived in a small rural village, picturesque with its little stone houses and stone walls. It seemed the inhabitants had discovered a shallow grave on the side of a hill that overlooked the village. With the criminal investigations officers leading, we followed the locals, walking across the meadow. It was a beautiful summer's day in the Balkans, and there was this scar across the meadow, about fifty metres long. The farmers at the site already had scarves over their faces, and as the soldiers and farmers scraped soil off this scar, the bodies started appearing. They were lying like sardines alongside each other: young men with bullet holes in their heads. The Paras handed out face masks and I took one. As the dirt was scraped off this mass grave the people from the village walked up and down looking for their loved ones. It wasn't too difficult to identify the bodies: the Serbs had left the wallets in the executed people's pockets when burying them. As the women cried out on seeing their sons, brothers and grandsons, I was overwhelmed by the smell of death. Kosovo is quite hot in summer, and as the sun warmed the area, the sweet smell of putrefying flesh went everywhere: up my nose, in my eyes and mouth, in my hair. Some of the soldiers and locals vomited as the smell wafted around, and I started shooting. The criminal investigators wanted a record of the bodies, which was mainly covered by Shaun's video camera work. I wanted to get the reactions of the locals as well as the specific shots the investigators asked me to get.

As invasive as it may sound, this was actually the story of civil war: not the politicians, the bombs or the machine guns, but the sobbing mother and father who held it together long enough to identify their son to the British officer at the back of his truck. Yes, I took that shot, and no, it's not a shot some people would take in that awful circumstance. But when I go over my Kosovo footage, that's still one of my favourites. When I think about how a picture can tell a story, that one sums it up: you're not killing a Muslim, you're killing someone's son.

There were around twenty-five bodies and they'd been in the ground for two weeks when we unearthed them. The sight of the villagers, walking from body to body, hankies over their faces, was something you don't forget. Trying to give the friends and families of these executed people some dignity, while also clambering for the best shots, was tricky to say the least. It wasn't like the locals were shooed away once they'd identified the corpses. There was a lot of standing around, hugging and crying. These gigs would take all day. And they all ended in the same strange scene: the soldiers putting each corpse in a black body bag and carrying it by the armpits and ankles to the back of a truck, until the truck was filled with corpses.

I actually found the whole experience devastating – the image of my first mass grave stayed with me for years – but there was a really strange upshot to it. The next day we were in Pristina, walking along the street, when the word got out that the Kosovars had won. Kosovo would be an independent

entity. After everything they'd been through, I watched these parents run inside, grab a couple of toy guns, and shove them in their kids' hands as they started celebrating. All around me, children were being given toy guns to shake above their heads as they celebrated the end of war.

I stood there stunned, wondering if the world had gone mad.

The civil war is over, and a Kosavar child shakes a toy gun in celebration!

10

East Timor

After five weeks in Kosovo I was returned to Germany. Everyone was exhausted, me included. When you do these gigs you're constantly travelling, working and occasionally sleeping. The army has you on a schedule for work–eat–sleep, but the schedule is ignored: if you have to take shots of a British commander with a politician in Pristina in the morning, photograph the weapons inspections in the east in the afternoon and then follow the MPs in the evening, there isn't much downtime. As happens in the media, the downtime is usually taken late at night in a bar, with some reheated food. And then it's all go again at sparrow's with a slight hangover.

While I didn't think I pushed it any harder than Shaun or the other PR people, when I got back to my original exchange unit in Germany my boss took one look at me and ordered me to take time off to recuperate. He said, 'You can't work that hard – you'll kill yourself.'

I suspect that sometimes, when you do a job like mine, the excitement can mask stress and fatigue. And the longer you ignore them, the more they're advertised on your face. People start to see in you what you can't see in yourself.

I spent my leave in the UK, and went up to Scotland to stay with my aunt Rita and visit my granny. While I was in Edinburgh, I went down to Royal Mall and got my tongue pierced. I'd become fascinated with Shaun's pierced tongue, so in a silly moment of 'I don't give a shit', I got mine done too.

I'd been in touch with Giles before I got into Edinburgh and he'd wangled me a ticket to see the Edinburgh Tattoo. I went up there with my camera kit and started doing the whole Ramage thing; next thing I know, I'm in the accredited photographers' section, taking some fantastic shots. I'm on holiday but I'm working. It's a habit I have to consciously suppress; these days I have a marriage where this quirk is outlawed in our basic agreement.

I then drove up to Inverness, where I'd arranged to stay on what I thought was a military base in Scotland. Once you're in the British military system, you can do this as long as you give notice. The first problem was that no one was there, so I had to go into town to locate the mystery person who would let me in. Second, the 'base' was actually a medieval castle! So the mystery person takes me up the hill to this dark pile of rocks, opens these huge steel gates, lets me into the place and turns on the lights. He tells me to pull the gates closed when I leave, and then he pisses off. Do I need to spell out how

strange it was to spend a night alone in a medieval castle? Do you think I slept much? There were so many unexplained noises it was like the building was talking.

* * *

I got back to Australia in early August 1999, and by then my tongue piercing had swelled up so badly I could barely speak. I was immediately put on standby for East Timor, so I had to do a complete physical for deployment. When I went to see the military dentist in Canberra, he took one look in my mouth and said, 'What the hell is that?!'

I told him, and he said, 'Well get it out of your mouth and then come back and see me.'

So I did, and I've never been pierced again.

Around Canberra, everyone was talking about East Timor. There was going to be a vote for independence at the end of August and then the Australian military would go into Timor after the election to secure the peace.

Having done my physical, I was told I wouldn't be going to Timor after all. Looking back on it now, it was the right call. But when a superior said he didn't want me in his Timor team, I cracked the shits. I thought I was the best man for the job, but really I should have just kept my mouth shut. I'd had a really good run, and after my helter-skelter operations in the Balkans, I probably owed it to myself to sit this one out. But I couldn't leave it alone, so I pushed and I won the argument and was sent to Timor. I wasn't allowed to be in

a field team, which meant I'd be staying back in Dili at the headquarters of the Media Support Unit, processing material and doing paperwork. I'd be a back-office guy.

Yeah, right. Ramage will shut his mouth and sit in an office all day while there's action in the hills. What are the odds?

* * *

Every conflict zone has its character, its creepiness factor. By the time I was whisked from the airport to the Hotel Turismo in downtown Dili, I was in my fifth conflict zone in six years and I had an appreciation of these places. Where did Timor sit on the spectrum? I'd give it the danger factor of Somalia with the geography of Bougainville. It lacked the civil war feel of the Balkans, where the different factions could give as good as they got: Timor's population was largely subsistence farmers and fishermen, being harassed by one of the largest standing armies in the world. You had villages filled with barefoot banana-growers being stalked by helicopter gunships; unarmed families hiding out in the bush while armed thugs torched their crops and killed their stock. Gratuitous bullying is what it was. I hate bullies.

The locals had overwhelmingly voted for independence from Jakarta, and in the first weeks of September, when the Indonesian soldiers started their pull-out, the pro-Indonesia militias were raping, killing and burning in the small towns and villages of the interior. Even in Dili there was a constant

smell in the air, similar to the smell you get in Canberra or Sydney when it's bushfire season. It was a time of great internal migration as entire villages were forced to hit the road: for many locals there was nothing left to eat, nowhere to sleep.

One morning, a large ship filled with Indonesian soldiers sailed from the Dili wharves. I was with some Aussie diggers on the wharf and we waved them off, but the Indonesians didn't wave back: they made throat-slitting gestures at us with their thumbnails. It was full of hate, the entire mission up there. On the one hand there'd been a referendum, and Jakarta was making all the right noises. On the other hand, there were bands of psychotic Indonesian militias roaming the interior, obviously armed by the Indonesian military and able to slip across the Lois River into Indonesian Timor as soon as the Aussie soldiers got too close. The interior of Timor is hilly and covered in bush, with limited road access. It was easy for guerrilla units to move unseen through the country and difficult for outsiders to know where to look. It was a strange situation, because we were a peacekeeping operation, but we had special forces operators in the jungles, tracking the militias.

Dili itself was pretty stable, though, and I settled into life at the Turismo, an old colonial Portuguese hotel where all the Aussie media crews were staying. I was with the guys from Channel Nine and Seven, News, Fairfax, Reuters and AAP – I was looking after the HQ photographic needs and troubleshooting for the media crews when they needed a fax

that worked or a pictogram with a sat-phone connection, which I always travelled with. I was behaving myself: Sergeant Ramage, keeping his nose out of it and tending to his assignment.

But one morning I was called up. The SAS regimental sergeant major walked up to me at the wharf. Was I Sergeant Ramage? he asked.

'Yes,' I said.

He responded: 'You're coming with me.'

I thought I was in the shit, with no idea what I'd done. It turned out he needed photographic coverage of bodies being dug up and I was his guy. It was all approved.

We drove up into the interior, with two MPs and some other personnel, into an area where a militia had been actively intimidating the locals. Graves were identified and digging commenced – this was half an hour's drive from the Turismo, so the militias were operating very close to the capital. While we were on site, a Land Rover turned up with the SAS commanding officer, the unit's intelligence officer and two other soldiers who were not special forces. While the soldiers uncovered the graves, a local man came up to us and warned us to not go back down the road. There was an ambush being laid for us, he said. Then he left.

The three senior SASR operators and the two non-troopers immediately jumped in their vehicle and set off to investigate. I wanted to join them, sensing a story unfolding, but the commanding officer said, 'Absolutely not.' All I could do was give my bulletproof vest to the intelligence officer.

So I stayed on the side of the road and tried to stay in contact with the SAS guys on our army radio, but we lost comms. This got me frustrated, because these guys were going into a gunfight and I felt I should be there with them. We should have at least maintained communication with a small force going into contact. Thinking I could open up the comms if I moved up to altitude and clear air, we drove up the road towards the summit. As I fiddled with the radio, I heard the scream of an over-revved diesel and the chopping of gears, and then around the corner – not two metres away – came this eight-tonne truck, flying across the road, with a full contingent of Indonesian militia fighters on the back. Then came a second truck with the same cargo, and the driver of this truck slammed the brakes and slowed. I held up my hands in an appeasing gesture as twenty shooters beaded up on me. I was close enough to see the pendant around one gunman's neck and work out he was Catholic. I've been in some scrapes in my life, but that was definitely the split-second when I thought I was going to die.

They eyeballed me, and then there were some shouts in Bahasa which probably translated as *don't worry about him*, and the truck got its revs up again and they were off, following the first truck down the hill. As I caught my breath, now I had another problem. The SAS guys were moving down to one situation unaware that a bigger more dangerous situation was looming from behind. And I couldn't get comms to warn them what was coming.

We decided to drive down there, even though there was little we could do. There were forty shooters on those trucks and we weren't heavily armed. When we got down there – gingerly, might I add – the SAS guys were chatting among themselves while the radio guy tried to get some support. Apparently, the truckloads of militia had come around the corner and stopped in front of the SAS guys. The commanding officer and RSM turned their rifles on the militias, and there was a tense stand-off until the militias decided to keep moving down the road. Now the CO wanted to get after these militias – these were the ones who'd been burning the crops and the villages. So he called in the quick response force from the SAS. The QRF is the troop on standby for precisely what the CO needed. He had his comms guy and his platoon sergeant around him, maps spread, coordinates worked out, ready to advise the QRF. But crackling out of the radio was an increasing amount of umming and aahing. I watched as the CO manfully tried to keep his cool while his QRF troop was clearly still on the ground at Dili airport. Finally, after all sorts of stuffing around, the CO was advised that the aviation regiment didn't have a bird for them.

The 5th Aviation Regiment was responsible for picking up and delivering special forces units, and responsible for on-call operations such as the QRF. In normal conditions, the SAS's QRF teams would be lifting off the ground mere minutes after receiving the order. But there'd been some comms breakdown at the airport and the upshot was that there were no Black Hawks available to the SAS. The commanding

officer was beyond angry. He'd just watched two truckloads of the worst militias disappear down the road and had no way of giving chase.

When the first Black Hawk did finally come in he put me on board with two of his snipers. He wanted better intel on what was happening. He said, 'Get me some video evidence of what these bastards are doing up there.'

* * *

It was through this work with the special forces that my eyes were opened to what the army is really about, which led to an increasing dilemma on my part. A warrant officer mate in the intel section was based out at Dili airport. When I went there to catch up with him one day, he said to me, 'Have a look at this.'

We went down into the basement of the terminal building where he led me into a darkened room. In front of me, squatting on the floor in a stress position, were fifteen Indonesian militia, hands tied behind their backs and blindfolded. They were clearly very scared. They were down there for questioning and it struck me that while this might have been an operation to build trust and security, it was actually a nasty little war. This demonstrated the limits of what I could do as a military employee. As a media photographer, my job was to show readers what was actually happening. But this was not my job in Timor, or Bosnia, Kosovo or Somalia. I was a PR guy, and a senior one at that. This was probably

the first time I reacted like a media photographer, only to realise I was a sergeant in the army. This was a hard place to get to; I didn't know it then, but once you see the world through media eyes, you're screwed. You can't see it any other way. I saw those prisoners in that basement, and I saw a story. My first reaction was to frame it and see it on the front page of *The Daily Telegraph* with a big headline. I wasn't interested in a PR spin for Defence.

Before I could become too frustrated by this growing awareness of my changing attitude, I was pulled out of Timor. Lieutenant Colonel Rob Barnes – commanding officer of the media support unit – said I'd done enough for the year and I should go home and have a rest.

I arrived back in Canberra in early November 1999 and when I returned from leave I was made a warrant officer class two and sent to Townsville to be a photographer for the 3rd Brigade in North Queensland. At first I felt a little like I'd been sidelined, but Townsville was a welcome breather for me and I became very social in that city. I played a lot of golf and met my mates every Friday night in the Heritage Hotel, where you could buy a dozen oysters and a beer for ten dollars. I started spending my time off in Perth, visiting my sisters and parents and my old Perth buddies. One night at my sister's place, where I was staying, I flopped down on the couch and turned on the TV. The Twin Towers in New York were on fire. Talk about your world changing.

I was in Townsville for twelve months and then I was assigned back to Timor as a photographer to the Australian

HQ in Dili under the United Nations. This time I'd run the show. Townsville had recharged my batteries – I was back.

* * *

As soon as I hit Dili I wanted to change everything. I first noticed that the old MTV – the darkroom caravan from Somalia – wasn't being used. So I suggested to Major Dave Munro that it be shifted to Balibo, home to the combat element of the battalion and the Black Hawks from the 5th Aviation Regiment. I wanted to be away from the bosses: get great pics and footage and just lift the whole performance.

Big Dave – an Army reserve PR officer and a great bloke – said yes, and so I combined my management duties out of Dili with photography assignments accompanying the jungle patrols. I had to pull every available string and call in all favours owed to me in the warrant officer networks. But a lot of army people thought it was important to get working with the patrols, so they found me Land Rovers and got us on Black Hawks, and I got back to doing what I do best.

The professional's job is to tell the story with a picture. If that means you control it and tweak it a little, then that's what you do. This is how one of the best pictures I have ever made came about. I was loving the sunsets they get around Timor, and I'd started thinking about a book that the ADF might publish, which would honour those who served in Timor. So I was on the lookout for something iconic, based on the

Timor sunset. I was thinking of a cover shot and I didn't want to leave it to chance.

One evening I was watching the ocean when I saw a Black Hawk come in and I decided, *That's it. That's my shot.* I sat down and did some scheming, came up with a lens/film combo and used my contacts in the aviation wing to get me a Black Hawk that I could control for the picture. I wanted to set up a helicopter against the sun as it turned into a massive orange sitting on the horizon. I had my Nikon F5 with a thirty-six-frame roll of Fuji in it. I screwed on my favourite 600mm Nikkor lens – in those days a $15,000 piece of gear that may have belonged to the army but was sure as hell *my* prized lens. I had a 5th Aviation guy on the radio who was relaying instructions to the pilot out over the ocean approach, and gave him exactly the channel I wanted him to fly down. Then I dialled in my shutter speeds and aperture. I wanted the lens to crunch all the information and light into a package that would almost overwhelm the film, but not quite. These things can be a very fine balance, but I'd done my homework and, as they say in this business, I'd already framed it in my mind.

The pilot lined up the sunset and the Black Hawk perfectly. Once I reckoned I had the shot, he came in to land. When the shots were developed, they were better than I'd anticipated. It was the end of an era, in many respects. The Nikon F5 was considered by many professionals to be the best SLR camera ever made, and this Timor gig would be its swan song. The special forces and intelligence people in

the army were already moving to digital SLR cameras and the photographers were about to follow. In a few months we wouldn't need the MTV anymore, because we wouldn't need to develop and process and print. I'd already used the Kodak 620 in the Balkans, and all I needed was a Mac laptop and a sat-phone. That was the darkroom and printing shop, right there.

The irony of this photo shoot was the journey of the images themselves. There wouldn't be a book of record to chronicle the Timor campaign like the one we'd done for Somalia. I argued hard for it; my guys had done some great work recording life on patrol with Aussie diggers in the jungles of Timor as well as daily life on the patrols bases. But I couldn't get the project off the ground. So many times over the years diggers have asked me why there was no Timor version of the Somalia book. Well, I tried. But the upshot of the sunset shoot was a story in itself. A lot of folks in the media unit saw and liked that shot, and with one thing and another, and with the way defence people leave and join the private sector, about a year after I shot that Black Hawk the ADF had an approach from Sikorsky, the US company that builds the Black Hawk. It was a formal request to use my sunset shot of the Aussie Black Hawk in their new advertising campaign. For many years, Sikorsky used that shot as the backdrop for their magazine advertising. It's a shame they couldn't spell my name right on the poster, though!

The set-up photo is not really dishonest, as you can see from the Black Hawk/sunset example. Photographers

In East Timor, I set up a shoot showing a digger with two local boys.

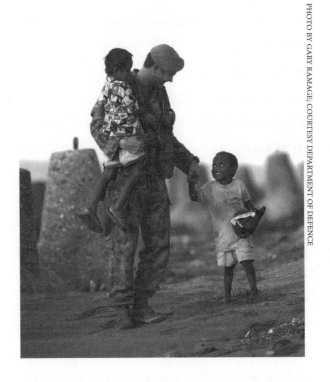

PHOTO BY GARY RAMAGE; COURTESY DEPARTMENT OF DEFENCE

regularly use catcalls and say silly things to get a person to turn, or to get them to change their expression. It's part of the business. There has to be a bit of the manipulator in you or you won't get the shot you want.

Sometimes, it's a little more than manipulation. By the time I was back in Timor, I was focused on providing pics for newspapers in Australia. That was clearly where I was heading. One afternoon I set up a shoot showing a digger walking with two local boys down the beach in Dili. It was a beautiful shot and it ran on the front page of *The Daily Telegraph* in Sydney.

And then there are times when the subject lands in your lap and there's nothing to do but shoot. One night in 1999,

I was hauled out of the Turismo and ordered to accompany Lieutenant Colonel Rob 'Barnsey' Barnes to a regional airport in East Timor. We drove out there and it was all hush–hush. All I knew was I had to take a video camera. We drove across the tarmac, and I climbed up into this RAAF C-130 Hercules. Inside was the reason for all this: Xanana Gusmão. He had been a key leader of the Timorese independence movement, and would later become the president of Timor-Leste. After several years of imprisonment by the Indonesian government, he had been released, and had returned home to help in the rebuilding of his country. As I started rolling the tape, he was very relaxed with the camera. You see, when the Democratic Republic of East Timor was declared in Dili in 1975, Gusmão had been the press secretary for Fretilin, a left-wing independence party, and he had filmed the ceremony. So on one level it was a super-secret midnight dash. But really it was just two cameramen sharing a moment.

11

A Career Explodes

The world was certainly changing as the 2000s got going. East Timor became Timor-Leste under Xanana Gusmão, the United States endured 9/11 and launched its War on Terror, and in Canberra a reorganisation of Defence media and PR was underway. In a post-9/11 world, the challenge we faced was how to fight an idea like jihadism with our own idea. The answer was strong messages and positive images.

After Timor I returned to Canberra to help create the centralised 1st Joint Public Affairs Unit (1JPAU). It was commanded by Barnesy, and was based at Fairbairn Air Force Base in Canberra. I was the inaugural sergeant major and chief photographer for the corps. Barnesy and I had first met back in Brisbane, when he was a young captain – plucked straight from being a journalist on country newspapers – and I was a young corporal starting a photography career. He was a couple of years older than me but we hit it off

from the beginning. He was a family man and I was engaged to be married, but we still liked having a laugh. Now we were in Canberra, with a big task. My role was to get the photographers around the country ready for the JPAU. There had to be a way of commissioning work and managing the flows so that the quality could be controlled from Fairbairn. We had embraced digital by now and so the MTV darkroom van was sent to Puckapunyal, where it was used as a target on the mortar range.

In hindsight, was the exploding caravan a metaphor for my career? As an astute reader might have worked out, my enjoyment in the army came from doing great work and becoming a better photographer. I was selfish like that. But you stay in the game long enough and suddenly they make you sergeant major, show you a desk, and you inherit all the management responsibilities you were previously too cool for.

We had about nine photographers in the state-based barracks, and now they had to work to our centralised schedules, standards and protocols. This was confronting enough. Then add the new technology of digital imagery: every image could be sent immediately over the internet. So there were no more excuses like, *It must have been lost by the couriers*, or, *I got a bad batch of chemicals in the lab*, and there was no more hiding behind the distance between a state barracks and HQ in Canberra. It took a while for the older photographers to fully grasp this, and I was under time pressure to get them into the new system. So I shifted very quickly from being

the guy who could make everyone laugh over a few beers to the unit's most-hated. This was not a gradual evolution: it happened overnight. I couldn't be everyone's friend and deliver for Barnesy. Barnesy was also under pressure to make this work, and what the CO wants, the CO gets!

Being in management didn't suit me. I lost all my friends, alienated people who had nothing to do with me and made a whole new class of enemy. In every state-based photography unit they had their own way of doing things, which I had to tear down. Barnesy would have high-level meetings with the brass about the way it could all work, and I'd have to push these ideas on to the actual photographers and make it happen. And they didn't want to change. I found myself in meetings with these resentful, intractable people (who were me, really), and I'd be saying things like, 'Either get on the train or fuck off.' Nice huh?

As we were trying to reorganise from within, Barnesy was having problems getting support from the broader military. Most people in the star plot (the people of general-level rank) didn't see the benefits of publicity. Even though some of them liked the Somalia book, they didn't see how it helped them. A notable exception to this was Angus Campbell, who would later be the Commander Australian Forces in Afghanistan and the Middle East region. He saw the value in communicating the stories to the public and politicians, and even to other parts of the military. And he was a natural at it. In 2011, at Al Minhad Air Base, he'd wake up News Ltd's senior defence journalist, Ian McPhedran, to

brief him on a casualty incident, so the facts got into the news cycle back home. But most weren't like Campbell in the early 2000s.

Just to ensure this had all the hallmarks of a Ramage snafu, I added to the complexity by commuting to Canberra. In the late 1990s, Lisa Keen had resigned from the ADF and taken a senior media role at Taronga Park Zoo in Sydney. Lisa arranged some moonlighting work for me taking shots of the animals for a catalogue, and through this gig I met another Taronga Park employee, Mel. She was a very good-looking, smart and vivacious brunette, and I was stunned when she showed an interest in me. We started going out and then bought an apartment in Lane Cove. We decided I'd commute. For two years I spent my weekends with Mel in Sydney and on Monday mornings I'd rise at 4.30 am, drive to my weekday digs at RAAF Fairbairn, and then drive back to Sydney on Friday. I had a double room at Fairbairn, and it was very comfortable, but I really don't like mess life. And I hated living apart from Mel.

I became exhausted, and with the ranks above and below me both resisting the new structure, I felt increasingly isolated. And then, in 2003, my granny – Martha Ramage – passed. It was during the Canberra fires in early January and I drove to Sydney to catch a flight to London, motoring around Lake George with this massive plume of smoke seeming to chase me in my rear-vision mirror. I was a bit nervous about the mercy dash because I was formally under a warning order from Barnesy for Iraq. A warning order is a

military standby to be deployed. There's a whole lot of rules attached to it about where you can go and what you can do. In my case, the warning order was for leading a photography team into Iraq, given the invasion was imminent. But I charged on to Sydney, found Dad at the airport and we headed for Scotland. It was a very sad time, and on the way back, Qantas cottoned on to the reason for our trip and they upgraded us to business class. When the hostie came around with drinks, Dad reached for his wallet. Everyone laughed, which really relieved the pressure; we had a few drinks and a laugh and a cry. It was a great trip home, in the circumstances.

But what was I coming home to? A massive crossroads, as it turned out.

* * *

This is how a career blows up. I came back from Scotland to find that I wasn't in trouble about the warning order – but Barnesy was fuming. He'd been dropped as the commanding officer of the 1JPAU in Iraq and replaced by Lieutenant Colonel Mark 'Pup' Elliot. The brigadier wanted Barnesy looking after things in Canberra and Pup got the call-up for Iraq. It was a pity, because Pup and Barnesy were mates and there were no hard feelings. But because of the role Barnesy was now expected to play, he needed me with him in Canberra, so Alan Green would go to Iraq in my place while Pup was the CO of the Coalition Media Centre in Kuwait.

I was devastated – I was thirty-six, it was my time. Barnesy and I had expected to be team leaders in a combat deployment, in a concept we'd built up against a lot of opposition.

But I got on with it and even proposed to Mel. She accepted and we were very excited. But in the background I schemed. Pup had a flat in Kingston, which he allowed me to use while he was in Kuwait. Pup looked like an army officer: just over six foot tall, greying crew cut and in his early fifties. He was basically me, only a bit older and with a lot more charm and polish. He liked to get things done and wasn't a big fan of red tape. I was in contact with Pup while he was in Iraq, and early on in the piece he was becoming frustrated with Australian policy. The media access was very poor and, rather than being allowed to disseminate information and help the media, the JPAU was being shut out of the ADF loop. After a couple of phone calls with me, Pup said, 'I need images, but I can't send anyone out.'

'Okay,' I said.

'So, what if I could get you accredited, and you take holidays from the army and file images to me as a freelancer?'

I paused at this. 'We can do that?'

'If it's legal, let's do it.'

So I did my homework and decided there was nothing within the rules of the army to stop me from going on holidays into a war zone as a serving member and take photographs as a freelancer. So I got a letter of passage from Pup – to speed up my visas and get me across borders – and I went on leave from the army.

By way of apology for pulling me off the Iraq tour, Barnesy gave me the coverage of the ANZAC dawn service at Gallipoli. So my plan was to go over there, do the dawn service and file my pics over the phone lines, and then go on leave the next day. I travelled to Turkey with Matt Grant, my old golfing buddy from Lavarack Barracks in Townsville, and we covered the ceremony. I took several good frames on that trip – one being the Aussie flag in the sand with a group of World War I medals on it as the water came in. We used Matt's great-grandad's memorial plaque in a few frames, with poppies and a slouch hat. Again, some of the best shots are set up.

We flew out again on the day of the ceremony, and when we landed in Rome Matt and I went our separate ways. He had time off in Rome with his wife Paula, and I flew on to Kuwait City, hauling my full photographer kit and a combat helmet.

The plan was I'd be met at the airport by Pup, and he'd take me under his wing. But while I was taking off from Rome the invasion of Iraq began, and when I landed there was no Pup and no communications with him – there was a war on, so he had other things to do. I just went into photographer mode, and walked up to the first person who looked military, a large, heavily built American. I explained the situation and he nodded and said, 'I'm not in the army, but I work for Halliburton.' Something to do with oil, then, I figured. But before I could respond he continued, 'Actually, my boss is an Australian – I'll call him and see what he says.'

This big Yank got on the phone, nodded a bit and then handed the phone to me.

'G'day,' came this voice down the line. 'Remember me from Somalia?'

It was an Aussie officer I'd met more than a decade before, and he remembered me. So the big Yank loaded me into the Chev Suburban and drove me to the Hyatt, where I had a meeting with his Aussie boss, who was now managing the Halliburton operation out of Kuwait City. That meant he controlled all the US Army's food service, accommodations and mobile latrines and washrooms. He asked me, 'Do you know Erica Collins?'

And I said, 'Fuck off, I knew her in Timor when she was a logistics officer.'

'Yeah,' he said, 'well now she's a logistics manager for Halliburton, and she's about to go into Baghdad.' On the TV sets around the Hyatt, we could see that Baghdad had just fallen. 'Sit tight and let's see what I can do for you once Erica is back.'

For four days I stayed in a suite in the Hyatt that was as big as my house. Early on the fifth day, I woke before dawn and made a coffee, and the call came to saddle up for Baghdad. Me and this other American got into the Chev and, with an MP escort of two Humvees, we motored across Iraq at very high speed on a freeway through the desert. We got into Baghdad before nightfall. There was a lot of damage, but the city wasn't what you'd call destroyed. There was power to quite a few buildings by the time we arrived and some of

the cell towers were working. It was a beaten city, but not a devastated one. And there was action, lots of action: gunfire ringing out and vehicles charging around with squealing tyres. We didn't really know where to put ourselves because the MP escort had left and neither of us was armed. So we tucked ourselves out of the way and slept in the Chev down by the Tigris. In the morning I stepped out for a piss and looked across the river to the plumes of smoke spewing into the desert sky. When I returned to the Chev, it was gone and all my gear with it. I was fucked.

I took a few deep breaths and wondered what I was going to do. I was alone, abandoned, without any gear or wallet or passport. In a war zone. As it occurred to me that yes, this time Ramage had pushed the envelope too far, around the corner came my travelling companion. He'd asked directions, and now he knew how to get to the US command HQ.

As the sun rose we drove through the streets, seeing in daylight what we couldn't at night. People ran and fast-walked everywhere. Men shouted, radios crackled, enormous trucks with portable generators, portable kitchens, portable telecoms exchanges were being waved through. There were guns and soldiers everywhere and the buildings occupied by the coalition were obvious from the sandbag walls being built by fleets of forklifts. Amazingly, I was in Baghdad. The energy was frenetic, with the sound of hundreds of large diesel engines shaking the air.

We got to the American HQ, which was located in a white marble building also known as Saddam's Palace. It was huge

and vulgar. I walked down a corridor that was all marble and mirrors, surprisingly untroubled by security. Approaching a bunch of Yanks, I asked where their media unit was. When I found it – a more salubrious media office than any I've seen before or since – I introduced myself and asked if they knew Pup. Yes, they knew Pup; he was in another palace. They gave me a cot and told me to relax until they could take me over there. I wandered off for a piss and I walked straight into Paul Bernard, a British Army media officer I knew from my exchange in Germany.

We greeted each other warmly, and he said he was headed over to the Aussie camp and I could go with him. We drove over there in convoy – because they did not want to fly – and I was directed to an enormous room lined with white marble and with massive crystal chandeliers hanging from the ceiling. The place was buzzing with Aussies in desert cam, and I noted a couple of blokes I knew: my good mate and fellow photographer Mark Dowling from 6 RAR, who I'd played combined forces soccer with, and photographer Corporal Darren Hilder. I walked up to Pup, who had his broad back to me, and tapped him on the shoulder.

He turned, saw me and his jaw dropped to the floor. 'What the fuck are you doing here?'

At the same time, Darren said something like, 'Fuck – it's Ramo!'

The commotion attracted the attention of the RAAF chief of staff, who was running the joint.

'What are you doing in my HQ?' he screamed at me. Then he yelled at Pup. And then he ordered me to get out.

Pup said, 'He's one of ours, you can't kick him onto the streets of Baghdad.'

But the COS pointed at the door.

So Pup assigned Mark and Darren to escort me to their quarters while Pup got to work on what to do with me. The poor bugger – Pup had tried to contact me once the invasion was on, to tell me not to come. But I'd been in transit from Gallipoli and didn't get the message. In any event, I wasn't supposed to be able to get into Baghdad.

After a couple of days in the Aussie media quarters, Pup had the Airfield Defence Guards give me an armed escort (called a PSD, or personal security detail) to the airport. They came into the palace with their big strap holsters and helmets, and a flight lieutenant explained the route and what was going to happen. They led me to their army Land Rover and we drove to the airport through incredible scenes. So here I was, being driven to what I assumed would be a court martial, and I had my camera out and was shooting these amazing sights: a street where one building had been reduced to a heap of rubble while the buildings on either side were intact; armadas of tanks around the airport; burnt-out Iraqi military vehicles; plumes of smoke rising into the clear blue sky.

The Defence Guards took me to the civilian terminal of the airport, watched me check in for a flight into Kuwait City and then Sydney, and waited for me to go through the security

gates. I was dressed in my civvies through all of this and not feeling on top of the world. I was thirty-seven, and I'd been in the army for almost twenty years. It was my life – they'd taught me my trade and given me one of the most interesting jobs you could ever do. And I'd royally screwed it up.

When I got off the plane in Sydney, I rang Barnsey in Canberra and he said, 'Whatever you do, mate, don't come to Canberra. Don't even think about it.'

So I holed up in the Lane Cove apartment with Mel for a few weeks, on leave. It should have been great to see Mel, but I was back to my post-deployment blues and I was incommunicative. And as I retreated inside myself, I started drinking, and that made me more inclined to be left alone with my thoughts. It was history repeating – I'd been here before, I knew the signs and I knew where it led. And I couldn't pull out of it.

Meantime, my case had gone all the way up to the Chief of the Defence Force, General Peter Cosgrove. Also involved in the debate about what to do with me was Brigadier Maurie McNarn – commanding the Australian forces in Iraq – and the Chief of Army, General Ken Gillespie. Basically, that's a fancy way of saying I was in deep shit. In these kind of situations, the decision-making usually goes all the way up the chain of command, because there's a case for a court martial and the military hierarchy allows the top guy to make the final determination.

Ken Gillespie called it ill-disciplined behaviour from a warrant officer – and, worse, it was selfish and dangerous

to other diggers when there was a war on. He wanted me punished. I argued that I'd gone through all the directives, looking for one that would preclude my going in as a freelancer, but I was simply advised there was a CDF directive stating it was not allowed. I didn't seek an army lawyer because I hadn't been issued a court martial. I made my case and I let it be known that I had a letter of passage from Pup, a navy commander and a young PR captain giving me authority to travel to Kuwait, to get a visa and to do freelance photography work for the ADF on an embedded basis.

In the end, they accepted the letter from Pup – and besides, they'd already had a case of the RAN clearance divers earning money on the side by taking a private American contract to clear one of the Iraqi harbours in the Persian Gulf for heavy shipping. If they court-martialled me they'd have to court-martial the clearance divers too. And the Australian military doesn't like that kind of attention when it's fighting wars on two fronts, which it was in Iraq and Afghanistan.

After two weeks sulking in Sydney, wondering what was next for me, I was sent as far away from Australia as possible without sending me to the Middle East. I was off to the Solomons.

12

Becoming a Civilian

So, another conflict zone: the eighth in ten years. By now, your colleagues start to assume that you're good at this, but there's no real knack, just a lot of focus and planning about how to get the best shots. In my case, I immediately – before I even land in the place – corral my resources and try to work out what I need to get the best material. In all of these places, there are resources you control yourself, and resources you need to build with alliances. By now I was travelling into conflict zones with a serious amount of equipment: three camera bodies, five lenses, lots of batteries and several rechargers. I was also carrying an INMARSAT sat-phone, a laptop and pads and pens. These were the resources I could control. Other support resources were supplied by the quartermasters. It was the outside resources I had to cultivate, often before I even left Australia, that could make the real difference.

For instance, when you enter a conflict zone you need to be able to travel widely. So you make friends with the transport corps boys and girls, because you need their Land Rovers and drivers, or you get close to the patrol leaders, or the MPs or the federal police, or whoever else has vehicles and access. One of the big differences between a good portfolio of work and a great one is access. And to get the best access, you need to get close to the guys with the helicopters. Invariably, this means befriending the pilots and the loadmasters, and it means doing something for them. If you can get some shots of a helicopter crew doing good work in your first week in the conflict zone and it gets a run in the papers (with their names spelled correctly), then you have your photographer's bus for as long as those guys are around. And speaking of resources, start your doxycycline a couple of days before you go into a malaria zone like the Solomons. There may be a bit of nausea and some bad dreams, but it beats malaria. And you get a great tan.

I was part of the advance party that flew into Honiara. Australia had committed to a project called RAMSI (Regional Assistance Mission to the Solomon Islands) with a bunch of other Pacific nations. The task was to keep the peace between rival factions (one of which had instigated a coup), disarm the Guadalcanal militants and open police posts in areas where it had not been possible for the last five or six years.

When we stepped off the C-130 Hercules, my old mate David Gray from Reuters was there with other Aussie media to greet us. Dave would later help me out in the

transition from the military way of doing things to that of a news photographer. This is the last great resource that all photographers need on their side: professional peers and friends, people who have your back and are generous with their time and ideas. You have to reciprocate, but the bonds you form in these places will last forever.

My new digs in the Solomons was a hotel in Honiara. I was told I was going to manage the imagery back to Defence PR in Canberra: being kept at arm's length from field work was my punishment for the Iraq snafu. The unit was headed by Major Jeff Squire and his 2IC, Captain Graham Henley. Jeff was a former armoured officer who was a staff officer on ops due to his rank, and Graham was a Vietnam veteran from the Q store stream. The other team members were very junior.

I had clashed with Henley several times prior to deploying; he couldn't let my history in Iraq go. But now we were in a conflict zone and I was the only one in the team with a track record in such an environment. When you're in a place where bad decisions can get people hurt or killed, you just have to ask the guy who's done it before.

The clash with Henley ended one night in a kitchen, our makeshift work area in the HQ, with me losing my temper. I snapped and asked him to step outside. To his credit, he calmed everybody and I'm glad he did, because I was so angry it would have ended very badly for me.

After that blow-up, we tolerated each other a lot better, but I could sense the end coming. The main group stayed in Honiara for several weeks and then flew out, leaving me there

to file pictures and video for another five months. When they left I took over the photographic role (no longer just sending back other photographers' work to Australia) and I'd already done the groundwork with the Aussie and Kiwi helicopter crews. So I was saddling up with them every morning and flying all over the islands, doing whatever they were doing – which was a lot of recon with no real action. I clocked so many hours with those guys that when it was time for me to go, we had a soft drink and they awarded me 'wings' because of the amount of flying hours I had accrued with them.

I flew back to Australia in early November, was given a week off, and spent as much of it as I could in Sydney with Mel. She still had to work but we had a few chats about the future and what was going to happen with the army. My behaviour wasn't making her feel secure as I was still dealing with the Iraq issue after being separated from her for seven months. I was due to go back to work at the JPAU in Canberra, but before that happened I got a call from Jeff Squire, who said we had to go out to see Barnesy at his house in Cooma. The three of us had to work out what came next after the Iraq affair.

I arrived in Canberra and taxied to Fairbairn. Jeff and I got in a car and drove to Cooma, a little more than an hour away. We made pleasant small talk and when we sat down to coffee at Barnesy's place, I was basically waiting for what was to come. Barnsey said I couldn't be regimental sergeant major at the JPAU because I'd undermined my own authority with that trip to Iraq. I told them I'd resign that day, and

then asked if I could go. It was their only option really, as I had managed to avoid the court martial and they still had to punish me and make an example so no one else would do it in the future. Being much older and wiser now, and in hindsight, I would still do it all again. They both did me a big favour. If I had not gone to Iraq as a freelancer I would not be where I am now. I always said I would leave before I became a cranky old warrant officer.

I returned to Sydney straight away. I had eighteen months' long service leave owing, and a tonne of recreational leave from twenty years' service in the army. It gave me some time to start renovations on our Lane Cove flat. Mel was still working at Taronga Zoo and she was my support through those first couple of months out of the army, when everything seemed confusing and overwhelming.

I spent much of 2004 mucking around. I went overseas, drove around Australia a bit and thought about what I wanted to do. In fact, it was obvious: I loved being a photographer, I'd just moved on from doing it with the army.

In October 2004 I rang Andrew Darby, the picture editor at *The Daily Telegraph* in Sydney. I knew him from my time in Timor; I'd been sending photos direct to his desk and even liaised with him and taken suggestions as to what he wanted. He'd run my shot of the digger with the local boy on the Dili beach on the front page, and he'd run some of the material that I'd taken while freelancing in Iraq. So I felt Darbs and I had a similar sense of what made a good picture, but I still had a lot to learn.

I told him what had happened with the army, and he was amazed to hear that I was doing nothing with a camera. He got back to me the next day and said he could put me on work experience for two weeks. After one week he gave me a job. The stirrer Ramage had met with the tabloid *Tele*, and we got along just fine.

I felt like I'd come home.

* * *

Darbs had more faith in me than I had in myself. I was paired with Mark McCormack, a really good News Ltd[1] photographer who these days is the picture editor at the *Cairns Post*. Mark put me through my paces and I owe him a great debt. He knew I was technically proficient, so he just focused on giving me the tasty bits, the inside tips on doing a variety of gigs. He took me to all sorts of shoots: the courtroom, police raids, corporate announcements, paparazzi chases, Parliament and just around-town shots. I watched him closely and saw the lenses he used and his flash settings, and most importantly his positioning. I knew how to position for the best shot, but he knew how to put himself in the best slot among other photographers and journalists.

It's an art I learned quickly, because in newspapers you have to get the shot. There were no excuses, no second chances, no conciliatory pats on the back if you turned up

1 The Murdoch-owned newspaper company in Australia was called News Ltd until June 2013 when it was renamed News Corporation Australia.

empty-handed. At News Ltd, if you didn't have the shot then you shouldn't be back in the newsroom. In the army, I didn't have to deal with the media scrum, but for press professionals it's a crucial skill. If you're on the wrong side of the courtroom steps and the circus veers off away from you, you're screwed. If you get caught behind a TV crew and the prey shuts the car door before you can shoot, you're screwed. So I focused on my positioning very early and I became a planner. Famously so, in some people's eyes. There was the time at Parliament House in Canberra when Tony Windsor and Rob Oakeshott were retiring, and I wanted to get the shot of them walking out of the elevator. In my mind that was the shot. So I snuck upstairs and walked with them to the elevator, put myself into the elevator with them where I wasn't allowed to photograph. And when the elevator opened two floors down, I got in front of them and walked backwards out into the media scrum with my camera going, so I got the best shots and everyone else got shots of Ramage's back.

The same thing happened when Kevin Rudd was on his way out the first time. The media scrum waited outside the party room, and I snuck into his office and got a shot of him as he walked in – totally against the rules. It's about finding the best position. It's a bit cheeky, sure, but you soon discover that most human beings prefer the control and dignity of having one person photograph them to being assailed by a pack. If you handle it properly, the subject will always take the opportunity to compose themselves and deal with a single photographer. So long as it's me, I'm okay with that. I still

believe it's much easier to beg for forgiveness than it is to ask for permission. This has been my mantra for some time.

It was a very steep learning curve for the first eighteen months, and I got through it with the help of photographers like Mark McCormack and picture editor Andrew Darby. Darbs was a classic tabloid man. Blond and slender in build – but not in attitude – Darbs was a schemer and we had a lot of strategy sessions at the Aurora Hotel, around the corner from the Holt Street headquarters of News Ltd in Surry Hills. About the only non-tabloid feature of Darbs was his choice of drink. While the rest of us sipped on beers, the staff at the hotel had a drink on the menu called the Darby Chardy: chardonnay with ice cubes in it, just the way Darbs liked it.

After a couple of weeks with Mark McCormack, I was on my own, doing photo calls with no one looking over my shoulder. I was quickly accepted by the News Ltd photographers, but not by the Fairfax photographers, who didn't trust my military background. The News guys saw that I had a work ethic and I delivered. My cheeky habit of scheming and getting around the rules also worked well at the *Tele*. The tabloid photographers were always thinking up a smarter (or sneakier) way to get a shot that was not allowed, and this culture was a perfect fit for me.

Along with some of the work practices I had to learn, I had to get up to speed with Canon. The army had used Nikon since the 1970s and News Ltd was Canon. I was worried about the transition, especially since digital was

only just getting started and there were a few different file formats bouncing around. But apart from some quirky dial differences, Canon and Nikon are virtually identical in terms of what their professional cameras and lenses can do.

The *Tele* was both a good cultural fit for me and also a culture shock. Suddenly I was going to work without a uniform, and a shift was entirely unpredictable. In the army, we'd always plan. But on newspapers, every morning there was a list of photo calls, usually on a whiteboard at the picture desk, and you went out to your call at the appointed time. But while you were waiting for the criminal to leave the court, or waiting for the chairman of the board to deliver his address, you'd be getting calls from the picture desk that always started with the words, 'Where are you?' The tabloid papers cover just about everything with small photographic staffs who work under insane pressure. The culture is 'go'. That is, there's a smash on the Harbour Bridge. Go! A pensioner was bashed and robbed. Go! A politician is about to resign. Go!

That was the biggest shock. The all-day, round-the-clock, frantic, panicked energy of *The Daily Telegraph*, a culture which is funny from the outside but entirely serious and all-consuming on the inside. I had to learn how to handle a different kind of fatigue from the one you get in the military. Newspaper photographers don't do much sitting. We don't do lunch, and we don't sit around talking about our feelings. When we talk, it's about gigs and equipment and who shot a front-page. And we get really sore feet. Not only that, but there's the camera bags. The average newspaper

photographer's bag weighs around twenty kilograms. The rule on papers is that the photographer can't go back without the picture, and 'equipment failure' is not a valid excuse. So we carry spares of everything: typically, two camera bodies, three or four lenses (a big telephoto if you're doing sport or chasing someone), extra batteries, flash units, laptop and even a back-up phone. This last one is crucial: you can never be off the air if you work as a photographer for a tabloid newspaper. Your phone always has to work and always has to be on, and a flat battery is no excuse. It doesn't matter where you are or the time of day. You have to be ready to take that call and answer that perennial question: *Where are you?*

Perhaps I shouldn't have been pushing so hard for this career change. I had more than enough problems on the home front. Mel and I had been in trouble ever since I left the army and moved into our apartment in Sydney. It was a case of *Gary's here now, but he's not here.* I'd withdrawn into myself, worried about my readiness for civvy life after spending all my adult life to date in the military. I was drinking too much, I was remote, and as soon as Darbs threw me the chance at the *Tele*, I was off like a scalded cat, as deep into the tabloid media world as you could go. Sometimes you think you're running towards something, but you're really running away. Mel did nothing wrong – she tolerated me and the way I was and held out hope that the Good Gary would return.

13

A New Career, a Tsunami

I'd been at the *Tele* for fourteen months when the tsunami hit Aceh, Thailand and Sri Lanka on Boxing Day 2004. I was up early when it struck, and I lobbied hard to be sent. In the first place, the *Tele* was going to take wire pictures and send in their reporter, Charles Miranda. But when the discussion turned to how many Aussies were over there and how many stories and pics there should be, they decided to send a photographer for the paper, and luckily it was me.

I flew into Phuket, where I met Charles. We started by following the major devastation wire stories, but actually, there was only so much you could do with that. After a day, we realised we had to forge our own portfolio. The devastation was so immense, the story so big, that what we had to do was tell the stories of the people – and not just the Aussies whose holidays were wrecked. So we travelled around a bit in a rented car, and I took the pictures of three babies taking a

PHOTO BY GARY RAMAGE; COURTESY NEWSPIX

Sometimes the small, personal shots tell the larger story.

bath in a bucket, and Charles got the stories of being washed halfway to the mountains when the tsunami came through. We covered the mass morgues and the body bags cooking in the sun, and the mothers' fight for clean water. We went for the big devastation story but peppered it with the personal stories and pictures, which is what the *Tele* loves to run.

We worked hard and took ourselves to exhaustion and back. It was a dirty, humid, hot environment and the smell of decomposing bodies – not just people but all the animals too – was quite terrible. The last time I'd smelled that was Kosovo, and I can tell you that the sweet smell of putrescence can turn even me into a vegetarian for a while.

The gig was over by 2 January and it was the hardest work I'd ever done with a camera. I barely put down my gear and I only sat down to eat or sleep. It was hot and smelly with

all sorts of crap underfoot, most of which would slice your foot open if you stood on it. There was a lot of confusion: homeless locals looking for their families, hungry people looking for food, thirsty people looking for clean water. Soldiers pulled up in their trucks and were overwhelmed. Army engineers offloaded bulldozers to clear debris and dig graves. Medical teams arrived in flattened areas where the smell of human flesh was getting high, and tried to head off the threat of diseases. If we weren't on the phone to the *Tele*, we were chasing a story; and if we weren't doing interviews and photographs, we were filing from the laptops, Charles finalising stories and me sending pics and captions from the sat-phone data connection. Sleep was a four- or five-hour luxury before we started moving again.

We ranged all over the Phuket peninsula and around to the province of Krabi on the mainland. The pictures you normally see of these places are of beaches or resorts, but actually it's mostly rural, and some of the sights and stories we were recording were heartbreaking. Phuket was fucked; the crops and plantations were flattened, the resorts had washed away, the fishing fleets were wrecked, the livestock was gone and hundreds of thousands of people were homeless. Because the devastation was so widespread, it took the police and military days and even weeks to reach some communities.

I learned some lessons on this, my first overseas gig with a newspaper.

First, always have a bag packed and always have your passport up-to-date.

Second, make sure your gear is functioning properly before you leave Australia – you can't get new camera straps or fresh batteries in a conflict or disaster zone. Back then, the overseas assignment kit for News photographers was two Canon bodies, three lenses, two flash units, a big clunky laptop and a satellite phone with data cord for sending images from the laptop. The Canons were only eight megapixels and there was no video capability. But they were reliable, took a good photo, had a long battery life and weren't as heavy as some competing brands. Looking after the gear was all-important; you can't see *the* shot and have your camera or flash die in front of you. So after that gig I always had my batteries on the charger at the end of each day and always downloaded my shots to storage. You do that so when you pick up your gear in the morning, it's ready to go. And when you get off a plane, you're ready as soon as they open the door: you don't have to be taken to the hotel to recharge your stuff.

Thirdly, always stay focused on doing the best stories for your readers rather than chasing wire material. In the really big disasters, it's the small, personal stories that best illustrate the drama.

A fourth big lesson to come out of the tsunami had to do with footwear. Photographers tend to think about this more than the writers, perhaps because we're on our feet most of the day and footwear matters to us. But in a scene of carnage like the Boxing Day tsunami, you need shoes that will stay in one piece. In Phuket, there was so much stuff on the ground that a pair of street shoes would have been shredded in no time,

and then what do you do? I wore army boots, but after seeing that the other photographers wore technical hiking boots, I switched to them for subsequent gigs. They're comfortable, they're tough and they dry quickly.

One of the things I did introduce to the newspaper world was the camera harness. In late 2003 I'd connected up with my great mate Rob Griffith. Rob was ex-military as well and was now chief photographer at Associated Press in the Sydney office. He had a sideline business, Griffgear, producing custom-made bits of gear for photographers: photojournalist bags, pouches and computer sun screens, and so on – the kind of thing we needed but no one made back in the day. I told him I wanted to solve the problem of trying to carry two cameras around, one over each shoulder. It wasn't just the annoyance of the cameras slipping off my shoulders; there'd been times at court when I needed to drop the cameras very quickly and not have them bumping around me. I gave him my old army pistol sidearm shoulder holster and he went to work. Using an industrial sewing machine, he stitched up a harness to which I could attach a camera with a quick-release connector. Rob put two of these together, so I had a quick release system for two cameras, and when I walked around each camera was held alongside my ribs under either armpit. They couldn't slip off and the cameras were evenly weighted across my shoulders. Best of all, I could jump in a car and start driving and not have to be ripping cameras off and finding a place to put them. I could drive with the cameras held fairly much in place. It's funny how technology

goes in photography. When I first started wearing my harness at the *Tele* in 2004, the other photographers laughed and called me a wanker. I told Rob he should patent the idea but he laughed. Now they're commercially produced by another company worldwide and everyone has one.

Covering the tsunami was my first assignment for newspapers in the stuff I love: the conflict and disaster zones. A number of things were different to my military career, but basically, I was good at this and it was what I wanted to do.

I'd kicked off my second career.

14

The Hunted and the Hunter

Some press photography is a cross between serious and paparazzi. Through early 2005 I was introduced to papping when I was assigned to 'Adler watch'. This meant taking photos of the former managing director of FAI Insurance, Rodney Adler, as he negotiated his way through the charges brought against him following the royal commission into the collapse of HIH Insurance.

Adler had encouraged HIH to buy FAI for a really good sum of money, and a couple of years after the purchase HIH had gone bust and the finger was being pointed at FAI, with allegations made about what Adler had said to a journalist regarding his holdings in HIH. It was complex white-collar stuff, which is the serious part. And then there's the pap part. That involves me camped out at the bottom of Adler's driveway in the fancy Sydney suburb of Vaucluse trying to photograph him and, if I missed my shot, following him

across the city. Which happened many times in the months of his trial and sentencing.

Adler was catnip to the Sydney media, and he was always a candidate – up there with Kerry Packer and Russell Crowe – for a front page at the *Tele*. Although few photographers understood the exact nature of Adler's wrongdoing, we understood he was tall, good-looking and rich, with a glamorous wife. And he'd been tricky with money. So it was open season.

It's just that Adler did not like being followed. I remember some of the chases he led us on through the back streets of the Eastern Suburbs and across the city. At one point I thought I could talk to him, man to man, and I stood in the middle of his driveway as the gate swung open and he charged down this steep driveway in his Mercedes 4x4. I was going to say to him, *Rodney, mate, give us a shot to take back to the newsroom and we'll leave you alone.* It sounded reasonable when I said it to myself, but he accelerated and I had to jump out of the way as he raced past.

His antagonism may have had something to do with the long-range pic I took of him and his wife Lyndi strolling outside their mansion. Perhaps including the wife was too much. But it was a good get.

So, he was annoyed about having his house staked out? Fair enough. I came at it from a different angle and I started waiting for him in the city, at his offices in Australia Square. I was thinking in terms of him stopping for a coffee, going to the gym, going for a swim at the beach. But he never deviated

from his customary route. He went straight home and up that steep drive. One time, it must have been a bad day with the lawyers, because I picked up his tail from Australia Square and he was so agitated by my presence that he began to drive erratically. I stayed with him, hoping he was okay, and then we got on to William Street, heading east. We were coming up to a red light and I was pondering a quick shot through my open passenger window as Adler sat beside me. I thought we might get a meltdown picture for the camera. But he didn't stop – he hit the gas and went sailing through the red light on what was a fairly busy William Street. I called it off and when I got back to the newsroom I told them I was concerned about the Adler story because I thought someone might get hurt.

I try to tell people this: yes, there are things I won't do. And sometimes photographers – as a pack – make a call that our picture editors don't want us to make. Throughout the early 2010s, the former speaker of the House of Representatives, Peter Slipper, was being pursued for misuse of parliamentary expenses – basically, using Cabcharge dockets reserved for official business to do the rounds of the Canberra wineries. We pursued every opportunity to get pics for the picture desk in Sydney, but there are limits placed on photographers around Parliament House and we had to wait for his court appearances. When Slipper was found guilty at the Canberra Magistrates Court, he was followed by such a swarm of media that I missed my prime position. Slipper found a taxi and quickly got in, so I whipped around

the other side of the cab, where I opened the driver's door, kneeled across the driver and got a beautiful shot of Peter Slipper, right up close. Wearing something between a smile and a grimace, he said to the driver, 'Okay, we can go now.' But the months took their toll on Slipper, and by the time he appeared for sentencing in September 2014, he was clearly unwell. He was sentenced to community service and this time we followed him: he went straight to a pub – the Uni Bar on London Circuit – and just sat there in his sunnies. He was in another world and so we called it off. We all stowed our cameras and walked away. The aim is to report the news, not to destroy people.

Anyway, the Adler job was my first pursuit assignment and I was glad to discover that I did have my limits.

* * *

My second such assignment followed hot on the heels of the first. I was in a backyard in the western suburbs of Sydney with a 200mm lens. My line of sight extended across a suburban fence, and into the back door of a house that belonged to the brother of Andrew Chan.

This was April 2005 and a *Tele* journalist and I were following the family of one of the Bali Nine – the nine Australians who'd been busted in Bali trying to smuggle over eight kilograms of heroin from Indonesia to Australia. The Indonesian cops had pounced on them at their hotel as they were strapping the bags of heroin to their bodies, and they'd

arrested the two ringleaders, Andrew Chan and Myuran Sukumaran.

So there I was, waiting for a Chan family shot, when the phone rang.

'Where are you?' said Darbs.

'Waiting for Andrew Chan's brother,' I replied.

Darbs told me to drop it – I had to be at Sydney airport in two hours. I was going to Denpasar to photograph the real Chan.

To get to the airport via Lane Cove with all my gear in two hours was in the 'don't try this at home' category. So I won't tell you how I did it. But I made it to the airport with my packed bag that now included a full kit of hard-wearing, quick-dry adventure wear of the Columbia variety, and a pair of Merrell hiking shoes. After the tsunami shoot in Phuket, I'd rejected jeans; they take up too much space in your luggage and they're a nuisance once they get wet. Now I was travelling with Columbia ripstop adventure pants, which dry quickly and roll into a small ball.

I flew into Denpasar – all smiles and a silly hat – because I didn't have time to apply for a working visa for Indonesia. News journo Rhett Watson and I travelled to Denpasar and then it was off to the hotel where the other Aussie photographers and journalists were staying. Rhett and I became lifelong mates after this trip. The cops came around the media hotel twice a week, because few of us had the required visa, but when they did we all scattered like rats and the cops didn't push it. The News correspondent for

Jakarta, Cindy Wockner, came down to see us and gave us the lay of the land. The Indonesian justice system is quirky and she outlined how she expected the Bali Nine arrests to be handled, the likely movement to and from the courtroom, and she warned us about what we could and couldn't do.

Also staying in the hotel were two other photographers with a similar sense of adventure to me: Jason South from *The Age* and Mick Tsikas from AAP. We formed a natural team and went up to the jailhouse, where the prisoners were kept while they went through the courts. It was remand prison, Indonesian style. The gig basically entailed sitting in the forecourt of this single-storey colonial building all day, waiting for family and lawyers to turn up, at which point we aimed the cameras. The cells fronted onto the forecourt area – a concrete quadrangle with gardens around the edges – and the visiting yard was quite public. Unfortunately, you could only see into the visiting yard through one window covered in bars and one concrete box that stuck out of the wall, also covered in bars.

Think about it: the only time that one of the drug mules was going to come to the visiting area was when a visitor arrived, and then there'd be thirty photographers and TV crew trying to get their shots through these two confined access points. So every time someone entered the administration block, the journos and photographers surrounded them, demanding to know who they were and who they were going to see. If a visitor said, 'I'm here to see Scott,' or 'I'm representing Renee,' we leaped to the best position at the window or the box, and strained and pushed

and shoved for the best angle. I had to really concentrate to stare from the bright sunlight into the dimly lit cell block and identify the nine faces. We all had to get up to speed really quickly or the circus just passed by and you didn't have your shot. I remember all the press pack asking one another if they'd seen this mule or that mule. We had to assign faces to names. Luckily the Bali prison system had no uniform so

When the parents came to the cellblock, it was really moving.

we came to identify the Bali Nine by their clothes as much as anything.

Those early days of the Bali Nine story were quite mad and we had to be well prepared, because it looked like it was going to be a marathon. That meant coming to the jailhouse each day in a sunhat and long sleeves, slathered in sunblock and carrying a good supply of water. I also needed a full photo bag and two cameras, because I used the 70–200mm lens to shoot through the bars and into the visiting yard, but when the authorities did a prisoner transfer I'd need the in-your-face wide angle.

In these situations, the photographers do a lot of secret deals, which I can't detail too much. Let's just say that when you wait all day in the sun for a shot, at some point you have to go to the loo, or one of you gets the lunch for everyone else, and we don't let one photographer go without. We ensure that the guy who missed the shot at least has something to send back, even if it isn't the best one. At the Bali Nine stakeout, Jason, Mick and I looked after one another and secured good shooting positions by force of numbers. The lads saved my arse on more than one occasion and we got some really good material. When the brothers and sisters, parents and friends came into the cell block, and everyone was hugging and crying, it was really emotional and moving. Even if the relatives called us vultures and scum.

* * *

Some of the press pack weren't happy to simply gather the news, and there was quite a bit of chequebook journalism going on up in Denpasar. Some of the network producers (who shall remain nameless) were allegedly paying the families of the drug mules for access to the Bali Nine, and while that was considered all fair in love and war, I decided to even it up a bit. After all, I was shooting for the whole News Ltd pool and the pressure on me was immense, not just to file but to have a mix of 'horizontals' for *The Australian* and *The Courier-Mail* (when it was still a broadsheet) and 'verticals' for the tabloids. I never stopped and never relaxed in the weeks I was up there, and if other crews were stealing an advantage then I wanted a piece of that too (did I mention that tabloid photographers have to be very, very competitive?).

One of the Nine was being moved from the cellblock to go to the dentist, or so we thought. Southie and I followed, but Mick was not concerned and did not need the photo. We staked it out and stayed hidden. But the male mule we were following was in there too long and finally I thought, *What the fuck? Is this a root canal or something?* I crawled up to the window for a peek. The entire dental surgery was filled with an Aussie TV crew, and the male mule was being interviewed in the dentist chair! The window was half open, so I got my camera in there and started shooting. Like I said, it was a free-for-all.

* * *

We often left the cellblock, especially when visiting times were over and the prisoners were having an afternoon nap. But that didn't mean downtime for me, Rhett, Mick or Southie. The editors at Holt Street were constantly pushing for more material, so we'd often follow the family visiting one of the Nine. We tried to be respectful, but there's only so far you can play that part when what you're doing is following someone to their car and asking them things like, 'How's Scott? Is he healthy?' Sometimes we'd follow family members in a car, but not like a car chase in the movies. It would end in a shot of them having lunch or going into their apartment building. That sort of thing.

Although this kind of job might sound tame compared to shooting in a conflict zone, it could nevertheless result in injury. We'd rigged up a pole to keep open a window that looked into the cell area. This allowed us to have the cameras set up for when the Bali Nine came to see their families. One morning an Indonesian photographer accidentally bumped the pole, releasing its hold on the window. It came down fast, smashing Southie and a TV cameraman in the head. They luckily escaped unhurt, but Mick was caught in the middle of the other two and as he looked up to see what was happening a large shard of glass smashed into his nose. Blood was pissing everywhere. The TV cameraman freaked, but Mick remained calm and cool, considering. I grabbed a dirty towel from the ground and rammed it into his bleeding face. While he was sitting on the ground, Scott Rush's father came out, placed his hand on Mick's head and said a quiet prayer for him. Mick

to this day believes he was praying for the media scumbag to get better.

* * *

I'd been back in Sydney for a month when I got the tap to go back to Denpasar for Schapelle Corby's sentencing. She'd been arrested on arrival at Denpasar airport in October 2004 with a boogie board bag filled with pot. In the process, she'd become a celebrity back in Australia. The women's mags loved her; the tabloids, not so much.

I got up there and things were delayed slightly, but Southie and Mick were at the hotel so we had some time to scheme and plan. The Schapelle Corby story was slightly different to the Bali Nine's. The nine drug mules were clearly smuggling heroin and they did it for the money, so the real Bali Nine story was which ones would die for their crimes, given Indonesia has the death penalty for drug crimes. But Schapelle was different: she protested her innocence, and she was a lone, young, attractive Aussie chick in a sea of nasty Indonesian men. I've said that the photographer's job is to tell the story with the picture, and the Schapelle story was 'frightened animal'. All the best images of Schapelle highlight those big eyes and the fear of her pursuers. Southie and I had to shoot it this way, and we had to get some action going.

One morning we got the tip-off that Schapelle's father Michael and his wife were flying into Denpasar ahead of Schapelle's sentencing. We confirmed the flight, waited in

the terminal and photographed them as they were coming out of the customs area. We papped them all the way to their van, which was parked about four minutes' walk away. It isn't savoury, going stride for stride with people calling you every name under the sun, but Southie and I stuck with it. You might recall that when I first started in photography, I couldn't be coaxed away from the wide-angle lens; I naturally liked being in someone's personal space, getting right in close. It served me well for the pap work. I had long blond hair in a ponytail in those days and I remember the father was quite disbelieving that there were people paid to do what I was doing. Although he didn't say it in those words exactly. Finally, when he was in the back seat of the van, he looked out the window at me and called me a 'fucking German'.

* * *

The days leading up to the sentencing were filled with mad conspiracy theories that flew around the press pack like a contagious disease. On the day of the sentencing, Southie, Mick and I got to the courthouse early and found a window that looked into the courtroom. We got stepladders and pinned up a sign at this window that said *News* and *Fairfax* while other crews did the same at their windows. But we also wanted the shots of the frightened animal being pursued, so Southie arranged for three motor scooters with drivers to be positioned out the front of the courthouse in readiness. We had a plan.

By the time the court was in session, there were more than a hundred Aussie and Indonesian media at the courtroom, standing on ladders at the high windows and on the forecourt apron of the courthouse. It was quite unhinged. I got some shots of Schapelle with my 70–200mm lens – of her doubling over when she gets twenty years in prison – and then she was dragged from the courtroom, away from her parents and sister Mercedes, and it was time to go to work. The press pack surged like a tide into this side driveway area of the court, where the prison van was waiting. This was the shot we all wanted: Schapelle being dragged away by the Indonesians to rot in a dungeon for the rest of her life. Otherwise sane professionals were screaming at this woman as she was half carried her by her armpits to the vehicle. The idea was to get her to turn and look at you so you could get the full facial shot. So there was lots of screaming at Schapelle. People jostled and pushed and elbowed and the Indonesians were actually very organised in forming a corridor to the van.

Southie was convinced that Schapelle was going to stick her face up against the glass of the van but it didn't happen. I got my shots and then Mercedes held an impromptu press conference outside the courthouse. Which was fine by us, because it meant the rest of the pack were looking the wrong way as we barged out of the scrum to our waiting scooters. As the van swerved past us, the sirens and lights going, we gave chase. They were really going fast and it was a bit of shock initially – I mean, I didn't have a crash

helmet or anything. We'd already told our drivers that we wanted a shortcut to Kerobokan Prison, because ideally we wanted to be there when the prison van door opened. When someone shows me a stop sign, all I see is a different way of saying go.

We tracked the prison van through Denpasar, and then our drivers split off onto the shortcut route out to Kerobokan. When prisoners are processed into the prison, they go through the admin wing, which features a drop-off apron under a large veranda awning. You then walk up twenty wide steps and push through the wooden doors into the administration section. We knew this because we'd cased it. So now we arrived just as the van was coming through the main gate. We dismounted and ran to the admin wing forecourt, but as the guards swarmed around the van's side door I decided I was too late to get the shot I wanted. I ran to the top of the entrance steps and put my back against the double doors, while the guards had kittens about Southie and Mick. Then they lifted Schapelle out of the van and she scuttled like a beetle, with guards on either side, up the steps and towards the doors.

And that's when these other guards came out of the main doors and clubbed me to the ground. No questions or arguments. I hit the deck as Schapelle got to the top of the stairs and ran straight over the top of me. I lay flat on my back, camera to my eye, aiming up, and just kept shooting. And that's how I got the shot of Schapelle Corby looking straight down at me, hands up against the side of her head. It was the best shot of the day. I remember Mick laughing

PHOTO BY GARY RAMAGE; COURTESY NEWSPIX

Schapelle arrives at Kerobokan Prison after sentencing; I lay flat on my back and kept shooting.

as I got crunched – he thought I wasn't going to get a pic. When we were showing each other afterwards what we had captured, he admitted mine was the better picture.

Just to demonstrate how no good deed goes unpunished, wire pics of Schapelle's sentencing ran the next day. So all of that work was down the drain.

15

Prime Ministers and Yobs

I was only in Denpasar for seven days on the Schapelle gig, but I slept for two days when I got back. When you do this kind of work, you'll be remembered for one or two shots – if you're lucky – but all the tiring stuff comes from what you're not known for. The police press conferences, the lawyer announcements, the standing around in the sun, the endless phone calls to Sydney, the tip-offs that go nowhere and the long, long days that can start at 6 am and end at midnight. The journalist can do a lot of work by email or over the phone, but photographers can't phone it in. We have to be there and we can't miss it.

The paparazzo side of my career sometimes shocks people – they assume that a 'serious' photographer who goes into conflict zones maybe has a poetic or profound side to his nature. But the pap work is really just one of the skills. If you're required to photograph someone and they run away,

you have to chase them to get the picture. And yelling out to a politician or celebrity is not really that rude as long as you do it properly. I remember when George W. Bush came out to Australia to address Parliament and News Ltd photographer Kym Smith yelled out, 'Hey, Bush,' to get his attention. She only needed him to look her way for two seconds, and she's a pro so she bagged that shot and got on with it. People tut-tutted but, actually, that's the job. You have to interact with your subjects, otherwise there's no eye contact or human involvement. So it's about getting attention without being rude. I speak to prime ministers while I'm shooting because when I have their attention I have to show ownership and a certain amount of control. Not everyone wants to do that.

I went on Julia Gillard's first tour of the US when she was prime minister. Fairfax's Andrew Meares and I shared a room on that tour – Fairfax were reluctant to let him go because of the cost, so News and Fairfax split the accommodation costs and Meares was on the plane. When Gillard was invited to address Congress in Washington, it was a big deal for Gillard and for Australia, and because the Capitol Building is so bloody big, Meares and I split up: he took an official spot in their press gallery and I found a place on the other side of the chamber, in the public area. I thought Julie Gillard did a really good job that day – I was proud to be an Aussie. And when the talking was done, I looked down on our prime minister and she was beaming, glowing with a newfound confidence. She was looking away from me, so in the House

of Reps of the US Congress, I yelled out from the public gallery, 'Julia! PM!'

She heard the lone Aussie accent and looked up with a huge grin and it was a great shot. It's one of my personal top tens. Was that disrespectful to a prime minister? Perhaps, but I had to go with the moment and trust my instincts. I saw a politician who'd just blossomed into a prime minister, and had done so in one of the cathedrals of modern democracy. I thought she was in a mood to hear a bit of ocker informality, and I got it right.

So you have to engage and you have to get a reaction. And you have to be adaptable and a good listener. I've had to refine my sense of who people are and where their sense of humour might end and their boundaries begin. You have to get it right most of the time because if you're a dickhead no one will deal with you, and if you're too respectful you won't get the shots they want at the picture desk.

Andrew Darby knew I'd do what I had to do to get a shot, and he knew I had stamina and no kids. He could assign me to these gigs and get a full-bore performance. And I was only just getting started.

* * *

Before the year was out, I was sent back to Bali to cover the aftermath of the second Bali bombings, which occurred on 1 October. Twenty people died (including four Aussies) in the blasts and about a hundred and thirty were injured,

mostly suffering burns. As I arrived, most of the nineteen Australian burns victims were being shifted to Singapore, and we had to follow them since the story was really about the families. It was a tiring gig with little sleep, the hours dictated by police conferences, hospital staff and families, and juggled with constant enquiries and suggestions from Holt Street. It was also a revelation to me about what terrorists are really about. They're not building anything – it's all destruction.

Barely a week after the Bali bombings, I was on my way to record a different kind of destruction. A 7.6 magnitude earthquake had hit the mountainous Kashmir region of Pakistan and Afghanistan and the whole side of a mountain had disappeared into the valley below. An estimated 80,000 people were killed and several million people made homeless. Initially, there wasn't much there for *The Daily Telegraph*, but when the government sent troops to help the locals I thought it might be worth a picture or two. At News Ltd my views on the Pakistan earthquake were aired in front of different, sympathetic people and I was put on the plane with Prime Minister John Howard and his entourage. We flew into the military airport at Karachi and headed out to Islamabad and then the village of Dhanni. On the walk up the hill to Dhanni I saw a bunch of boys playing cricket on this brown dirt field, and so did cricket fan John Howard. His adviser said to him, 'Don't play cricket with the children.' Howard looked at him, confused, and the adviser repeated, 'Don't play cricket with the children.' So Howard just walked over there and started talking to them – and of course they wanted him to play. So

he stepped up to bowl one of his off spinners and I started shooting. On the first delivery the ball seemed to go straight up in the air and drop at his feet. He tried again, and again, and couldn't get it right. And in one of the shots he's making a very silly face – he was confused and frustrated. At least, that's the story told by the photo I emailed back to the *Tele* half an hour later. The real story was that the boys made their cricket ball out of sticky tape, and Howard couldn't get the damned thing to leave his fingers properly.

Dhanni was built on a mountainside and the earthquake was so strong that when we arrived there was no more village,

John Howard's advisor warned him against playing cricket with the Pakistani children.

PHOTO BY GARY RAMAGE; COURTESY NEWSPIX

just an enormous scar. Everyone was living in tents and being fed and looked after by the Australian Army. The fact that the army had named their base Camp Bradman put a smile on John Howard's face, but only briefly. There wasn't much happy news in that annihilated part of the world.

When it came time for Howard to leave, he flew back to Islamabad and I stayed and documented the reconstruction effort of the soldiers, engineers and medics in Dhanni. It had started as a political gig, but I found I was quite affected by the plight of the Pakistanis and the efforts of the Aussies. There was nothing really sensational about the disaster from a photographic perspective – just a massive scar on a mountain where pastures, schools, rivers and houses used to be. *The Australian*'s senior political journalist Dennis Shanahan and the *Tele*'s Malcolm Farr went back to Islamabad with Howard, as did the young ADF photographer Neil Ruskin. I gave Neil the key to my hotel room in Islamabad and I moved into his army tent in Dhanni. I flew back to Sydney a few days later having grabbed a fantastic portfolio of shots.

* * *

The next big story I covered unfolded much closer to home. In early December this thing started brewing in Cronulla, a beachside suburb in Sydney's Sutherland Shire, to the south of the city. There was a conflict between predominantly Anglo-Saxon locals and Muslim youths who would come in from

the Western Suburbs. Apparently they had harassed the local girls and bashed a couple of lifeguards.

I'd been casually keeping an eye on this, and during the week a group of Cronulla locals planned a protest for Saturday morning. It might have passed without notice, but talkback radio personality Alan Jones talked it up a bit and so it was on. We discussed it around the *Tele* and, since I had the enthusiasm for it, I was assigned by Darbs. I set off early on Saturday morning and got down to the public park beside Cronulla beach at around 5 am. Darbs thought this could go either way, so he had Craig Greenhill as the second photographer on standby. I staked out the place and watched as the area beside the beach filled with what were obviously young yobs who'd been drinking all night (and probably the day before in the blistering sun). The police presence seemed to grow as the number of yobs increased, and by the time the sun came up there were thousands of drunks milling around in Aussie flag singlets with cans of beer in their hands.

Then it started. A boy of around sixteen who, in the crowd's eyes, looked Middle Eastern was suddenly being chased by the yobs across the street from the beach and into the park, with the cops in pursuit. The yobs got to the kid and were kicking the shit out of him as the cops arrived. That's when things got out of control. The cops, led by this very brave sergeant, dragged the kid out of harm's way and into the pub to secure his safety, and the mob surrounded the pub, throwing cans at the building, spitting, chanting racist slogans, that sort of thing.

I was shocked at what I was seeing and I rang Darbs, telling him I needed help. It was too big for one shooter. He sent reinforcements.

It was vile. Two Sri Lankan youths drove down a nearby street and were set upon, thugs jumping up and down on their car and smashing beer bottles against the windscreen. Thankfully, the scared-shitless occupants of the car managed to drive away.

At the surf lifesaving club, a hundred people were standing around the building baying for someone's blood. I asked what was going on and one of the yobs told me a couple of Muslim women had been given refuge in the building by Anglo-Saxon 'traitors'.

A group walked past me and I took a photo that I'm glad the *Tele* didn't run: in it, one of the yobs is wearing a T-shirt that says *Mohammed is a camel-raping faggot*. This was the tone.

Over the road in the beachfront park, a couple of yobs had climbed to the top of a huge Norfolk pine and were planting the Australian flag, to the rapturous applause of the yobbery. At that point I actually snapped out of my professional role for a couple of seconds and felt anger and revulsion. I'd served my country and been deployed under that flag, and here it was being used as an excuse to abuse police, scare women and bash people. I was ropeable.

We were under rolling deadlines that day and the picture desk wanted its cover shots for *The Sunday Telegraph* by 1 pm. I had to file what I had, which meant getting to the car and using the laptop. Craig turned up and I asked him to check

out what was happening at Cronulla railway station. Some of the drunks had been yelling about waiting at the station for 'them'.

While I sat in the car putting on captions and sending the images, Craig walked onto the station platform. When the train arrived he entered the carriage in front of him. It just happened to be the carriage that a bunch of yobs stormed into looking for non-white people to bash. Craig was in the middle of the melee. Although he was a bit shaken by it, he stood his ground and kept shooting, and his images informed a nation about what was going on that day.

The Cronulla Riots, as they became known, went all day. I finally got out of there at one in the morning of the next day, making it almost a twenty-hour day for me. It was a disgusting spectacle. Not only when Fairfax photographer Andrew Meares got a bottle in the face, but when the police escorted an ambulance to rescue the Middle Eastern women and children from the surf club, and the yobs saw what was happening and attacked the ambulance with bottles. They chased it up the road, showering it with glass. Can you imagine how scared those women and children must have been?

When you do this job you can't really flinch when evil erupts in your face. It's your job to record it and get it onto newspaper pages. The judgement and thinking can come later, in your own time. But after this display down in Cronulla, I had to really stop myself becoming negative about the bogan elements of our society. I reminded myself that the flag actually represented the good guys who gave refuge

171

to the women and their kids, and the police and ambulance personnel who just kept throwing themselves into the fray and doing what they had to do. In particular, the good guys had a hero that day, Craig Campbell. This was the police sergeant who came running to the aid of the first Middle Eastern victim at the park that morning, and who later waded into that train carriage when the yobbos were getting so carried away they might have killed someone. He threw himself in, baton swinging, and protected those passengers.

And speaking of good guys, Craig Greenhill stepped up and his images went around the world. They gave him a Walkley Award in 2006 for best spot news photograph. Well deserved.

* * *

Christmas rolled around and I was now single. So I employed the standard Ramage remedy and threw myself deep into the work; specifically, I wanted to go back to Pakistan to do a pre-Christmas gee-up with the troops, who were living in a tent city in the freezing cold of Kashmir. I thought there had to be a story up there and I pushed to do it. I went down to see Darbs one evening at his home in Cronulla, and I put it to him. And he said, 'Go for it.'

It was an uncomfortable, cold, wet way to spend Christmas. The daytime temperature averaged a balmy -2 degrees Celsius and the nights got down to -15, sometimes driven by icy winds and often accompanied by snowstorms or cold rain.

I remember one night making a mad dash to the makeshift loo. It was a steel seat with a half-44 gallon drum cut down to fit under the seat. Now, in below-zero temps at two in the morning this is not a comfortable manoeuvre. There was an upside to it though: it had the best views overlooking the massive mountains and the valley below. Which reminds me of another tip for novices: in conflict zones, assume nothing. For instance, don't assume the military will supply sleeping bags or gloves or a decent jacket. You always go prepared. If you have to scrounge and beg for kit from the soldiers you will never get their confidence. You must attend to your own warmth, especially your hands, head and feet.

Despite the conditions, we got some great material. When I got back to Sydney the bosses at Holt Street wanted a return on their photographic investment, so they did a book called *Pakistan Assist: A portfolio of images by Gary Ramage*, and they got Rhett to write the foreword and Major General Michael Jeffery to pen an introduction. While a lot of good was done over there by the Aussies, there were some confronting sights, many of which made it into the book. Like the twenty-five-day-old baby who was brought into the field hospital. He was malnourished and I thought he had a chance, but he died twenty-three hours after I took the shots. Was it ethical to publish those pictures? I had to develop a personal code of conduct for these situations, because I was no longer photographing corpses in a mass grave for the investigators. Now I was taking images for newspapers and books, with the intention of entertaining and enlightening. I really had

to think this through because it seemed my specialty was conflict zones, and those places involve people who have lost everything; I didn't want to take their dignity too. In the end, I decided that if one person saw my confronting images and it contributed to them urging a new policy at their organisation, or made them give to an aid charity, then I could take photographs of a little baby who subsequently didn't make it.

16

Mines, Ministers and Palaces

After the Pakistan shoot was done I was transiting through
Dubai's airport on 10 January 2006 when I took the weight
off in one of the lounges. I was a bit preoccupied because,
having split up with Mel a few months earlier, this downtime
just gave my brain the time and space to start going over how
terrible it all was: would I ever get it right with a woman?
I decided there was a good chance I'd be single for the rest
of my life, and working that out in a transit lounge with the
waves of exhaustion washing over me was pretty depressing.

Before I could really give in to self-pity, though, I ran
into a Channel 7 crew who told me about a bus crash in
Cairo. There were at least two Australians killed and several
more injured – off-duty police officers, mostly. I was really
tired, but I thought what the hell, I should at least touch base
with Darbs to give him the opportunity to send me there to
cover it seeing as I was only three hours away. I called him

and he said, 'Leave it with me.' Three minutes later he called back and said, 'Go.'

I went to the counter and changed my flights. A few hours later, I was flying into Cairo. The Channel 7 crew and I arrived at the hotel I'd booked to find it was also the hotel where DFAT had put the Aussies from the bus crash and their families. So, yes, it was a tragedy, but good pickings for us. We did well not to miss out. We got the stories and the pics and went out to the crash site and harassed the local cops about the investigation and so on. And then I flew back to Sydney with the lesson ringing in my ears: cultivate my contacts at DFAT and always check on where the families are being accommodated before making my own booking.

I'd been back in Australia for two months when News sent me to Iraq with Paul Kent, to report on Australia's contribution to the coalition effort. We were under the wing of Security Attachment Baghdad and went on some night patrols with our guys through the streets of that ancient city. But there was no fighting, no bang-bang. The city was being rebuilt and there was little drama while we were there. I took a lot of shots of soldier life, and when I look back on those shots I see now that every soldier's locker is covered with pin-ups of naked women, something that is no longer allowed. Those shots are now part of history – probably the last deployment where diggers could be themselves.

It was a short trip, the most enduring evidence of which was the shot taken of me standing in front of the 'crossed

swords' monument. It apparently commemorates the victory in the Iran–Iraq War, and is made from melted-down Iranian army helmets. The enormous monument is also notorious for the fact that underneath it are the interrogation headquarters of Saddam's secret police. Who would build a monument to a war and construct torture chambers beneath it?

* * *

The underground theme continued back home. In April I was having dinner with my old high school friends Karen and Grant one night when I got a call from the night editor.

'A mine's collapsed in Tasmania,' he told me. 'They want you down there, now!' It turned out there'd been an underground rock fall, triggered by a small earthquake. One man, Larry Knight, was dead, and two others – Brant Webb and Todd Russell – were still trapped down there.

I dropped everything, grabbed my prepacked bags, tore out to the airport and got on a flight to Launceston, where I hired a Thrifty campervan. I'd already been on the phone to people in Beaconsfield and I knew there was no accommodation.

Not that I'm complaining or anything – I mean, I've worked in Kashmir in the winter and Somalia in the summer – but Christ it was cold in Beaconsfield. I had this campervan, but no plug for power, so no heat. I got sick trying to sleep in that tin can. My morale wasn't improved when I saw the way some of the media circus was living: big Winnebago camper

trucks for the Channel 9 and 7 crews and the motel booked out. Some of the 'anchor talent' would later be driven in each evening so they could do their live crosses.

But the real mission for me was to get the shot. And there was only one shot: Webb and Russell emerging from the mine when they were rescued. I was in luck, because one of the senior Tassie cops at the scene was Phil Pike, a mate of mine, so I was confident I'd be tipped off when they were coming to the surface. But then there was the question of getting the *best* shot. The mine head was a small area, with all the rescue people standing around, and it was surrounded by a security fence. There was no doubt it was going to be tricky. Recalling the manoeuvre Southie and I had pulled in Denpasar, I bought ladders to put against the security fence, but it turned out they weren't really high enough for our purposes. We did a trial run and found that getting up high over the security fence gave us a nice angle. But the mine operator took one look at the ladders and had a wall of shade cloth put up in front of our prime position.

The drama went for two weeks and the Sydney picture desk wanted material, so at one point we were chasing dog stories. It was a media circus on the surface while, one kilometre below, those two guys were alive and interacting with a remote-controlled camera, which had managed to find them.

The locals resented us breezing into this small town, using the place and just leaving. There was some princess behaviour too. A female Channel 7 journalist refused to use

the public loo and instead used the crew's Winnebago, which had no running water. She took a dump in the camper and immediately blocked the on-board toilet. Beaconsfield was also the unveiling of Bill Shorten, who was then the national secretary of the Australian Workers Union. I can tell you that the exposure he got was at least as much to do with having to fill minutes and pages as it was his innate charisma.

Sadly, there was a second death at Beaconsfield. Richard Carlton, from *60 Minutes*, was standing beside me in the park across the road from the mine one afternoon. We were at a media briefing of the type that we had to cover, but which wasn't worth much, when Carlton just keeled over. What do you do in these situations? Drop your camera? Try to save him? I can tell you that no one put down their cameras; we all got our shots before we tried to help Richard.

Having been gazumped on the ladders I went back to old-fashioned wheeling and dealing, managing to negotiate access to the miners when they were brought to the surface. A wire photographer would take the shot, to make pool pictures that we could all use. I ordered a cherry-picker from a hire company and the News Corp photography contingent managed to get it positioned and operating for the miners' release. Southie still gives me shit about that bloody cherry-picker!

But my generosity – expected in the photographer community, by the way – wasn't matched by the TV people. As the ambulance loaded up Brant Webb and Todd Russell to take them to the hospital, Channel 7's David Koch leaped

in the back with them and was promptly thrown out. And because of that, they shut down the media access: no more photographs at Beaconsfield.

* * *

I'm a very lucky photographer because I get to pursue the parts of my profession that I find the most interesting. But in 2006 the powers that be at Holt Street decided I could take more responsibility.

The year actually got off to a flier, travelling with News Corp defence writer Ian McPhedran into Tarin Kowt, where we were hosted by 3 RAR. It was only a short trip, but Macca and I hit it off and formed what would be a formidable team in the future for both journalism and books. Macca has become one of my closest and trusted mates and is now writing books, having recently retired from the industry. But when I got back from Afghanistan, the spectre of 'management' raised its head and a long discussion started between Andrew Darby and myself. The discussion went through most of 2006 and hinged on whether I was prepared to go to Canberra and head up the News Ltd photographer's bureau at Australian Parliament House. The chief photographer for News at parliament, John Feder, was moving to Sydney, and they wanted someone to go down there and shake the place up a bit. Darbs wanted me to be his man in Canberra.

The last time I'd switched from being a photographer and field leader into a full-on Canberra-based manager, it had

been a debacle. I had disliked the experience intensely and the people I'd managed didn't think much of it either. In many respects, the editor positions in the media are more stressful than the operational jobs. Their phones are always on and they have to make many decisions – big and small – with the margin for error getting smaller as you approach deadline. These people aren't usually noticed for all the good decisions they make, but they sure get targeted for their mistakes.

I had bigger decisions to make: to keep doing the Sydney tabloid work or go to Canberra and Parliament House, where the job would be politics. I had no view on that. I didn't know anything about politics, I didn't know about parliament and I had no idea what the culture was with the media in Canberra. So I was neutral about the work, except that I really liked the *Tele* tabloid culture and pace. But it was the management thing that got me. While I was ambitious, I didn't know if I wanted to manage again.

This all coincided with a massive life-change on the romance front during 2006. Ali – the friend I'd made at Herford in Germany – came back into my life like a whirlwind. After I left the army, I'd taken some time in Scotland to see my family, and Ali – who was back living in Scotland after her Germany posting – had invited me to have a few drinks in Edinburgh with her good friend Tim. The Edinburgh Festival was on and we drank at these amazing pubs along the Royal Mile and around the Grassmarket, pubs older than white settlement of Australia. It turned into a big night and Ali's friends took her home while I wandered,

drunk, around Leith. Six months later she was in Sydney to see a friend and we went for dinner. And whammo! It turned out we weren't just friends. Ali is an intelligent and beautiful redhead, and I'm lucky to have her by my side. It amazes me now that I supressed my attraction to her for so long. It also turned out that we got along on a new level now I was a mainstream media operator. The media types have their own way of communicating and socialising and now I was in that. So while I was negotiating with Darbs and other managers about the Canberra position, I was in love and trying to work out what to do with a new girlfriend who lived in the UK. Halfway through 2006, we met in Thailand at a beautiful resort and I clarified things by proposing. It wasn't terribly romantic, but it was effective. I still had some hang-ups about previous failed relationships and I did not carry out the proposal as I should have. Ali still gives me shit about my feeble attempt and rightly so. She said 'yes' and we agreed to get her out to Australia and have the marriage before the end of the year.

I went back to Australia, got back to work, and the discussions went on: Darbs said I could go down to Parliament House for 10 days and have a trial. So I went down and was shocked at how many rules the photographers operate under in the parliament. It was a new world and at one point I was looking around the Press Gallery, wondering if this place could handle what I bring to the job. It was a pensive drive back to Sydney but really the opportunity was once in a lifetime. A senior position in the Press Gallery isn't offered

to everyone and when I got back to Sydney I told Darbs, 'I'll do it.' So now all I had to do was inform Ali of the decision. Which I may have left a little late for her liking. When I told her she'd be coming to Canberra, not Sydney, there was a long pause (perhaps a phone malfunction?) before she entered into a robust discussion on her involvement in the decision. As it turned out, she supported my new role, on the basis you only get offered such a job once. Canberra turned out to be a great move for us both because she scored a job at the ABC's Canberra newsroom. Ali arrived a week later, and we got married on 9 December. I organised the whole thing by myself, and even found an old hall – that looked vaguely like a Scottish castle – for the wedding. And why did I need a 'castle'? Because I got married in my kilt. Why I kept the ponytail, I have no idea, but back then I thought it was okay. If I had the power of time travel I would definitely have it chopped off.

New wife, new life, and a whole new learning curve.

Learning curve? It was like climbing a cliff. One moment I'm chasing crims through Western Sydney, and the next thing I'm photographing suits at question time. When I arrived to become the new bureau chief photographer, I hadn't really acquainted myself with the rules of photography at Parliament House. Worse than that, I didn't give a shit. I was there to take photos for the News Corp newspaper group, which meant distinct styles and regional interests served out of one photographic bureau. In my conversations with the senior people at Holt Street about this job, I'd initially complained

that it looked bloody boring, and they said, 'That's why we want you there.'

So I had a clear mandate to lead a charge from the front, but there were *so many rules*. There's a difference, for instance, between how you can photograph the House of Reps and the Senate. In the Reps you are restricted to a square cut-out through which you can photograph the chamber and the MPs. I can't go into the public galleries in the Reps. When I first started there in 2007, the rules said you couldn't shoot photographs from the Press Gallery – that is, you couldn't shoot from where the journalists were sitting and listening. Andrew Meares and I got that changed a few years ago, so now I can shoot from the centre of the chamber, while my News colleagues Kym Smith and Ray Strange can be shooting from either side. The Senate has another set of rules for photographers which says we can't shoot a senator who doesn't have the call and is not also on their feet. And we have to shoot with wide angles in the Senate: we have to include the whole chamber, not just an individual, while the in-house TV broadcast can shoot whatever they want. So much for freedom of speech. In the Reps we can shoot anyone, at any time.

Access to politicians was also a minefield when I first started there. I was used to the way photography is done in Sydney: take what you can and worry about the lawyers later. But with the federal politicians, it was entirely their call. There were designated areas around the compound – courtyards, entranceways and gardens, mostly – where we could shoot

politicians. Everywhere else was off limits. In those days, John Howard had a confident and assertive way with the media, and his ministers followed his example. Rudd was also available to the media, but it got worse from there: Gillard, Abbott and Turnbull all have – or had – a very controlled media apparatus, with more 'messages' and less communication. A lot of people didn't like Howard for their own reasons, but boy, he knew how to communicate his ideas.

I'd been at Parliament House for a few months and we were leading to an election. The ALP had a new leader, Kevin Rudd. Rudd had enjoyed a few cycles of strong polling and he'd been enjoying himself in question time. Then one morning the latest poll bounced for Howard and he was back in the lead. I found an angle on Howard so his face would be in line with Rudd's back, and I waited. He smirked at Rudd and very quickly pushed his glasses up his nose with his middle finger. I got the split-second shot where the smirk and the finger came together and the team at *The Australian* went nuts for it, ran it big on the front page the next day.

The Prime Minister was not amused, apparently. My predecessor, John Feder, once took a shot of Peter Costello leaning back and Howard leaning over him as if he was … well, it was done with tongue in cheek, and it was a little naughty and very funny. It got sent all around the media world by an unnamed source, only to arrive at the office of the Prime Minister the next day. They were not amused.

Peter Costello, by the way, was a real warrior when it came to the media. For days after I took that shot of Howard

lifting his middle finger at Rudd, if I was up in the gallery Costello would eyeball me, give that famous smirk, and push his middle finger up across his eyebrow. It takes a stirrer to know one.

* * *

Barely had I started at Parliament House than we were into 2007, which really meant the federal election and Kevin 07. I was put on the Kevin Rudd campaign, which I assumed was going to be a lot of getting on and off planes and buses, and spending each night in a hotel. I got a few insider tips from people about how it was going to play and how I had to prepare. But I wasn't prepared for how fatigued you get living like this, and after a week on the trail I had a new respect for campaigning politicians. You learn quickly that for someone to be a prime minister in this country they have to have stamina way beyond the normal. They have to cover a continent, and wherever they go they have to be charismatic, and it often isn't just their own barrow they have to push but that of the local member who they're supporting in the campaign. I'd worked some really bad hours in some really bad places by the time I covered Rudd in 2007, and I can tell you that man was a cyborg: armies of advisers, photographers, TV crews and journos were left exhausted in his wake, and you'd see Rudd standing there in the lobby of the hotel at ten o'clock at night, briefing some hapless journo on how his story could have been better weighted.

I spent six weeks with Rudd on the campaign and I still have my Kevin 07 flag signed and hanging in the office. I never really got close to politicians, but Rudd seemed like a good bloke. He was always nice to me. When travelling on the VIP jet he would wander down the back and ask me what I thought was my best photo of the day. His wife Thérèse was lovely, as was his daughter Jessica. Rudd would eventually be put through the wringer by his own party, but I never heard him say a bad word about anyone, and his family always treated me warmly, even at the end of his reign.

The election in November 2007 was my blooding, and then I was into the job and running. I had a slightly different approach from some photographers at Parliament House. For me the photo call was merely the time when the politician would be standing in a specific spot. I liked to control the shoot and the images, and I found that some of the politicians went along with that, especially when they realised that they came out looking okay if they did it my way. The photo calls where you turn up for the opening of an envelope and some PR hack is telling you how it has to play? Forget that. I just ignore them and by now most of them have got the idea.

Rudd was a natural in front of the camera and he set a tone and a standard for dealing with the media that his team probably found hard to match. When Howard led from the front, he had people like Costello, Nelson, Vanstone, Pyne and Abbott, all of whom had the confidence to match the boss. Rudd's charisma wasn't really matched by his team. He was very accommodating to me once he liked the way he

looked in my photographs, and in those couple of years that he was PM, I guess you could see how he annoyed advisers and colleagues. If he wanted to do the photo, he'd do the photo. He'd give us the time to do it properly, and that wasn't always convenient for the people around him.

* * *

If you think becoming bureau chief made me a different person, think again. I may have been photographing politicians by day, but I was still always on the lookout. I still loved a stir. I was in London in 2010, following Rudd, and SBS TV cameraman Tom Finnigan and I were the pool (him for TV, me for stills). We had to follow Rudd to Buckingham Palace one morning and I was like a kid in a candy shop. I can appear irreverent to many people, but I was deeply impressed, walking through the halls and antechambers where the public don't go. Every corner of that building is filled with history: the art, the statues, the suits of armour, flags, ensigns, memorabilia of the royal family. It's incredible.

Anyway, we walked down this long corridor towards Her Majesty's morning room, with all these dukes and earls looking down on us from paintings the size of buses. We got to the end of the hallway and the aides came out and apologised to Rudd: the Canadian PM was running over time, but would you please come this way, sir?

Tom and I couldn't accompany Rudd where he was going. It was a protocol thing. So the bobby with us put us

in a holding pattern. Then the bobby's radio crackled and he looked up and told us that Prince William was about to come up to see his grandmother.

'I'm sorry, sirs,' he said. 'I'll have to put you in the dog room.'

'You're taking the piss,' I said. Our only job was to get a bunch of shots of Kev and Liz. That was the gig. It wasn't complicated.

He walked us into this room and I started giggling as soon as I set foot in the place. Couldn't help myself, and it spread to Tom. We were just pissing ourselves: this small room had one tiny window and a huge fireplace, with a portrait of two corgis above the mantel. The bobby sensed trouble and warned us as he left, 'Watch it, you two. There's a CCTV system.'

Yep, the dog room was under surveillance.

Tom took some footage of me in that room: I'm all spruced up in a shirt and tie and a fifty-quid suit from Marks & Spencer, and doing a piece to camera from the corgi room. I couldn't help myself. I said to Tom, 'Roll camera,' and I stood with the corgis' portrait behind me and started to whisper and take the piss. The video was sent to the *Tele* as a piss-take. I thought the lads would find it funny. Unfortunately for me the paper put the video on the web. It's still on YouTube and I'm still persona non grata with the royals.

The Prime Minister's office took calls about the bloody colonials who couldn't respect protocol. The week before, President Obama had put his arm around the Queen, so

Doing a piece to camera from the dog room.

Buckingham Palace was sensitive about it. The English tabs were hounding me, trying to get an interview about those corgi room pics. When they couldn't get hold of me, they rang Garry Linnell, editor-in-chief at the paper. They expected him to be outraged, but he told one of the reporters, 'It wouldn't be the first time Gary's been in the doghouse.'

* * *

So I was living this split personality: the hunter who had a serious job, the sensible manager of photographers at Parliament House who could pursue with the best of them. And that's the way News liked it. It would go like this: I

got a call on Australia Day 2009, around 8 pm, and it was picture editor Jeff Darmanin in Sydney with a tip-off. Ivan Milat, the serial killer of backpackers who was serving seven life sentences in the Goulburn super-max prison, was on the move. Apparently he'd cut off a finger so he could go to the hospital and get some attention.

I raced up to Goulburn in the News RAV4, which was always crammed with equipment. I waited and waited at the side entrance where the ambulances arrive. There was an ambulance there, but no action. Hospitals don't release details about patients except to next of kin, which is annoying for photographers. Nothing was going on. But with no warning – and just as I was about to drive away – the main doors of the hospital opened and out walked this guy in an orange jumpsuit and handcuffs. In the four seconds it took him to walk to the back seat of the waiting police car, I brought the camera up level and got him. And then just as quickly, he was gone. As the police car moved away an ABC TV crew turned up and were really unhappy with the outcome. News had an exclusive on that one and it reinforced the way it goes in this business: you can wait all day and finally you have a few seconds to take the shot. It's a very thin line between coming up empty and getting the front page.

17

Embedding

Despite my new role, the conflict stuff wasn't over for me. That was my deal with Holt Street: if I could get on top of my brief and get other photographers up to speed, they'd let me go on deployments. I was lucky that in 2009 the ADF decided to trial the 'embedding' of media in the same way that the Americans do. The Australian military had never embraced embedding journalists in actual combat operations. About the closest they'd come was allowing the press into a media detachment – such as we had in Somalia – and making the patrol leaders and commanders available for interviews.

For the 2009 trial embedding, Defence invited three press people who had experience in conflict zones: Ian McPhedran from News, Sally Sara from the ABC and me. The gig would start in Tarin Kowt, at Australia's base in Afghanistan, and then we'd be taken out to one of the forward operating bases (FOBs). We weren't given that information before we left. As

it happened, I went ahead of the others. I'd spent the back end of 2008 working my contacts in the US Army to get some embedded time with a frontline infantry unit. I think conflict photography is important – I feel sort of responsible for ensuring there's a document of what happens in the field. The Americans agreed to put me with the US Army's 10th Mountain Division in Logar Province. I didn't really know what they were going to be up to – Logar didn't have the heavy reputation of Uruzgan or Helmand at that point – but I asked around and it became clear the 10th were going to be busy: their job was to establish new patrol bases and dominate an area which had fallen under Taliban control.

I didn't see a lot of action with the 10th, but they woke me up to some realities that the media don't always grasp. I was first flown into the unit's patrol base at midnight, in a Chinook, which as it turned out was a blessing in disguise. I was originally rostered to drive up in convoy with the headquarter elements. I had been assigned a seat in an American heavy troop carrier called the MRAP, or mine-resistant ambush-protected vehicle. It does the job for the Americans that the Bushmaster does for Australia. I was pleased with the shift to the helicopter option, because when the convoy arrived at the base two days later, the vehicle I was supposed to be in had taken a direct hit from a roadside IED. Most of the damage was on the side I should have been sitting on.

So I dodged that one. But the morning after I arrived I was told to report to a captain at the 10th, in the operations room situated in an abandoned school. As I approached the

building, a couple of the NCOs started laughing at my blue gear. One of them said, 'Hey, Aussie, you ain't coming with us in that blue shit.'

That pulled me up. The protocol for the media in a combat zone is to wear a colour that differentiates us from combatants – the agreed colour is blue. I told my hosts that war correspondents are supposed to dress like non-combatants, but the sergeant wasn't backing down. He told me that, to the Taliban, I wasn't a non-combatant, I was just a nice big blue target. A VIP worth shooting.

'Paint that shit green,' he said, giving me two spray cans of drab olive paint. That was the end of the discussion and the end of my media-ID days. No more blue shit.

The 10th actually woke me up to the soldier–media divide. And once I'd seen it from the military perspective, I couldn't go back. When a non-state actor – usually of the guerrilla, rebel or terrorist variety – sees a person in blue, they see a chance for maximum publicity. A captured or killed soldier doesn't get much attention; a captured or killed journalist is big news and gives these peddlers of violence the attention they need. So see it from a soldier's viewpoint: you're travelling through hostile territory and on a normal day the snipers and shooters might let you pass because they feel outnumbered. But if they see a blue helmet and blue ballistic vest, they will force the issue because the journalist is seen as a VIP, not a soldier.

It is absolutely against the Geneva Convention for an accredited press person to carry a firearm, concealed or

otherwise. Yet the 10th Mountain guys thought I was crazy for going unarmed, and on occasion they would offer me a weapon. I always laughed it off, but it wasn't funny. This mission and these patrols were about pushing the Taliban out of their territory. Hardly a picnic.

I came to this accommodation with my hosts: I said I wouldn't carry, because once one photographer does, that person makes it dangerous for every journalist or photographer. But that said, I told them, if there came a time for me to pick up a weapon, then something must have gone terribly wrong and I would use a firearm to defend myself and others. When you work with soldiers in their environment, around places like Helmand, Logar and Uruzgan, you are actually a liability if you're not prepared to defend yourself. I don't advocate journalists carrying firearms in conflict areas, but when it comes down to survival, I have my own code of ethics.

Once we'd got past the 'blue shit' issue, I got along famously with the 10th. They – as distinct from many other infantry units in Afghanistan – did a lot of their work in night patrols. This is considered by many commanders to be dangerous because it gives an advantage to the soldiers who know the country (the Taliban, in this case). The first night patrol I did with the 10th was one of the eeriest and creepiest experiences of my life. Imagine walking with around twenty men – a platoon – who are weighed down with packs and firearms and they're making virtually no noise. I wasn't allowed night-vision goggles, but they were fairly useless to a

photographer anyway. So I padded along in the middle of the unit, through the inky blackness, in a silence that amplified the sounds of my own breathing and even my own pulse. The 10th were highly professional and very tough and it was with them I started duct-taping all my gear against webbing so there was no sound. These guys were night-stalkers and the tiniest sounds gave them away. I had to secure my gear so there was no clicking or banging. The first night with them, carefully strolling around the canals and irrigation ditches of Logar's agricultural areas, was an absolute blast to the senses and is something I won't forget. The night patrols meant sleeping rough with these people and it was the best in-field access I'd had to date.

* * *

After the intense night patrol work with the 10th Mountain Division, I felt physically hardened again and ready to embed with 1 RAR out of Tarin Kowt, where I'd meet Macca and Sally Sara. I was tired, though, so when the Defence media people said I had to do the pre-deployment course in Kuwait before we flew in, I wasn't pleased about it. I'd done this course many times and I'd just spent four weeks with the 10th on combat patrols. But I zipped it. This was a trial embed and I wanted it to go well. So I flew out of Afghanistan to Kuwait to do the ADF four-day induction training.

Having done the training, we flew back to Afghanistan in a C-130 and landed at TK. And it went downhill from

there. From the first meeting with Lieutenant Colonel Peter Connolly, commanding officer of 1 RAR, it was obvious he didn't want us there. It was a real shame, as I had first met Pete Connolly in Somalia when he was a young officer under David Hurley's command. Macca and I spoke to the PR liaison and managed to talk our way out of TK and into one of the forward operating bases. This involved a ten-hour drive across the desert. Ian, Sally and I travelled in an armed Bushmaster convoy and there was a level of security alert that put us all on edge. But while the FOB was small and rudimentary, they had good stores and water supplies – always a good start in Afghanistan. We settled into our new home within the confines of this remote compound. A few days later we went though the patrol brief for an upcoming foot patrol. The officer in charge of the FOB was very clear and professional, and I thought this was going to work well. But at around midnight the patrol base commander got a phone call from Connolly's office back at TK: he was withdrawing the embed. 'No journalist is to go outside the wire,' he ordered.

Ian and I were both pissed off and I had a go at the public affairs captain. I told him I'd just spent a month with the Americans, on various combat patrols with no escort officer or restrictions. He shrugged and said there was nothing he could do and it was out of his hands. But it wasn't out of my hands: when the 1 RAR soldiers went out that morning, I negotiated to go out with them for about a hundred metres so I could get shots of our diggers outside the wire. The pics came out okay and News gave them a run in a couple of

papers. But this was a one-off thing that was quickly shut down. We were expected to cool our heels. Sally kept calm while we killed time out there, but Macca and I were restless. We weren't doing what we signed up for. There was a bit of action: an American Dust-Off crew landed in their Black Hawk to collect an injured local whom the patrol had returned with. But we were kept in the base, away from interesting information. Finally the CO called us back to Company Outpost (COP) Mashal, where he was now based. Once more, we were expected to sit around, and Macca and I must have been too much to bear, because the CO sent us over to his own tent area of the base. So we lounged around a table in an area surrounded on two sides by HESCO blast walls (big barrels filled with sand, which when joined together form a barrier against blasts). There was also some shade over the large table because the space was covered in camo netting. I had nothing else to do so I started filing and archiving my pictures from the previous days. It was early in the morning, before it gets hot, and Macca and Sally were sitting against the HESCO walls while I worked at the table. Behind the HESCO, somewhere out in the desert, came this shrieking sound. When you've been in Afghanistan for a while, that shrieking – especially when accompanied by a whoosh – can only be one thing: incoming fire from rockets, usually 'Chinese rockets'.

The shrieking turned into shaking ground as one rocket hit the dirt a few hundred metres behind the blast wall where Ian and Sally sat. *Shit – we were under attack.* Dirt flew and

then there were more shrieks, more whooshing, and I looked up and saw Sally diving towards the corner in the blast wall, where Macca just happened to be lying already, trying to get his flak jacket on. With the rush to the wall and Macca's awkward position, Sally's head looked like it ended up in Macca's lap. I'd probably been in the field for too long by this stage, because I just started laughing. I was pissing myself laughing as the rockets shrieked.

The public affairs officer ran past, telling us to get in the ASLAVs – the Australian Army's eight-wheeler armoured troop carriers. I shot footage of Sally and Macca, and also got video of the Aussie ASLAVs shooting back against the enemy rocket positions with the 25mm chain guns mounted on the turrets.

Having recovered from this attack, we finally felt like we were in Afghanistan. I was amped by now, and Macca got writing and so did Sally and I had the material filed to Sydney inside the hour. This was what we were here for. But no sooner had we got our game faces on than the army got the shits. We'd filed so quickly that the CO said we'd given the Taliban a heads-up about high-value targets (journalists) and the enemy would now try harder to hit the base.

So the army's experiment with embedding didn't really work out. We were only embedded for two weeks and everything went wrong. For instance, on the Afghan election day, which was the event we'd been embedded for, I wanted to get out and about and get some stories about the locals voting. And the CO said, 'No, it's too dangerous.'

I became aggressive – not just because the embed wasn't working, but I thought he was stopping me from doing my job. I said, 'This is the whole reason we're up here.'

'It's not your call,' he said.

'No, I mean this voting – democracy, elections – this is the whole reason *Australia* is up here!'

The penny dropped and he saw the problem with it. So he said 'yes' to me, but Macca and Sally had to stay in the camp. I was ropeable that day, but I went down to a voting booth and started shooting video and stills. I got a good shot of a local elder hugging the young patrol commander and it ran across the front of *The Australian*.

But the gig was cursed because a few seconds after I got that shot the shrieking started and in came seven rockets, clearly aimed at the polling station. I ran for cover along with

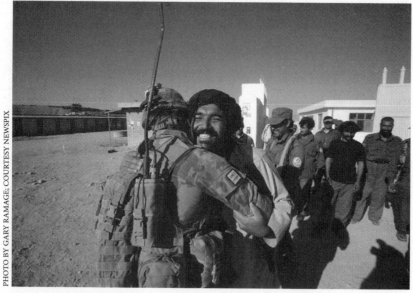

A local elder hugging the patrol commander on election day.

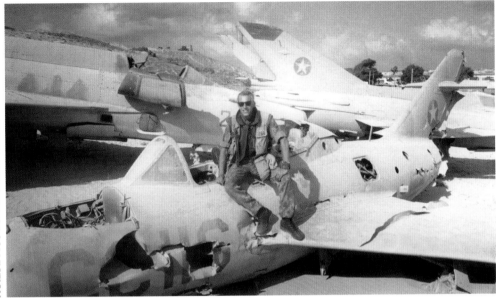

ABOVE: Somalia, 1993. My first overseas conflict assignment with the Australian Army. While on patrol with the Aussie Military Police at Mogadishu Airport, we found an area where destroyed Somali Airforce jets had been dumped. (Photographer unknown.)

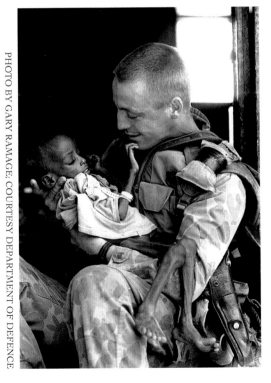

LEFT: Somalia, 1993. A young 1RAR digger holds a badly malnourished child in his arms during a visit to the orphanage in Baidoa.

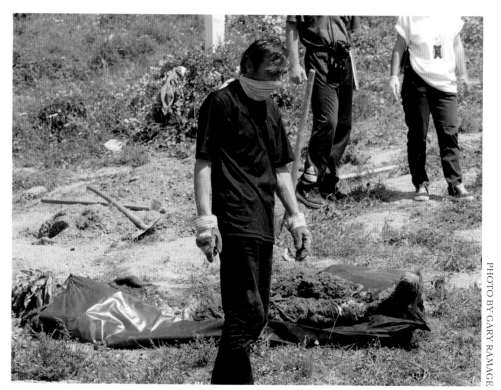

ABOVE: Kosovo, 1999. A mass grave had been discovered in a small village outside of Pristina. A number of young men had been murdered. All the victims had been executed, shot in the head at close range. Here, the villagers have come out to identify their sons, husbands and grandsons.

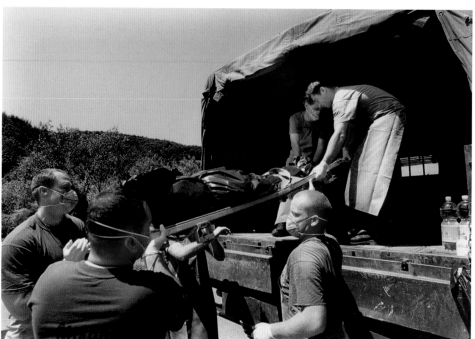

ABOVE: A body is loaded onto the back of a British Army truck. Most of us wore facemasks because the smell of death was overwhelming.

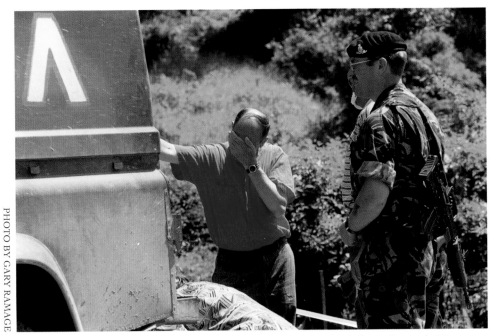

ABOVE: This couple has just identified their son, who had been loaded into the truck. You can hardly see the woman – she has collapsed to the ground.

LEFT: Kosovo, 1999. You can see the strain of living through a conflict on the face of this old lady sitting in the streets of Pristina with her worn-out shoes kicked off. Lots of people were out and about, trying to get their lives back together after the bombing campaign.

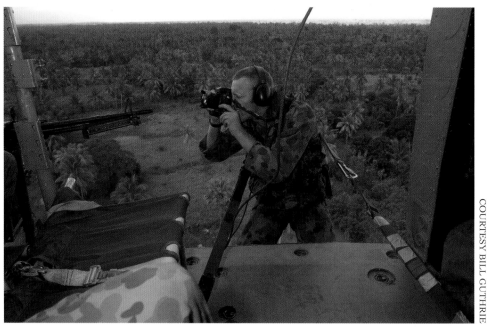

ABOVE: East Timor, 2001. I tried to emulate a photo Larry Burrows took in Vietnam, where he mounted a camera on the front of an M60 machine gun. I couldn't mount anything, so the next best thing was to stand on the skids of a UH1H Iroquois helicopter, held on with a couple of straps, two carabinas and a bit of gaffer tape.

BELOW: Here's the shot. I used a Nikon with 16mm lens to catch this photo of the door gunner.

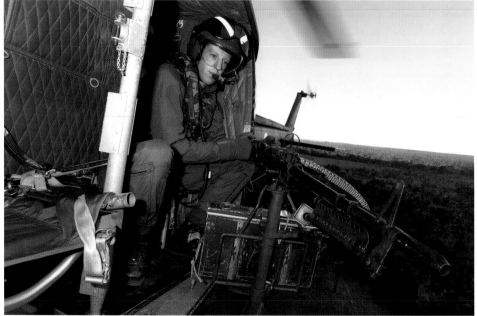

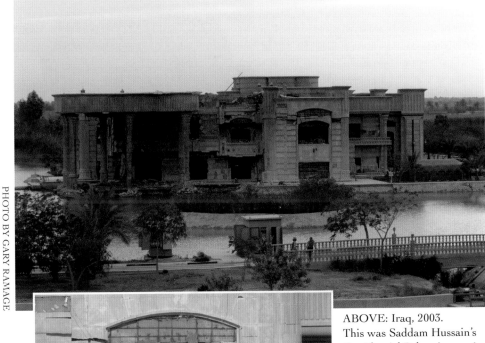

ABOVE: East Timor, 2001. This 5th Aviation Regiment Black Hawk was coming back from a flight at Balibo. I had someone directing the pilot on radio so he could keep the sun right behind him. Later on the boys made stubby holders and the Unit T-shirts out of this picture.

ABOVE: Iraq, 2003. This was Saddam Hussain's Presidential Palace in Baghdad. The US Military was based in what was left of the palace.

LEFT: The guys we can see are Americans, relaxing, reading a book, enjoying the sunshine behind one of the bombed-out windows.

RIGHT: Canberra, 2007. PM John Howard pushes his glasses up his nose while sitting across the floor from Kevin Rudd, then opposition leader. This shot did not make me popular with the PM's office.

BELOW: Canberra, 2007. Press gallery photographers and network cameramen with Kevin Rudd at the Lodge, shortly after he became Prime Minister. He liked to horse around with the photographers – he was more careful with the journos.

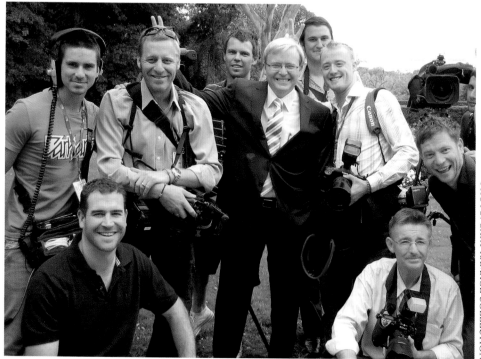

ABOVE: Washington, 2011. When Julia Gillard addressed the US Congress it seemed to me like the first time she really rose to the occasion, realising she was the Prime Minister of Australia. After the speech, she was crowded by people wanting her to sign the program.

BELOW: Sydney, 2013. During the 2013 election campaign, an old bloke, Nino Barbaro, kissed Tony Abbott on the head at the Sydney Markets. He told him to 'fix this country up'. Abbott seemed a bit shocked, though his daughter Frances thought it was funny.

ABOVE: Cronulla, Sydney, 2005. In the middle of the afternoon the crowd turned angry. This young guy, shirt off, bad attitude and full of grog, is abusing the cop, trying to get a reaction. The cop is saying 'Calm down, go away' – he was doing a great job.

BELOW: During the riot a Honda Civic drove down the 'wrong street'. An idiot came running in from left of frame and jumped up and down on it, trying to break the windshield.

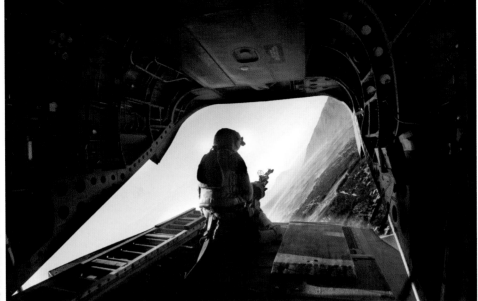

ABOVE: Afghanistan, 2009. Looking past the rear-door gunner of a Chinook helicopter at the stunning view of Uruzgan Province. The pilot is banking hard right around the base of a mountain to avoid incoming fire from RPGs or small arms.

BELOW: Afghanistan, 2009. A United States Army 155mm Howitzer carries out a firing mission in Logar Province.

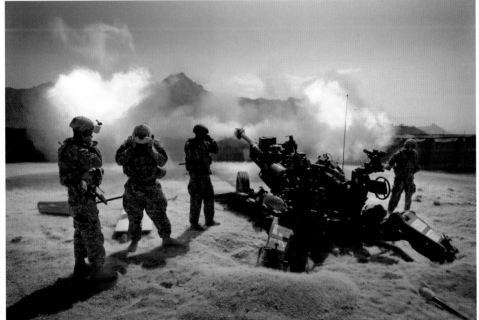

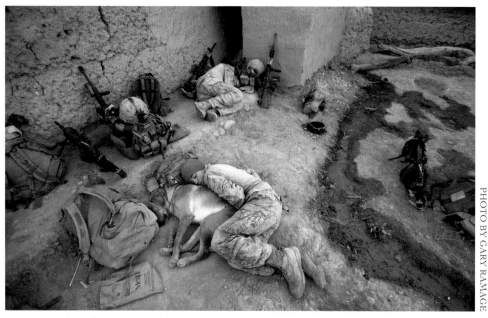

ABOVE: Helmand Province, Afghanistan, 2009. US Marine Lance Corporal Brendan Tucker and his detection dog Augie. We were holed up overnight in a compound, about 40 of us in a small space.

RIGHT: Afghanistan, 2009. Major Marc Dauphin at the Multinational Hospital, Kandahar Air Base, on 'the day the Australians came'. His unit dealt with 17 casualties in one day.

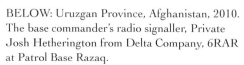

BELOW: Uruzgan Province, Afghanistan, 2010. The base commander's radio signaller, Private Josh Hetherington from Delta Company, 6RAR at Patrol Base Razaq.

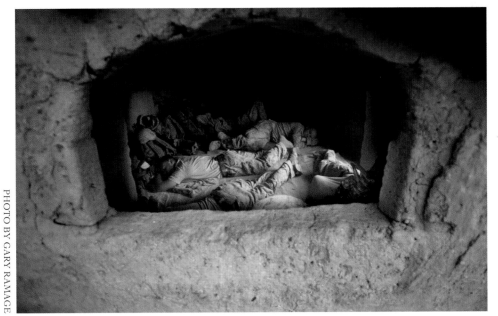

ABOVE: Helmand Province, Afghanistan, 2010. Marines resting or sleeping in a compound. It was stinking hot, about 55 ° inside the mud-brick building – and no air-con. There was a lot of tossing and turning.

BELOW: Helmand Province, Afghanistan, 2010. A Marine outside what they called Shady Village (it was full of shady characters). This little girl in a red dress hangs around while the Marine takes a sight picture on a suspected Taliban fighter.

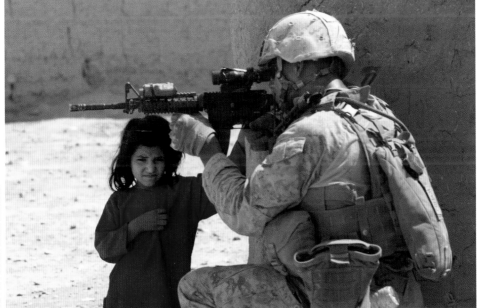

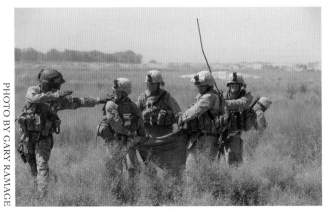

LEFT: Afghanistan, 2010. We've flown into a hot LZ to pick up a wounded Marine. The Marine's mates are carrying him, and the flight medic is directing them to the Dust-Off helicopter.

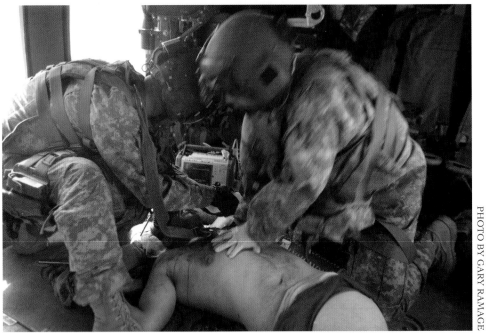

ABOVE: The flight medic and loadmaster are trying to save the Marine's life, while flying 100 miles an hour, 30 metres off the ground in a bumpy, confined space.

LEFT: Once the patient is dropped at the triage centre the helicopter refuels. If it has transported an 'angel' (a death) then non-flight staff help the flight crew dismantle the helicopter interior so they can wash out the blood.

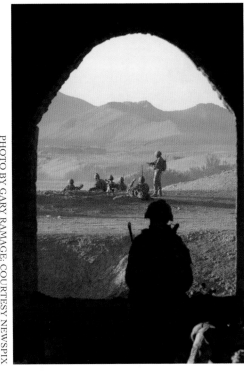

LEFT: Early morning, Khod Valley, Uruzgan Province, Afghanistan 2011. The boys from Charlie Company 2RAR are off on a mop-up patrol in an area the American Special Forces went into the night before. They'd killed all the Taliban fighters – a lot of bodies were brought in that day.

BELOW: Walking back to the vehicles we came across two old men who were watching over the remains of three alleged Taliban fighters, killed by Special Forces the night before.

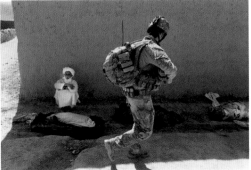

BELOW: An engineer and dog looking for weapons caches and IED (improvised explosive device) components in a compound near Doan. They didn't find anything – not in that one.

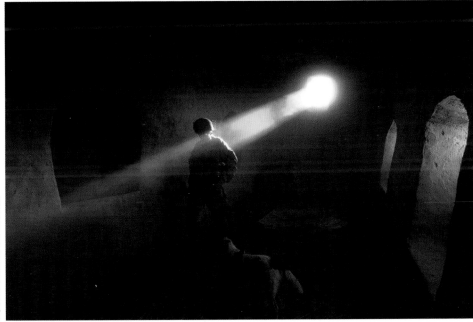

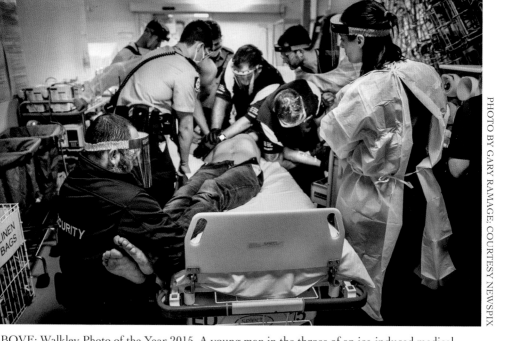

ABOVE: Walkley Photo of the Year 2015. A young man in the throes of an ice-induced medical emergency at a hospital in Perth. It has taken nine staff to restrain him for treatment.

BELOW: While still handcuffed, the young man was sent for a full body scan.

ABOVE: Iraq, January 2014. An RAAF FA 18 fighter jet on a refuelling run after a mission. Included in my 2015 Walkley portfolio.

BELOW: London, 2014. The Tower of London moat was filled with 888,246 ceramic poppies, to commemorate the start of WWI. Every poppy represented a British fatality. Included in my 2015 Walkley portfolio.

ABOVE: Canberra, 2014. My photograph of Lance Corporal Shannon McAliney at a food drop in Somalia in 1993, held by his mother Liz Hanns. In his last official task in the job, then Chief of the Defence Force, General David Hurley, told Lance Corporal McAliney's story in the Last Post Ceremony at the Australian War Memorial on 30 June 2014.

BELOW: Iraq, 2016. Me in full gear in Taji, the tank graveyard at the military base, north-west of Baghdad – old tanks, old armour, old junk, all piled up, used for nothing. If you have a business in scrap metal there is money to be made here.

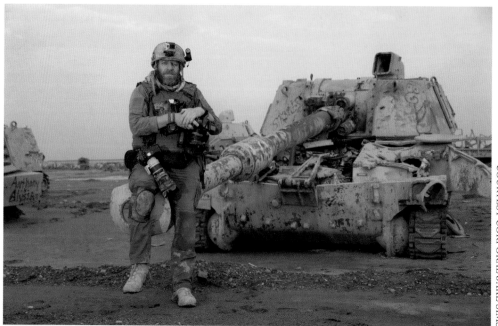

the grunts, who called for reinforcements from Patrol Base Mashal. The ASLAVs came down to pick us up but, when half the patrol had piled in, the vehicles just accelerated away, leaving the rest of us standing there in the open. We had to run back to the base feeling like the proverbial sitting ducks for those Chinese rockets.

In the end, I didn't shed a tear when we wound it up after two weeks. What had worked very well in Somalia was a complete failure in Afghanistan. The ADF had overcomplicated what was a simple idea, and besides they were just going through the motions: they didn't want media embedded with their patrols. And they ensured it didn't happen.

18

War's Real Cost

Major Marc Dauphin was a friendly, smart Canadian surgeon who was in charge of clinical operations at the Role 3 Multinational Medical Unit. The massive field hospital was housed inside the wire at Kandahar Airfield, and while it was run by Canadians it serviced all of the coalition units in the area. This was our last few days in Afghanistan and we'd dropped in at Dauphin's invitation to see how one of these places works. Shortly after we arrived at around 10 am, Dauphin's warm greetings were interrupted by the emergency sirens and barked instructions over the radio system. It was the first incoming warning for what would eventually be seventeen casualties in a single day, a day of carnage so infamous that in Major Dauphin's own book he refers to this as 'The Day the Australians Came In'.

No one who was there will forget that day, as the hospital handled a constant parade of devastating injuries that included

head, chest, leg and facial injuries, amputations and burns. You name it: the full horror of war, right there in one place. We just stood, stunned, as the waves of people came in, limbs hanging off, blood everywhere, screaming.

The first to be admitted were three children. One boy was dead, one boy lost an arm and a baby girl was all smashed up by shrapnel. As I recovered my composure and brought up the camera to shoot some video, another child was admitted. All the kids were in a terrible way. Mutilated. They'd been playing in the dirt and hit an unexploded Soviet bomb, and it detonated. Sally was very upset after this. Macca stayed out of the way. I was concerned but not upset at the time. I just kept working – looking for that picture that would show the horror of what I was witnessing first hand. I wanted the viewer back home to see this carnage. In retrospect it was amazing that we retained our access on that day because all areas of the building were jammed with hospital workers, gurneys and surgeons, as well as military folks wandering around looking for their buddies. The noise was terrible – the worst I've ever experienced: the screaming and crying was overlaid by the emergency sirens alerting staff to more incoming and the radios crackling and barking with increasingly urgent hospital workers and flight medics. The entire scene was one of hell, and there were so many serious injuries that Major Dauphin took to writing the casualties on the back of his hand to keep up with what was happening. In the midst of it all he joked that the Canadian government wouldn't buy them notepads. He gave up

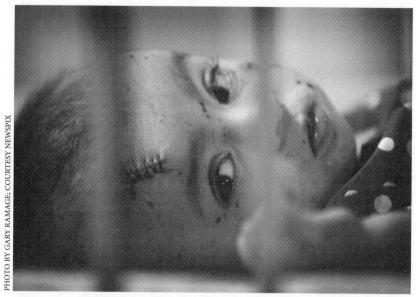

Seventeen casualties in one day: all the kids were in a terrible way.

writing on his hand at sixteen people. There wasn't enough room for another patient.

They brought a young US Marine into the emergency section. He'd been walking through a market when a suicide bomber approached and detonated a suicide vest five metres away from him. He was filled with shrapnel and, amazingly, conscious. I stayed with him for a while and he was more confused than angry. He spoke to me on camera about the event while being treated by the hospital staff. This is how good the access was. If only the Aussies had the same sense of value when it came to telling the whole truth of this war.

That visit to Role 3 is burned into my memory and to this day I can't watch the footage I took in there. Actually, I'm still not comfortable with anything on TV that is set in a hospital or involves a medical trauma scene. I feel the

emotions rising and all I can hear is the sound of children in pain.

These days you can no longer get that close to the real cost of war. The publicity machine doesn't allow anyone – let alone the media – into combat hospitals to document its workings. I guess if too many people knew the real cost, we'd put an end to it pretty damn quick. We got lucky – a major wanted the outside world to see his hardworking, under-appreciated team in action and we walked in a few minutes before the chaos started.

But we were there and we witnessed it. I suppose that's the job of the press, but we are just people and everyone in the media handles these environments differently, in their own way. It doesn't matter how many times you look at this stuff – and you have to look when you're a photographer – it never gets easy. There is nothing comfortable about a child screaming because she has shrapnel buried in her face; it's hard to watch a child lose a leg, lose their life, be blown apart. One of the fatalities was a baby who suffered blast trauma.

I have found a way to get through and be able to come back the next day and do the job. But it's not without consequences. I had trouble after Somalia; I had some counselling back home and I was told to avoid trauma, which was unfortunate, because trauma is what I do. Instead, I had to find another way of dealing with the insanity of conflict, and when I work in these confronting places I tune into the adrenaline and really, really focus on the work. Major Dauphin retired with PTSD and wrote a book about it. He

was a cool cookie in that emergency department, believe me, and he just put his head down and worked. That's how he got through. That's how I get through. I recall having to make this pact with myself way back in Somalia, when I watched the obese woman having her leg amputated by the Médecins Sans Frontières team, only to watch the young girl being brought in to have *her* leg sawn off. I had to keep my focus on the work, not on our shared humanity. It's not a trick, it's a survival mechanism, and I saw the same thing at work in Major Dauphin that awful day.

It took me a while to recover from this trip to Afghanistan. The month of patrols with the 10th Mountain Division was tough and exhausting, and then the rocket attacks with 1 RAR and the emergency surgery at Role 3 hospital were quite a load to carry.

19

Jessica Watson

After Afghanistan, I took a week off to recharge and then I was back into it. Gillard had challenged Rudd, and so we had a new prime minister. This was interesting from the press perspective, because Gillard was a personable and funny woman to be around, but her media advice and management was not good. The overly controlled access to her and the micromanagement of her public image worked against her natural strengths, which were a relaxed Aussie humour and a big laugh. After the confidence of Howard and Rudd, she came across as defensive in front of a microphone or camera.

The News editors in Holt Street were always looking for a splash, and one morning I was standing in a stationery shop in Canberra when my phone went. It was the picture manager from Sydney.

'Where are you?'

'A shop.'

'I want you to photograph Jessica Watson,' he said, and my brain started spinning because as far as I knew she was somewhere in the South Pacific Ocean, aiming to be the youngest person to sail around the world.

'Where?' I asked.

'South America.'

'When?'

'Now.'

This is how it goes once you have a reputation for getting the job done. Just lucky I have a wife in the media, who gets it.

I went home immediately, threw my go-bag and my camera gear in the car and phoned through to the Press Gallery photo desk to tell Kym and Ray that I'd be gone for a week. I was in Sydney about four hours after taking that call, and as soon as I arrived they added another surprise layer to the gig: they wanted video, too.

At this point the story was taking shape: Jessica Watson, who at sixteen was sailing around the world solo, was off the coast of Chile, getting close to Cape Horn. News wanted me to fly the parents, Roger and Julie, to where she was and photograph them interacting with their daughter. How hard could it be?

Both picture managers guaranteed me everything was arranged and there was a helicopter on standby for me. I took that as read. But our first problem was the gear: if I was going to record the parents talking over the radio with Jessica as we circled her yacht – *Pink Lady* – then we'd need radio mics

jacked into my camera, otherwise there'd be no conversations recorded. My manager said, 'Well, get 'em.'

That took a day out of our planning as the gear was couriered up to Sydney. I met with Roger and Julie, and we went through the plan; there wasn't a journo on this trip, so I had to manage the whole thing. We got along very well – they're great people – and they were feeling an understandable mix of nerves and pride and excitement as we flew to Santiago. They had various ways of staying in touch with Jessica, and of plotting her approximate whereabouts. They showed me on a map where they thought she was, and I left the hotel and went down to the charter services company to finalise the trip we were going to make on the helicopter the next day.

The lady at the counter looked at me blankly. 'Señor?'

There was no booking for News Ltd, there was no payment from Australia. I was standing in this office in Santiago thinking, *This is why you always let the photographer plan the gig.* Here's a tip for young players: always do your own planning and logistics, and always confirm bookings prior to departure. You might still bugger it up, but you'll only have yourself to blame.

So I stayed cool and explained to the woman at the helicopter office, 'I need to be on a helicopter tomorrow morning.'

The woman told me there was no chopper available, and anyway, *Pink Lady* was too far out to sea and they had no helicopter which could handle that trip. But the woman

was helpful, and she told me that while a chopper wouldn't do the trip, a fixed-wing would. She agreed to shift her bookings around a little and allowed me to charter a Twin Otter – a twin-engine plane used by medevac and air rescue organisations because of its versatility and reliability.

I was happy, because now I could check in with Sydney and say with a straight face that everything was on track.

Having eaten well and had our beauty sleep, we got out to the airport the next afternoon and plotted the course to Jessica, who was about forty nautical miles off the Chilean coast, heading south for Cape Horn. Then we climbed aboard the Twin Otter, and off we went.

We flew out to the south-west and into this wild part of the world where the Pacific eventually turns into the Atlantic. We flew around for an hour, until the pilot gave us a fuel warning. There was no sign of Jessica. The way it was turning out, we'd barely have fifteen minutes over the target area before we had to turn back. So knowing the location of *Pink Lady* was crucial or we'd be doing a very short photo shoot. But this was largely academic – we never saw her.

Once back at the hotel we sat down and looked at the maps again. We decided she must be further south than was calculated, and she was probably at that moment going through Drake Passage and around the Cape. So I booked a commercial flight to Buenos Aires in Argentina, hoping to do the shoot on the other side of South America, where she'd be sailing into the Atlantic.

We flew into Buenos Aires and, once at the airport,

searched for a fixed-wing charter service. The only one with planes available was the flying school. They had this little trainer plane with the wing over the top of the fuselage. They had enough fuel, and they seemed to know what they were doing. We were fairly tired by the time we got into that plane, and I knew as soon as I was seated that it was a mistake. It was a small four-seater, so you've got Roger and Julie in the back row, chins on their knees, and me beside the pilot so I have the best chance of getting the shots. The cockpit was so small that I couldn't lift the 600mm telephoto lens up to the window as I was too close to it – once I'd aimed the lens at the window, the camera body jammed up into my cheek. I had a back-up camera for stills and I was hulking the video camera. And I'm six one, and a bit leggy for a space that resembles a dog kennel. But we pushed on, and before we'd been flying twenty minutes, we were turned back by the weather, which in the South Atlantic can turn nasty very quickly.

So now we were back on land, and I was feeling like Wile E. Coyote. I don't give up on these things. I got talking to the harbourmaster, initially because I wanted an authoritative opinion on the weather. He was English, and when I told him how small this trainer plane was he suggested I have a chat to the company that ran the medevac plane. This harbourmaster was also excellent at getting us good coordinates for *Pink Lady*.

The medevac company agreed to help us. We finally took off in the Twin Otter and after an hour of flying we got Jessica on the radio. It was very exciting and Julie had a little cry as Jessica's voice crackled out of the radio. Her girl was down

there somewhere. We talked with Jessica and coordinated it with the pilot, and finally – as I'm freaking about the fuel running out and getting ten seconds to take my shots – the pilot said, 'This is the spot.' He descended through the clouds, and in front of us was this grey-green expanse of ocean, all choppy seas and whitecaps. And she wasn't there.

We flew for a minute or so down the line the pilot had plotted, and we came up empty-handed again. I was really over this.

On the radio Jessica was saying, 'I can't see you,' and Julie was saying, 'We're here.'

The pilot said we were in the right spot, but perhaps she was behind us. So we threw a U-turn and flew back the way we'd come, and twenty seconds later, there was *Pink Lady*. It was exhilarating hearing Jessica's voice yelling out of the radio, 'There you are,' and then she was crying and so were Julie and Roger.

Now came the hard part. I needed to keep the pilot over that spot for as long as I could, which in the end was twenty minutes. We flew around the yacht and I had to shoot stills, and then video, from a Perspex bubble window that stuck out the side of the fuselage. It wasn't until I started shooting in earnest that I realised how scratched the Perspex was, and I was paranoid about the images coming out properly.

Actually, for such a difficult and frustrating gig, it turned out nicely. The images weren't too bad and it was a really emotional job; the reactions of parents and daughter when they were so close but so distant was quite something. I also

learned two lessons: the photographer has to plan everything – the fact that someone else got it wrong is absolutely no use when you're in the field and trying to get it done. Second, I used the wired mics to get audio on the video, but they were also invaluable when flying. They allowed me to jack into all the communications on the aircraft, and that gave me an idea for my next assignment.

20

A Photographer Packs His Bags

The job at News Corp was both satisfying and exhausting. My responsibilities gradually expanded to the official title of News Corp Australia's Network Chief Photographer at the Canberra Bureau at Parliament House. Try getting that on a business card.

You wouldn't think having to be Johnny-on-the-spot for a parliament full of politicians would be physically tiring, but there were some days when I'd crawl back home and just lie on the bed for a couple of hours. Parliament House is large enough that when a photo call comes it usually involves a lot of walking: the National Press Gallery offices are on the second floor of the building, able to look down on the Senate chamber. But when a member is making a media announcement it's invariably on another level of the building, or outside in a courtyard, or in the ministerial wing. Australian Parliament House has 4700 rooms and covers 32 hectares, and News Corp

photographers at Parliament House service a lot of newspapers, in many cities, with a host of different needs and agendas. My job is to manage my staff making sure we stay on top of the jobs and deliver the best product we can. It's a team effort.

Despite having this flat-out day job in Canberra, by 2010 I'd decided that I wanted to continue my combat photography. I felt very strongly that we had thousands of our people serving in Afghanistan and that there wasn't enough journalistic material on this long war. By then we had been in Afghanistan longer than both world wars combined. Because of my military background, and my media access, I'd basically given myself the tap on the shoulder. There's no use whining about a state of affairs if you're the person who can actually do something about it. I was going to do something about it.

I consulted with Ali and told her what I wanted to do: she'd been very understanding about the 2009 tour in Afghanistan. My style was not to tell her the stuff about rocket attacks and children with legs hanging off them, but she works in the ABC newsroom, so she'd read the story and heard the audio from Sally Sara a few hours after the rocket attack we endured in Afghanistan. So she knew about those rockets, and how close we were to death, and she didn't appreciate me sweeping it under the carpet. Our new agreement was that I could go and do this work with her blessing, but she had to know everything. No secrets.

Less than a year after I'd been under rocket attack in Afghanistan, I told her I wanted to take a few months of leave and spend it in-country in Afghanistan with a combat

unit. I wasn't sure if that unit would be Aussie, British or American, but the plan was to embed, go forward and make some memorable photographs of this war. Ali is never happy about these trips, but she knows I'm careful and prepared, and she puts on a brave face. This is a great gift, because it allows me to focus on what I have to do.

The folks at Holt Street were good about my leave request – or as good as you'd expect an undermanned, overworked picture section to be. Like all newspapers, there are fewer photographers employed than there were ten years ago, and all of us have to work a bit harder to get the shots. They wanted me back for the federal election, which was expected in the later part of that year, and I promised to oblige.

I'd been in conversations with my contacts in the US Defense Department's media and publicity section, and I was

Ali is never happy about these trips, but she puts on a brave face.

over the first hurdle. The Pentagon had checked my bona fides and cleared me to be in a US military compound, travel in a US military vehicle and eat US military food. That was a good first step, but it wasn't the only one: the Pentagon allows its officers on the ground to decide which media they embed and under which circumstances we can tag along. This is fair enough, because in a combat situation you don't want a captain becoming distracted by journalists who are out of their depth. In Afghanistan, there could be bullets flying, people injured, IEDs going off. It's not for everyone and the American operational leaders have to be comfortable before they take you out with them.

I was also in contact with the Australian Defence Force public affairs people, especially my old mate Lieutenant Colonel Mike Harris. They could get me into Dubai and then Kandahar. And after spending a month with the US Marines, the ADF was going to let me spend some time with D company 6 RAR. This was a pretty special moment for me, because D company 6 RAR was my old rifle company from Enoggera, and in July they would be replacing the Dutch at Patrol Base Razaq and taking on a leadership role in Uruzgan Province. Early discussions were promising, because if things turned out I'd be the first photographer allowed to embed with an Australian infantry unit full time in a combat zone (usually the media is escorted in for two days, under tight control, and then removed). If I could pull this off it would be a great get.

I was happy with the progress of things and I was nailed down for a June start with the Americans. It would be summer

in Afghanistan, when the Taliban and its militias launch assaults and ambushes, put IEDs in the roads and harass the farmers. It wasn't the kind of detail I dwelled on with Ali, but I put even less focus on where I would be going: Marjah, Helmand Province, probably the most violent part of the world at the time.

* * *

One of the main differences between a keen amateur photographer and a full-time professional is the preparation. There's a very high standard of affordable, readily available cameras and lenses for sale, and there are many courses that camera owners can do to become highly proficient with these powerful bits of gear. I'm impressed with the results that many passionate photographers get. But the difference for someone like myself is that we're not hobbyists, so we don't get to come back to the newsroom and say we didn't get the shot. You can't *not* get the shot. When you see professional photographers walking around with those enormous back-breaking bags across their shoulders, you are looking at someone who has a back-up for every piece of their kit. And I'm no exception.

When I pack for three months in a combat area, I assume there will be equipment failures and I have to ensure that the failures don't leave me without the ability to take photographs. These days my first step in preparation is to have a good professional service behind me. I used Nikon for all those years in the army, and when I got out and went

to News I was straight into Canon. Canon's CPS (Canon Professional Service) is legendary, and I would feel naked if I was working overseas and they were not behind me. CPS boss Rick Slowgove and manager Jay Collier are brilliant.

With the CPS sorted, I set about building the case that I travel with. For two-week jobs I might take two smaller camera cases, but for a three-month stint I take one big camera case and arrive with around a hundred kilograms of gear, including my own ballistic body armour and helmet. Packing can take two weeks and involves at least three packs and repacks, with everything spread out on the floor in the garage. I start with a case: for the long jobs I use a Pelican 1650, which is a large, plastic case with heavy-duty lockable clips to keep it closed. It's dustproof, crush-proof and watertight, and it comes with a wheelie trolley. Into this case I load various camera bodies: a Canon 5D mkII, a Canon 5D mkIII, a Leica M6 TTl and a Hasselblad XPan, which is a 35mm panoramic camera. I always take my favourites, two Canon 1DX, with me on the plane. The D series Canons are very good, very tough cameras that will shoot publishable images. I use these Canons because I can also get excellent video performance out of them.

In 2011 I opted for a designated Canon video camera as well. However, a lot of my video footage has ended up in television news segments and you'd never know it was shot on a DSLR. I also like the ability to move freely when I'm in a combat zone, and I know how to tuck a DSLR under each armpit when the shit hits the fan.

I put in three or four zoom lenses, each with a back-up lens: in the old days I used 70–200mm, 16–24mm and 28–70mm (all zooms), but now I take a selection of prime lenses, with back-ups, and they're all checked before I leave. Each camera has a battery, a back-up battery and its own charger for the battery; I take stacks of AAs for the flash units and nine-volt batteries, and a box of basic camera cleaning and maintenance kit. I also take a bunch of compact flash cards (CFs) for the DSLRs: eight 32GB cards, four 16GB cards and four 4GB cards. I use 32GB cards as my primary cards in the DSLRs, which are much smaller capacity than is available. When you're shooting for the media you have to keep track of what you're shooting and where it fits into the story. When we send shots to picture editors, they have to be captioned and put into a context. Sometimes an extended caption is the basis for the story that runs. With digital cameras there's a temptation to over-shoot – to just hold down the button and hope you get something. You can't do that if you're doing my job, because you'd spend too much time looking for the shot and trying to remember what it all meant. When I use a 32GB card, I use it like the old thirty-six-shot film rolls: one roll for one subject or one gig. It helps me link the job to the shots, and it keeps me focused on framing up something really good rather than just shooting as much as I can.

I also take three 2-Terabyte hard drives – and back-up – onto which I download the images every night (or when I can) and file them into an archive system. The 1DX Canons have two CF slots, so I shoot each image in both RAW (unprocessed

data collected by the image sensor) and Large (for example, Canon's large JPEG file format, up to 6MB). When I archive them I save all my images from the RAW card onto the hard drive, while the Large files go in a different folder. When I want to send the images somewhere I email the Large files, because RAW's too big to email. The files are emailed from a MacBook Air and I always take two of them, with a charger for each. The connection I use to get the images back to Sydney is via a BGAN sat-phone, which I use because it's the standard issue for News Corp picture desks and so I know how to use it. The BGAN is a not a large piece of equipment but it's very reliable. It plugs into the side of the MacBook and acts as the internet connection. If you follow the on-screen directions and aim the little dish at the satellite, then it doesn't matter where you are in the world, you can get a data or voice connection.

I also travel with two Leica TTL M6s, which are German 35mm film cameras – rangefinders, not SLRs. When I go in-field I'll typically have a Canon D series over each shoulder, held by my quick-release shoulder harness that allows them to hang down against the side of my ribs, while the two Leicas are also on quick-release buckles but attached to my Kevlar vest. I guess it's a little eccentric, but there are occasions when I see something that I just really want to shoot on film. The Leica M6 allows me my indulgence – it's so small and light that I can justify bringing it along for the ride.

Along with my camera harness, I also take a selection of gear that's all-important in a combat zone. I use a military-style set of pouches hanging off my webbing to carry bits

and pieces around my torso and ensure the weight is spread around. These, like my harness, were custom made by Griffgear. I have a Kevlar vest which was made for me by another mate, Craig Line of Armor Australia, a specialist armourer in Sydney who makes ballistic vests for military and special forces around the world. In the 2009 embedded tour with the US Marines in Afghanistan, I was issued a News Ltd-owned bright blue 'UN' vest. It was probably safe, but it weighed twelve kilos, and a couple of days into that trip I realised I needed something that wouldn't inhibit my movements the way that thing did. So I went and bought a custom-made Kevlar vest that was the envy of every soldier I embedded with – I need a special licence to possess it in the ACT, because it's listed as a prohibited firearm. I wear a combination of ESS and Oakley ballistic sunglasses, which will apparently stop a 9mm slug and blast fragmentation, and on my back is a 5.11 patrol pack, which is supplied standard to Australian soldiers. It's very strong and light, and into this I put my military food ration packs – enough to last three days – and my sleeping bag and extra water. This last one is crucial: I carry around 10 litres of potable water when I go in-field. In the rear slot of the ballistic vest is a three-litre camelback water bladder and the rest I spread around in my pouches and my pack. When you embed with a combat unit, a walking patrol (generally six to eight hours) can turn into a three-day detour, and if you don't have water you become parched very quickly. Water is a precious commodity among soldiers and it's quite rude to be tagging along as the media, unprepared,

and ask a soldier for his water. In East Timor once, I was with a Kiwi unit. We met up with a New Zealand *60 Minutes* crew and about an hour into the walk, the TV crew started whining about being thirsty. They'd set off on this patrol, on a steaming hot day, without water. I felt for them, and because I carried extra, I offered a bottle to this TV producer. He said, 'Thanks,' and poured it over his head.

Before I leave Canberra I create an entire manifest for every item of gear I am taking, and list the serial numbers for Australian Customs. I make an appointment and go down there with my case, and they inspect it and stamp it.

The final two items I bring to a war zone are crucial for different reasons. First, footwear. The one item I can't duplicate in-field is my shoes. An extra pair would take up too much space in my pack, and they weigh too much to lug around. So I'm very careful about what I wear because on a typical conflict assignment I'll be living in them for three months. As I've already mentioned, I now wear Merrell hiking shoes. And last, if you want to embed with a combat unit – and ever be asked back – take gaffer tape. Lots of it. I love the stuff. I can't believe how many times that stuff has got me out of the shit. When you move through countryside, especially at night, the soldiers you're accompanying are going to become really annoyed if your gear is banging and clinking with every step you take. And who knows? A well-aimed piece of gaffer tape might just stop a Taliban's barrel being aimed your way, too.

21

Helmand: Not the Hilton

The C-130 RAAF transport plane banked in the clear blue sky and lined up for a run at Kandahar Airfield – the massive US-built military base in the south-east of Afghanistan. Kandahar Province is one of the thirty-four provinces of the country, and it's located next to Pakistan. Helmand Province is to the west, Uruzgan to the north and Zabul Province is in the east. Kandahar Airfield was also home to British, Australian and Canadian forces. When I'd first been there, it held less than ten thousand people. Now, thirty thousand lived within its HESCO blast walls, so from the air it looked like a fenced city, out of place amid the hundreds of miles of bare dirt, irrigation canals and sudden patches of bright green.

I'd flown from Sydney to Darwin on a commercial charter jet, and then to the Australian Middle East Command at Al Minhad Air Base in Dubai. At Al Minhad I did a four-day induction course, during which they gave us briefings,

explained the rules of a war zone and reminded us not to do things that created danger for others. Mostly, they taught us first aid, field triage and how to stem blood loss with a basic tourniquet. In the final test, I had to crawl into a shed with three soldiers, where there was a simulated battle and several lifelike dummies lying around with bad injuries. I had twenty seconds to find the person bleeding out and get a tourniquet on him. I took it seriously: if one small action of mine could save someone's life, then I wanted to be able to perform that one small action.

So I was well rested and feeling excited by the time we landed at Kandahar. I was picked up on the tarmac by the Australians and taken down to see the commanding officer. The deal was I'd spend my first stint with the Americans before joining the Aussies, so I took a few things from the Pelican camera case then stashed it at the Australian Q store, and went down to meet my hosts for the next month: the US Army public affairs team. These guys would be responsible for hooking me up with all of my American embeds, including my first attachment to the 3rd Battalion of the 6th Marine Regiment, under the command of Lieutenant Colonel Brian Christmas.

I'd only been with my new hosts for an hour when the incoming rocket siren went off. I was told to head to the shelter straight away, and I complied. The rockets were fired by the Taliban from the mountainside adjacent to the airfield. These were normally Chinese-made 107mm rockets, which are fired from the ground without any guidance system, so the

bloody things can land anywhere. Having already endured a number of these attacks, I'd say my state of mind was respectful of the damage they could do rather than panicked.

There was a delay in the US Marines system, so I had a few days to cool my heels in the air-conditioned donga that the Americans put the five journalists into. I went for a look around and of course the first thing everyone noticed about Kandahar Airfield was an area called the Boardwalk. The Boardwalk was a large, prefabricated quadrangle area made up to look like a town square, with a soccer field in the middle. All around the sides of this town square were places to eat and drink, fronted by a large covered wooden walkway. There was a Mamma Mia's Pizzeria, KFC, TGI Fridays and an assortment of Mexican places and delis. There were also tactical shops that sold the bits and pieces that soldiers always need more of: socks, water bottles, webbing, packs etc. The base was relaxed and had many of the home comforts the Americans were used to. The gym was as good as any you'd find in an Australian city, and there were basic amenities such as chapels, well-appointed rec rooms with Xboxes and PlayStations, and an ice hockey rink without the ice – the Americans and Canadians played in their shoes, although just as roughly as you see in the NHL. Besides the eating places at the Boardwalk, there were five messes on the base, all serving pretty good food.

What wasn't working so well was the sewage system. The plumbing and septic systems hadn't been designed to cope with such a large population, and the US Army had had to

dig these massive 'poo ponds' in the base compound which were essentially lakes of whatever was being flushed from the toilets. I didn't notice it for the first couple of days, but one afternoon the wind changed and a warm waft hit me like a punch. It was so strong I could actually taste it and breathe it, and as I looked for cover I realised that the base's inhabitants wore those Arabic scarves around their necks so they could quickly cover their faces. To this day, when someone says 'Kandahar', my memory produces a taste.

We were eventually assigned to a transport plane and joined up with the 3/6 US Marines on the outskirts of the infamous city of Marjah. Marjah had been largely under Taliban control until four months earlier, when the US war planners put on one of their big 'surges' and took back the city. Marjah is in the south of Afghanistan, and is closer to Iran and Pakistan than it is to Kabul. It was still hairy and dangerous down there, and as we approached in a US Marines twin-prop MV-22 Osprey under the cover of darkness, I caught glimpses of the ditches and dykes that crisscrossed the land. It looked like the most inhospitable countryside to cross on foot, and I remember thinking what an obstacle course those ditches would be at night. Boy, I had no idea how right I was.

We shacked up in the USMC patrol base that night, which was a mud-brick compound that had been leased from a local family. I was itchy to be on patrol by this time, so when I caught wind of the first Marines platoon going out at dawn – doing a walking patrol through the countryside to a

forward operating base – I suggested we tag along. Lieutenant Colonel Christmas liked the idea, and we were briefed for joining the patrol.

I was up and about, eating my rat-pack and checking my gear, by 4 am. I was wired and keen to get going. At 4.30 am the USMC sergeant led us out into the dusty streets of the outskirts of Marjah, down alleys that were created a thousand years ago, and then out into the ancient farmlands of Helmand. It was eerie watching the sun rise, seeing the valley slowly fill with light as the platoon padded along dykes and down canal paths. I felt the same thrill I had every time I went on dawn patrols in Afghanistan – the early-morning light is a real treat for a photographer. We got onto a more mainstream road after an hour or so, only occasionally veering off to check on dwellings and take a closer look at who was out and about at that time of the morning. When these patrols move around, they are asserting their dominance over territory. The Americans were polite and businesslike with the locals, but some farmers were almost certainly Taliban, so the 'friendly American' act had a real edge to it

I was blending in to the unit by the time the sun was over the ridge, right down to my green helmet. It was right on 7 am, the light was now good, and having skirted some mud-brick farm outbuildings, we pushed through a stand of scrubby trees and into a clearing where goats foraged. And that's when the shooting started.

It's difficult to know who is being shot at when you encounter automatic gunfire. What you're hearing actually

comes from thirty to a hundred metres away. As I ducked and ran for the cover of the buildings behind two of the Marines, bullets hit the mud-brick wall with spouts of dust and a couple of shots raised dirt from the ground.

I scrambled along behind them, cameras under my arms, hardly able to believe I was being shot at on my first walk in the field. I could hear the Marines shooting back, and then the three of us ducked into a recess in the wall that housed a wooden door. I was heaving, panting with the adrenaline, but somehow I had my finger on the button of the D series, shooting video of the incident. I don't do this consciously and it was only after this event, when I played back the footage on my camera, that I realised I'd shot the whole incident. The Marines joked that I now I had a souvenir from my time in Helmand. The shots thudded around the recess and the Marines shot back. I kept shooting footage but it wasn't like it is in the movies: there isn't much pinging or ricochet in Afghanistan.

Then the soldiers peeled out of the recess, pursuing the shooter. The time code on the video footage shows that it was all over in less than thirty seconds, but the burst of fear and excitement slows down time. As the Marines left the recess, I took a deep breath and stuck my head out. Marines were jogging forward in assault patterns, running to corners and kneeling at walls while the goats took refuge. I got in behind the unit and followed them through the farm compound, the sergeant directing traffic: two to check the farmhouse, two to check the grain store etc. Around me I could pick up the

American radio chatter: they were chasing one shooter, and the Marine who had seen him was saying he was an older guy, probably the farmer.

It took an hour to secure the area, and they didn't catch the shooter. But it was a reminder of the way the conflict in Afghanistan is fought. The Taliban in the area are like a mafia gang: they operate using fear and intimidation, and if they shove an AK-47 in your hands and tell you to shoot at the approaching Americans, you'll probably do it. If they tell you that your crop for next season is going to be cannabis, then there isn't a lot of incentive to defy them. In situations of the type I'd just lived through, the Marines are in an awkward position. On the one hand, they can't allow people to shoot at them, but they also know that many of the rural folk in southern Afghanistan are just busy farmers like you'd find anywhere in the world, with no real interest in politics.

I had some time to think about what had gone down. I'd been admiring the light and thinking about where to put myself to get a great shot, and the next thing I knew I was ducking for cover. I'd had my wake-up call: from here on in, I might have been a photographer, but I was now part of the platoon. For the next few weeks being attentive might just keep me alive.

We finally walked into the FOB we'd been heading for, and I was stunned by what was going to be my HQ for the next three weeks. The base was an ancient compound, a large mud-brick building with a dusty quadrangle in the middle. I found shade and took the weight off, letting the stress of the

day ebb from me. My home for the next few weeks was this biblical-era compound and I was introduced to how I was going to sleep for the next month: in a sleeping bag, on the ground. I was back in a war zone and now I was thinking not only about documenting the lives of the soldiers, but also how I was going to illustrate the resigned fear of the locals, so many of whom were co-opted into the Taliban's activities. This is one of the challenges of combat photography: capturing the entire story, in its real context.

In the few days I'd been with these guys, I'd slipped into a rhythm, so I'd almost forgotten that I was travelling with soldiers. But I snapped out of it when I looked around the compound and noticed lots of pats on the back and arms around shoulders. There was a lot of quiet muttering – none of the loud greetings you associate with US Marines. Approaching one of the Marines I'd run with when the attack started, I asked what was going on.

'We lost a couple of guys a few days ago,' he said, looking away. 'IED.'

The mood was sombre and I put away my cameras. There was little talking that night, and I noticed that most chatter was pointedly *not* about the incident that killed their two guys. Soldiers will grieve and drink and remonstrate when they're no longer on the frontline, but when they're on patrol they have to stay focused.

A few days later, the padre and a few high-ranking Marines flew in. The Marines asked me to cover the memorial service for them. It was a real honour: soldiers are very tribal

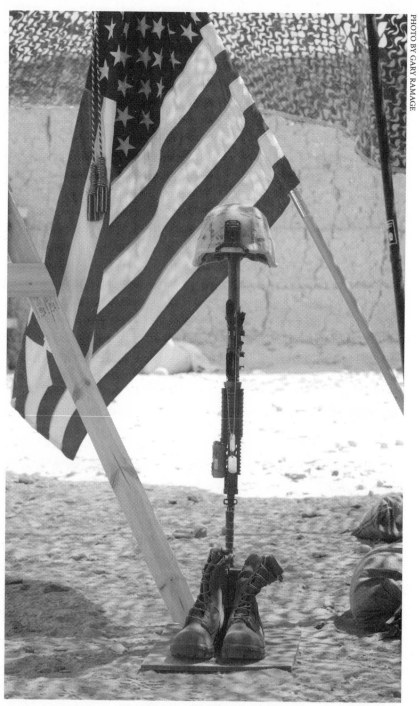

It was a privilege to be asked to document the Marines' memorial for two soldiers.

about who farewells one of their own. We stood there in the cool as the padre and then the captain and the sergeants had their say. There were two big photographs of the fallen, their boots with M16s planted in the ground, bayonets fixed, dog tags hanging off the butt of the weapon. I felt sadness but also appreciation. Memorials and ramp ceremonies always remind me that so many small liberties I enjoy have been hard-won by someone, and sometimes they paid with their life.

After the ceremony I retreated into the shade, where I could be by myself. Looking over the footage I'd shot of our initial entry into the compound, I could now see there were a lot more bullets coming my way than I was aware of at the time. I really had to be on my game in this part of the world: it was my fifth day in the field, and I'd survived a shooting only to walk up the road and attend a memorial for two Marines. On the toilet walls back at Kandahar, the graffiti called it HELLMAND.

I took a couple of deep breaths as the sergeant roused us for another patrol. This was going to be a tough gig and my eyes were opened to something you don't see in the media that much; far from the image of the soft, pampered soldiers, these Americans slept on the ground and it was with them that I experienced what I'd thought was an urban myth: the camel spider. One night I was lying on the ground in my sleeping bag when I felt something run across my shoulder and across my stomach and leg. It was heavy enough to be felt through the padded sleeping bag. Sitting up quickly, I could see this creature scuttling across the dirt, into the scrub. I

was a little freaked at the size of the tawny spider but the soldiers were nonchalant about them: despite their size and ferocious appearance, they apparently don't bite humans or want anything to do with us. So life on patrol with these guys was really earthy – no steak and potatoes out here. After the eventful first patrol I was feeling a bit crusty. As the new day dawned a sergeant asked me if I wanted a shower. 'Sure,' I said, and he handed me a few water bottles.

The Hilton, this was not.

22

With the Marines

The 3/6 Marines had been assigned to one of the real wild west parts of Afghanistan. The countryside around Marjah was considered by the Taliban to be their natural area of influence and was not only a military power base for them, but an economic one too. The Taliban generated money by coercing the farmers to grow drugs, and they weren't happy to have US Marines patrolling through these areas.

My official embedding with the Marines was scheduled to last for ten days, but when at the end of that time Lieutenant Colonel Christmas asked me if I was ready to go, I said I'd stay a bit longer if that was okay. That was fine by the Marines, so I extended for another four days.

The next afternoon, the Marines went to meet with a gathering of tribal elders from around the district and I was intrigued to see some hearts-and-minds engagement, American style. The Marines were invited into the compound

of the local mosque, and everyone sat around chatting, getting to know one another, doing 'soft' diplomacy. It seemed friendly enough, and I got some great pics of Americans and Afghans sitting in a circle and talking. As the light faded, the elders stood up and walked out of the compound, all smiles and handshakes, and I remember it well because I was standing against an outer wall, which in that compound was one and a half metres high. I don't remember exactly what I heard or why I did it, but without warning I threw myself to the ground, as did the Marines I was talking to. The air came alive with bullets, rounds thumping into the mud brick all around me, the dried mud showering my clothes. Voices yelled out as soldiers dived for cover and crawled up against any wall they could find. I found cover and started shooting video footage of two Marines along the wall from me. One was duck-walking around, getting his grenade launcher set up, but the furthest Marine from me was lying at a section where there was a break in the wall of the compound, and he was returning fire. As I watched him shoot, I heard more gunfire and then I saw puffs of dirt in the wall not more than 3 cm above his head. A shooter was coming in from another direction and we were caught in crossfire. In this situation the noise is frenetic with all the sounds of automatic gunfire popping off, but the soldiers kept it pretty formal on the radio. There wasn't much yelling or panic. They went about their business in a very professional way.

The attack only lasted a minute, but it was a big shock to the system. You sit around in a mosque, talking about peace,

only to walk out into an ambush? It was an eye-opener about who these people really were. Some bullets hit the wall close by to me, something I realised when I played back the footage. But mostly I'd focused on finding a sheltered position behind the wall. Whatever instinct it was that made me drop to the ground was an instinct that probably saved my life. And then another instinct cut in: the instinct to get footage.

When the danger was over, and the incoming stopped, the guys immediately formed up into their sections and scanned the area for Taliban. This is when you hear the platoon captain calling for information and calling out to other platoons to get info on what is happening. The unit I was with had become a hit-and-run target for a particularly savage militia operating in the area – a militia with no compunction at all about shooting at people leaving a mosque. After all, their place of worship bore the brunt of the incoming from the AK-47s.

It was frantic in Helmand – you never knew where the danger was coming from and the atmosphere occasionally pushed me towards paranoia. One morning at Patrol Base Beatley, I was brushing my teeth and the thump of rotor blades and turbine engines came in so low over the roof that I dropped my toothbrush, grabbed my camera and ran outside to see what was happening. There were two American Apache gunships, hovering over a point just outside the walls where they were obviously chasing something. The Apaches took out two shooters on a motorbike. One of them, I was told a few minutes later, was a high-value target (HVT) known

to the Americans as 'Kojak'. He'd been tagged for planting IEDs and ordering raids. A patrol was dispatched to pick up the body parts, which were to be scanned and documented before sending the data to the Intel people. I had already come under attack twice from the Taliban militia operating in this area, and now I wasn't inclined to shed a tear for these people. It turned out the intelligence staff had had an eye on Kojak for most of the night, and by the time he made his run at the US Marines' base, the Apaches were waiting for him. The patrol never located the body parts as the bodies were whisked away by locals before we reached the location.

A couple of the Marine snipers attached to the 3/6 were taking fire ahead of the patrol I was travelling with. The Marines got down to the gunfight very quickly, and I followed them, running in a zig-zag pattern across open ground, as they tried to sneak up on the Taliban shooters. And yes, with the cameras going all the time. I tend to think about the balance between taking my shots and staying alive later, when I'm having a rest. When things are happening and we have contact with the enemy, I just use the camera instinctively.

The pattern of life at Beatley was pretty rough. Not only were there constant threats from the Taliban, but it was a harsh, dusty, isolated part of the world. It's easy to imagine American soldiers living a life of luxury in their foreign wars, and obviously Americans are wealthy compared to just about anyone living in the developing world. But Beatley had no running water, only a small generator for power, no beds, and 'poo bags' for going to the toilet. These were plastic

sealable bags with a chemical agent in them that broke down the faeces in four days, making their disposal easier. One night the pallet containing our poo bag supply was burned down so we had to re-use what we'd been issued until we could be resupplied. I was very specific about which one was mine, but the Marines got a bit mixed up and there was a lot of dysentery in the patrol base after that.

The 3/6 Marines mostly did foot patrols in the day. So there was the heat exhaustion of walking with a loaded pack and a rifle in 50° heat, but it was worse when you consider how much water they had to carry to stay hydrated. About the only thing heavier than water is steel, but even then, a rifle is pressed steel – it's not solid. So water becomes your friend and enemy. I learned to disperse it around my body and my pack in smaller even weights, to at least balance the load. On a hot day we'd be out and about by 6 am, trying to beat the heat, but if there was a delay or a contact or they found an IED and decided to call in the engineers, you'd be out until dusk and that meant carrying enough water to see you through. It wasn't unusual for a soldier to carry 10 kg of water.

A patrol could be delayed because spotters were following us. Spotters were Taliban lookouts who hid on the ridges and kept an eye on where the Marines were travelling that day, informing their commanders of the movement. Some spotters would just watch us go by but some would have rifles and rocket-propelled grenades (RPGs), and sometimes they'd fire at us. The US Marines patrols had recon and sniper elements that roamed ahead and around, finding these

spotters and also working out where reinforcements were massing and reporting back to the patrol leaders. The first time a spotter took a shot at the unit, the Marines worked like a machine: they immediately went into harbour protection, where they'd fall into a circle pointing their rifles outwards. This was because an obvious spotter sitting on the ridge line might be the distraction for a bunch of shooters hiding in the bushes. So they covered the threat in front of them and the potential one at their backs. When these sightings occurred several times a day, we wouldn't be back at base until nightfall, everyone tired. People ask me if I felt unsafe on these patrols, and the obvious answer is 'yes' – these are inherently unsafe environments where people try to kill you. But once I got used to the rhythms of the patrols and their training and focus, I realised there was probably no safer way of travelling through rural Afghanistan.

I loved my time with the 3/6 Marines and they were in my thoughts whenever I heard a news report from Afghanistan. They were right in the middle of the shit and they always made sure I was okay. I made some fantastic photographs during my time with those boys.

23

Dust-Off Action

When I left the Marines I returned to Camp Dwyer in Helmand province, the base for a unit called the Dust-Off crew. The Dust-Off guys are a legendary bunch of highly-valued casualty-evacuation (CASEVAC) people who fly Black Hawk helicopters into the worst situations and try to retrieve and keep alive those injured in the field. I'd had these guys in the back on my mind for a while, wanting to document them because of how highly every soldier in-country spoke of them.

I joined them at Camp Dwyer in early June 2010. Dwyer was a major US Marines base in southern Helmand, which looked as if it had been plonked down on a beach. The ground beneath it was very sandy and when the wind blew, it was an immediate dust storm. The soldiers and pilots lived in large standard tents, surrounded by HESCO blast walls, and also mini cities of Quonset-styled tents.

The Dust-Off teams – run by the US Army – consisted of four crew in each Black Hawk: two pilots, a crew chief and a flight medic. They immediately struck me as humble, strong people with a lot of focus. As I was to realise as I did missions with them, these people were not the 'high five' style of Americans. They were something quite different.

The main benchmark for a Dust-Off crew is a return trip called the 'golden hour'. If they get an Alpha call – which means the casualty is verging on being a fatality – the US Army requires the Dust-Off crew to get to the casualty, stabilise him and bring him back to the hospital in under an hour. This includes the twelve-minute run-up, which is how long the flight crews need to bring up all the temperatures and pressures, and do a safety check on the aircraft.

I wanted to document their amazing work, especially since it hadn't been done for an Australian audience. They accepted me quickly and after a couple of days asked me to join them on one of their mercy dashes. So I took to hanging my Kevlar vest in the helicopter, where the crews had theirs. I was ready to go. Now all I needed was an Alpha call.

In this part of the world, I wouldn't have to wait long.

* * *

I was sitting in one of the canvas-covered tented areas at the Dust-Off HQ, talking to a medic, when the Alpha call came over the speaker system. It was 6 June, 11.35 am, and the urgency was incredible. Everyone, myself included, dropped

what they were doing and scrambled onto this Black Hawk, whose pilots were doing their run-ups as we climbed in the side door. I put on my ballistic vest before getting into my cameras harness, then clipped into the rear forward-facing fold-down seat and tried to keep my adrenaline under control as we sped across country to the scene of a fire fight. By now I had my earphones plugged into the helicopter's comms jacks via my camera – a technique I stumbled on during the Jessica Watson gig – and I could hear all the back and forth between the Dust-Off pilot and the officer on the ground. A US Marine had been shot in the hand.

We flew in from the south, towards a typical scrub-covered hill where US soldiers were spread out in attack formation, looking up the hill. The pilot asked for the situation on the ground – they don't have to land in a 'hot' landing zone (LZ) – and the officer said the shooting had died down. Perhaps the shooting had died down but shots were still being exchanged on that hill as we descended. The guys I was with in the back – Adam and Derek – got the injured Marine into the cabin and started treating him immediately, cleaning the hand wound and doing triage. I took some shots without getting in the way. But on the way back to Camp Dwyer with the injured Marine we got a Charlie call – a bad injury but not imminently life threatening. He was a local boy, about 10, with an injured eyeball that looked hacked, but no one seemed to know what from. The Black Hawk swooped, we picked him up and continued back to the hospital. This child was in a bad

way. His head was already bandaged, and the Dust-Off guys went to work on the eye. We got both of these people to the base hospital and were at the base for half an hour when another Alpha call came in, this time for a Marine who'd taken a gunshot to the head.

It was a big introduction to Dust-Off and I was seeing how they'd earned their reputation. They were very efficient and organised, and obviously incredibly well drilled. There isn't a lot of space in the back of a Black Hawk once you have a couple of patients and the two crew back there. And they worked around each other, with all of their IV drips and heart-starter machines and bags of medical supplies. It was like watching ballet – no one ever had to tell their colleague to get out of the way.

The pilots were amazing too. The zones they fly into are usually ones where there are rifles and RPGs going off, and their calm judgement about where they can put down is pretty cool to watch. I mean, these were sites where Taliban were shooting at us, and they were pretty motivated to down a US helicopter.

The next morning I was eating eggs, coffee and hamburger in the shade of the over-hanging tarp. In my first day of flying with Dust-Off, I'd seen the boy with the hacked and bleeding eye and I knew I had to focus, stay busy. As I sipped on my coffee, the siren sounded – an Alpha call. I ran to the chopper and got on my body armour and we were airborne in the regulation twelve minutes. I plugged my headphones and camera into the comms jack in the helicopter,

and listened in to the radio traffic. After a few minutes we got to a hot LZ. Through the pilot's windshield I could see two Cobra gunships pouring cannon fire into the scrub. The commander on the ground was telling the Dust-Off crew to hang back for one minute while they dug the Taliban out of there. As I listened to the radio talk I heard the agonising compromises being made between pilot and the team leader: they wanted this injured soldier out of there so he could live, but no one gets to live if the Dust-Off chopper is shot out of the sky. They had to have caution ahead of courage.

Confusion reigned. The noise was deafening, and it wasn't until the words, 'The patient is crashing,' came over the radio that Adam – one of medics with me in the back – said, 'Fuck this, we have to go in.'

The panic from the ground crew was palpable over the radio. They were losing one of their guys and they couldn't secure the ground so we could land. Finally, the pilot said, 'Screw it,' and descended to the designated CASEVAC site. Adam, an athletic twenty-seven-year-old from Illinois, jumped out of the chopper before it touched down and sprinted two hundred metres over broken ground to where a group of four Marines was struggling under the dead weight of their wounded colleague. Adam directed them to the chopper and the patient was placed on board. As we lifted off above the melee, the medics in the back were already going to work on this guy. He'd taken a bullet through one lung and so it was a sucking wound with no pressure to get the breathing going.

Adam tried everything, all the way back to base, even CPR, while I got shots of a young man struggling to save the soldier. There is nothing glamorous or heroic about a sucking chest wound, and when Adam got me to operate the CPR mask on the patient, it didn't feel uplifting; it felt futile. We came in fast and low to the Role 3 hospital. Derek threw the door open and Adam frantically waved towards the waiting medical staff to get their arses out to the aircraft. It was a slow process because the medical staff tried to get him onto a wheeled litter but it had got stuck in the makeshift pebble landing pad. I couldn't stand the delay – I'd taken the journey with this injured soldier, tried to keep him alive – and now I wanted him in that dammed intensive care unit. I dropped my cameras, grabbed both stretcher handles and pulled upwards. I took his weight so the medics could untangle the trolley. They eventually unengaged it and took him away to be treated. When Derek and Adam returned we lifted off and flew back to the Dust-Off hardstand at Camp Dwyer. And that's when the reality of this work started to sink in. Having got off the chopper, and looked in, I saw it from another perspective. The back of the aircraft was a real mess: blood everywhere, discarded dressings, bloody tubes and CPR masks – a real mess of human flesh on metal.

I breathed out a couple of long breaths, feeling the adrenaline slowly letting go. Flying into a hot LZ, with gunfire all around, and then trying to save a soldier with a bullet through his chest, and seeing how much it meant to the Dust-Off crews, was a profound experience. And one

that really smelled like war: the cordite of battle, the exhaust fumes of a helicopter. It was indelible.

Once the engines were shut off the rest of the detachment came out on the hardstand and helped with stripping the armour from the floor so they could wash out all of the blood with hoses and scrubbing brushes. They handed out plastic gloves and they all pitched in, scrubbing the Black Hawk floors. I realised that this was more than just cleaning – it was a ritual, and in a strange way I felt part of it. At very least, I didn't think I could go through a mission like that and pretend I wasn't affected. So I got my shots – and then put down my cameras and pitched in with the clean-up. The picture of a medic holding a hose as he sprayed water into the floor of the helicopter with the red cross off to the right said so much. You actually get the idea of what is going on at that moment without actually seeing the horror of the event.

After we'd finished Sergeant Derek Costine called my name.

'Gary, catch,' he said, throwing me the Dust-Off unit patch. 'Welcome.'

It was his way of saying thanks for helping.

By now it was only 10.30 am – this was a breakfast job. As I looked for a coffee, I was joined by Adam. In Adam I was seeing many of the good qualities of Americans, the qualities so often overlooked by our media. He was humble and brave, up for a laugh and also serious about his job. And I had been impressed with the way he urged the pilot to land in the hot LZ and then ran to grab the casualty.

'He was basically dead when I reached him,' said Adam, of the soldier with the lung shot. 'But I couldn't give up on him — we don't give up.'

* * *

Flying with the Dust-Off crew was busy and action-packed, but I hadn't been fully prepared for the non-stop intensity of the work. A couple of days after the soldier with the shot lung, I was informed by Dust-Off that two Australian soldiers had been killed and then, the morning after, a US Marine unit was attacked and there were already two confirmed Angels — Dust-Off code for killed in action — along with a lot of Alpha patients. We scrambled and flew across country, two helicopters just thirty metres off the ground. The first Black Hawk took the Angels and Alphas, and we picked up the Bravo patients — who were out of action but with injuries unlikely to lead to death. This meant bullet holes in young men, a lost eyeball, shrapnel buried in flesh. It was quite a sight, and what was remarkable was the range of reactions to combat injuries: some were yelling, freaking out; some just wanted to sleep; some were panting, calling for water; and others were floating in an out of consciousness. Most babbled, wanting to know that their fellow soldiers were okay.

On the way back with our Bravo casualties, I was introduced to one of the things that has really stayed with me from that war. We stopped off at a village because a two-year-old local girl had ingested diesel and needed hospitalisation.

We had to be very careful about this pick-up because Taliban militias were forcing diesel into kids' throats to lure the medic choppers, which the Taliban could then shoot down. But ignoring the call was not an option. So when we landed it was a cautious set-down. Adam was very quick to grab the girl and get her into the chopper before we lifted off again at great speed. When we landed back at Dwyer, Adam jumped out of the helo; he landed badly, breaking his ankle, but kept hold of the little girl. He got her onto the waiting gurney and into the hospital, where she was saved.

The stress of this embedding mounted by the hour – there was no respite from it. A day after we picked up the girl with diesel poisoning a US Special Forces PEDRO helicopter was shot down and four Americans were killed. This helicopter carried the best of the best medics (Dust-Off is US Army, PEDRO is US Air Force).

We were called out again, another Alpha – a young soldier had triggered an IED and had taken the full blast. He was lucky to survive but was going to lose both his legs. When we got back to Dwyer there was another Alpha callout. After fifteen minutes of CPR in the cabin of the Black Hawk, the medic sat back and shook his head. The soldier had died. That was now three dead Marines in three days, in the bird I'd been travelling in.

Two days after the PEDRO had been shot out of the sky, we flew into the same area, to attend another casualty. But this one wasn't an American or Aussie, and also not an innocent local. He was a Taliban bomb-maker who'd had

his hands damaged by an IED that detonated in-place. The Dust-Off guys flew to him and saved him as if he were one of their own.

I was becoming fatigued by the missions: not just the physical effort but the mental and emotional burden. A lot of death and agony, up close in a confined space, is very confronting, and when I'm working I'm forcing myself to see things that are upsetting, so I'm really processing too much. So the next morning I missed my alarm and slept through.

I joined the crew again that afternoon and we went to a call at a hot LZ, where bullets were coming close to the nose of the Black Hawk as we landed. When that sort of thing is happening, there's a chance of dying and, sure, I feel some trepidation – if a PEDRO helicopter can be downed by the Taliban then so can a Dust-Off. But I also assess the environment and the company I keep, and I trust professionals who care about their own welfare; if the risk is too great, they won't do it. But that isn't to say I'm comfortable with landing in a hot LZ – no one is comfortable with that, not even Dust-Off crews.

As we touched down a soldier ran towards the chopper with a dog in his arms. He'd walked with his dog into an IED and the dog had come off worse. The US Marine dog handler followed the animal onto the chopper – he'd taken shrapnel to the neck in a big, ugly bleeding mess. We returned to that hot LZ later in the day and a soldier who had been shot in the leg broke from the bushes and ran for the chopper. Watching him run in an agonising hobble is another

very strong memory from that gig. The look on his face, the will to live, the encouragement and help from the Dust-Off crew. He flopped into the Black Hawk, relieved to be on the aircraft, but in agony from the gunshot. Sights like that don't leave you.

After that day I had to move on, because I had other embeds to do. But I wrote my first feature piece about my time with the Dust-Off crews, and it got a run in the Murdoch press. I was very impressed with these people because to me they're the guys who live by their motto, 'Never refuse a mission, never return with an empty helicopter, and the needs of the patient come first'. And to them I was the Aussie who helped them clean the blood out of the helicopter.

24

Airlifts and Elections

I caught a small C-130 from Dwyer, and I was at Camp
Bastion one hour later with my five bags. Bastion was a
British-built base, home to the NATO logistics hub in the
south of Afghanistan. I'd requested to visit the British/
Australian Cutler Troop at Camp Armadillo in Helmund.
It was a real Taliban-magnet and had been the subject of
a Danish documentary. It was situated near a place called
Gereshk, which had been a pain in the arse since the British
were at war in Afghanistan the first time around, in the
nineteenth century.

I was assigned to a Royal Navy helicopter, where the
loadmaster was an Aussie on exchange. It was really wild out
there. Armadillo was a coalition Forward Operating Base
sitting on a hill, and down the road from the hill was a small,
hostile village. The Taliban militias in this part of Afghanistan
were so brazen that they'd come up the hill and plant IEDs

on the front gate of the base, from which two people had been killed; they'd been known to throw grenades over the walls. The Aussies and Poms got on very well and were eager to engage the Taliban.

Back in Kandahar I travelled with the British RAF Air Defence Guards in their Panther and Cougar vehicles, which are armoured patrol vehicles with heavy machine guns on them. I did this for two days, taking good pictures, but not getting into any contacts. Then I was back to spend time with 6 RAR out of Tarin Kowt in Uruzgan. The big mission for 6 RAR was the take-over of Forward Base Razak from the Dutch contingent and replacing them with the Aussies. Ironically, the 6 RAR end of my stint was relatively safe, and the Razak handover was highly controlled and professionally managed. Until – that is – the final days of my embedding with 6 RAR, when private Nathan Bewes was killed by an IED.

* * *

It was an exhausting six weeks in-country and I probably overdid it. I took a couple of weeks' holiday when I got back. My best mate, Trevor Bailey, was getting married and he'd asked me to be best man. After Trev and Jodie's wedding it was off to cover the 2010 election: Julia Gillard versus Tony Abbott. Not exactly blood and guts in the back of a Black Hawk, but an all-consuming six weeks all the same: totally exhausting and deathly repetitive. Planes, hotels, photo calls. I got to know Tony Abbott, who was

always nice to me and was always up for a short chat. He knew me by name and would wander down the back of the plane. I don't see this as vanity, by the way, with either Abbott or Rudd or any of them. When your job is how you are presented in the media, you notice the shots that present you well and it's your job to understand that process. Later, when Abbott won the 2013 election and became prime minister, he was still affable and I saw glimpses of a real Tony Abbott who wanted to break out of the controlled media performance and be himself. He was similar to Gillard in that he liked a bit of a joke and he had an infectious laugh. Photographers probably see this more than the journos because we're not quoting them and writing the stories. So when we did a photo call without a journo, Abbott or Gillard were fun, likeable people. Especially when you give them the photographer's gee-up to get them smiling. Rudd and Howard? They were the same whoever was around. Abbott's final months in the job – before being rolled by Turnbull in September 2015 – saw him really pulling back from the Press Gallery in general and the photographers in particular. Perhaps he felt besieged by all the talk of a coup? I don't know, but he really withdrew.

I covered the 2007, 2010 and 2013 federal elections (and as I write this I'm gearing-up for the 2016 election). I also covered a large number of foreign delegations led by prime ministers or foreign ministers. For these jobs everyone in the media likes to be on the plane, but the exhaustion is something you have to accept before you do it. These politicians cram a

lot into a week when they go overseas, and when you're the photographer you have to be on deck for all of it.

I've seen some real stamina from these top politicians, and I thought the Iron Man of them all was Rudd. But when Malcolm Turnbull became PM, his first foreign tour covered five countries in eight days. On that trip we did fifty hours straight on our first leg into and around Jakarta, and then the Paris attacks happened while we were in Berlin, so it was all hands to the pump. Also on the itinerary were Turkey, Manila and Kuala Lumpur. And the PM charged through it like the Duracell bunny, scaring the bejesus out of a journalist or two.

* * *

I arranged to head back to Afghanistan in August 2011. This time I was I was going to be spending time with the 2 RAR, first at Tarin Kowt and then at FOB Tinsley in western Uruzgan. But before I joined the Aussies, I was going back to embed with a new Dust-Off crew, this time a group from the Minnesota National Guard: or, to be more precise, C Company 1/171 Air Ambulance, 4th Platoon. This crew was based at FOB Edinburgh in Helmand, codenamed Task Force Thunder. Edinburgh was built on rocky ground, was enclosed by HESCO blast walls and, because it supported so many aviation units, there were large stacks of shipping containers (for mobile mechanic workshops and spare parts) and lots of refuelling infrastructure. It was like living at a makeshift airport, albeit bloody and dusty.

It was early August, the first day of my embed with C Company. I was eating my lunch – my first MRE, Meal Ready to Eat, of the assignment – when the loudhailer broke the silence with a *medevac, medevac, medevac* alert. The crews of both Black Hawks scrambled towards the aircraft, their boots loud on the stony ground. The blades were spinning and I was already strapped into my seat by the time Damian, the flight medic, jumped in. He gave me a nod of approval and then the bird lifted off. Our call sign was 'Dust-Off 41', and the crew had a category Alpha – someone was close to death.

Over the radio system I picked up that we were racing towards a local boy who'd been shot in the lower right abdomen. Unlike some of the longer flights in my first Dust-Off assignment, this time we were on the scene in minutes. The left-hand door slid back towards me and Marines raced towards the chopper with a small boy lying motionless on a stretcher. As soon as he was in the helicopter the door was slammed shut and we were in the air, racing towards the field hospital at FOB Edinburgh. The flight medic, Sergeant Michael Armesto, and the crew chief, Sergeant Brendan Anderson, went to work on the boy immediately. Michael applied CPR chest compressions as the boy faded; his airway was blocked with vomit and Brendan tried to clear it as Michael continued CPR. The boy's blood pressure was dropping all the time, and it got down to twenty beats. He was bleeding out.

The Black Hawk came in quick at the base and the hospital staff grabbed the boy and raced him into surgery. I followed them and watched the military doctors crack open

the boy's chest and start manual CPR of the heart. One of the medics later told me that even if the kid survived he would be brain dead as he was down for about twenty minutes. When I enquired about the boy later that night, I was told he didn't make it. He had became another tragic statistic in this campaign against the Taliban.

The second mission for the day involved a local driver in a military convoy who'd been shot in the right elbow. The round had gone through and exited the other side. Two Marines walked him to the helicopter, through a huge amount of dust kicked up by the spinning blades. Michael provided care for the man as he was flown to the hospital at Bastion.

Four days later we responded to a double-category Alpha at FOB Robinson. One of the Georgian soldiers had taken a round to the back of the head but he was conscious and still talking to the medic during the flight to the Role 3 hospital. The other Georgian had been shot in the back and there was a hole the size of my fist in his lower left side. He was also conscious and talking to the medic during the flight.

As my second week started, I was paired with another crew, who introduced themselves as Jeremy, Lucas, Shep and Will. These guys told me that whenever they were put together, the days were hectic. I thought they were pulling my leg, but then the siren went and we were into the first mission of the day at around 8 am, a category Alpha for a US Marine with acute appendicitis. Having dropped him at hospital, the second call was another cat Alpha: a US Marine

had stepped on an IED and it had taken off his left foot above the ankle. The calmness of the Dust-Off guys as they triaged the soldier's mangled leg was humbling. The sight of a fellow American with all his meat and bone on display must have been upsetting, but they got on with their job. Then I had a strange interaction. The soldier was in shock but was conscious and talking, and he wasn't talking to the medic, he wanted to talk to me. I'd crouched down to give him some attention while the medic dealt with another patient, and as we talked about life he had a really good grip on my forearm. When we got to the hospital, he thanked me profusely, and I told him I hadn't done a thing.

'Yeah, you did,' he said. 'Thank you, man. Thank you, man.'

That Marine survived, and I have no idea why our chat mattered so much to me, but it did.

We were barely in the air again when the Dust-Off guys were assigned another cat Alpha. An insurgent fighter with a gunshot wound to the right shoulder had to be taken to the Role 2 medical facility at Edinburgh. Amid the blood and screaming agony, it was mildly amusing, because when the medic cut off the patient's clothes to look for other injuries, the guy was more worried about people seeing his dick than he was about his shoulder wound.

After this, we stopped to grab a hamburger and coffee, and we were just taking the weight off when a fourth cat Alpha was announced. A US military truck in a large convoy had hit an IED and four Marines had been injured. When we

arrived all of the injured were walking, at least, which was a good sign, but they were beaten up: the improvised shrapnel bombs leave a variety of terrible injuries. Someone had a smashed wrist, someone's thigh muscle was sliced through, another person had an injured skull. We dropped them at the Role 3 hospital at Camp Bastion, and before we flew out the Dust-Off boys pre-ordered pizza from Bastion so we feasted when we returned to FOB Edinburgh.

From day one at C Company, there was at least one Alpha case every day, with amputees, multiple bullet wounds and shrapnel trauma. Lots of bleeding, lots of screaming and lives hanging in the balance. I was ready for it this time – as much as you ever can be ready for it. The first assignment with Dust-Off had been a shock to the senses: the eyes, the ears, the nose. Combat CASEVAC is a torrid business, with no opportunity to look away once the patient is on the chopper. On this trip I was doing some interviewing, asking military personnel about their tours and their lives and getting it on tape. One time, I was having a chat with Shep, a strongly-built paramedic from Minnesota, and a larger-than-life operator who exuded confidence and strength. But when I asked him about life back home, he got upset; he missed his family, he missed his buddies and he was feeling the hourly stress of this job. No matter what these people went through in that shit hole called Helmand they still maintained their humanity.

I was realising that these people were not so different from me. And that there is only so much you can take. As

I was to discover when we picked up a patient from FOB Judas, operated by the Georgians. A ten-year-old boy had been chasing a chicken in his rural village when a Taliban IED triggered, killing the boy's younger brother and riddling the surviving boy with hot shrapnel. The Dust-Off crew wrote medications on the boy's chest, willing him to stay alive. I documented it as well as I could. But I documented his final minutes, not his miracle recovery.

When you do this job, you have to tell yourself not to take it personally. But there are limits to that philosophy.

25

The Contact at Doan

I flew into Camp Russell at Tarin Kowt – the Australian base – where I'd spend a few days alone before meeting Macca at FOB Tinsley. At Camp Russell there was a ramp ceremony for Matthew Lambert, from 2 RAR, who had been killed in action. He was a sniper, and the whole sniper section turned out dressed in their ghillie suits and carrying their sniper rifles to see him off. It was quite a sight to see all these soldiers dressed in suits with foliage hanging out of them.

I caught a US Chinook out to the remote patrol base called Tinsley, where the Australian Army was helping to train Afghanistan National Army (ANA) soldiers. The Australian Commander – Middle East, Major General Angus Campbell, was willing to support me doing an assignment at Tinsley, to show the folks back home that we were nation-building, not just terrorist-destroying. That was the plan, but Tinsley was in the violent outer reaches of Uruzgan, and it

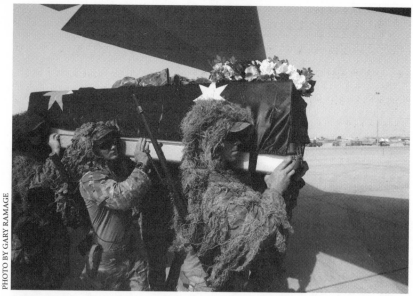

2 RAR snipers in their ghillie suits, seeing off one of their own.

turned out that the PR mission coincided with what I now describe as the Contact at Doan.

It started well enough. Tinsley was a comfortable patrol base, and with the support of General Campbell I was accompanying the Aussie patrols as they trained the ANA. But very quickly hostilities erupted with the Taliban, and the Aussie commanders decided to launch an aggressive patrol around the outlying area. We set off at around four o'clock one morning and first contact didn't take long. As we walked among the mud-brick homes of a farming village, the first shots rang out three or four hundred metres from us. One of the Aussie patrols was in contact, and it was on. Suddenly the radio traffic was alive with Aussie Army shorthand and slang as the platoon tried to zero in on the enemy.

It was a cat-and-mouse game for a few hours, as the scouts, snipers and recon guys drew sporadic contact and the HQ platoon element I was with tried to assess how the fight was developing and where to commit. It's important to understand how infantry units balanced their aggression with caution in Afghanistan. One of the methods of the Taliban was to use skirmishes – where the Taliban take a few shots and then disappear into the country – to pull the Aussie or American soldiers in a certain direction. Having encouraged commitment from the foreign forces, the Taliban could launch an ambush or get the foreigners to rush their vehicles through a choke-point at which point the IEDs would be triggered.

So the stop-start nature of these patrols wasn't dithering. It was like boxers circling, trying to sort the real punch from the feint and working out where the force was really hiding. The recon guys and the snipers seemed to work from pre-dawn until dusk, getting information back to the unit leaders. Just as the sun was coming up that morning, we came out of the green zone – the cropping area on the valley floor – intending to climb a hill of steep scree. With the diggers muttering their annoyance we started climbing. The first shot rang out when the first of the section was halfway up the slope. The bullets went between the first two diggers and there was no cover and nowhere to run. So the soldiers beside me just fought their way up that slope and it's lucky the shooter was such a lousy shot, or a few of us would have been dead. Corporal Mark Tunnicliffe, the section leader, was up the front with the scout when the

firing started, and he later told me he felt a bullet brush past him. Once we got to the top, everyone was panting for breath and soaked with sweat. Now I knew why soldiers avoided those slopes – you're not just a sitting duck, you're an exhausted sitting duck.

We travelled for two days in what might qualify as the most hair-raising two days of my life. We were constantly harassed by snipers and random hit-and-runs. Some was sporadic gunfire, suddenly bursting out from a ridge or bushes; other attacks were more serious, comprising RPGs. Some attackers worked solo, others were in groups. I can't remember ever experiencing such a sustained feeling of danger as I did on that patrol. We were in a part of the world where every local, apparently, wanted us dead.

The boys set up camp in a disused mud brick compound in the middle of an area known as Doan. The compounds dot the landscape – they have a hut in the middle of a quadrangle formed by walls about one and a half metres high on all sides. They're not military posts; they're where shepherds keep their livestock when they rest for the night. While these patrols were technically foot patrols, when they made aggressive sweeps through enemy countryside – as we were doing on this patrol – they were supported by Bushmasters and ASLAVs. We were just relaxing in this compound, everyone tired and nervy, when an RPG whistled over our heads with an almighty whoosh, clearing the tallest man by maybe three metres. The entire unit either hit the deck or dived for the nearest wall.

Soldiers grabbed their rifles and set up mortars as they tried to establish where the hell the rocket-propelled grenade had come from. Corporal Tunnicliffe reckoned he could tell the origin of the grenade, and he leaped up and grabbed a Carl Gustav 84mm anti-armour antipersonnel weapon from the back of a Bushmaster. This is used as an anti-tank gun – a rocket is launched from a short fat tube that you rest on your shoulder. Tunnicliffe raced out of the compound, yelling commands, and the guys leaped up and swung the turrets of their Bushmasters and ASLAVs. The turrets and guns can be operated by remote control.

When Tunnicliffe reached the gateway of the compound, he let off the rocket and in concert the diggers triggered the heavy machine guns on the Bushmaster turrets. Red tracer lines spewed into the night and we were in contact with the enemy, their blue tracer rounds coming back at us. I started filming the fight, taking cover behind a Bushmaster directly behind Tunnicliffe. He called for another Carl Gustav 84mm and it was delivered to him. He placed the 84mm on his shoulder and aimed up – and I do not recommend you try this at home, girls and boys, but I leaned out from my hide behind the Bushmaster's steel door and kept shooting. Tunnicliffe fired the 84mm rocket and the backwash percussion was so great that it broke my Canon 5D – actually, the backwash fried the internal components of perhaps the toughest camera you can buy. This is why professionals always carry at least two cameras.

A Bushmaster immediately behind us hit an IED, and a red flare went up, the signal that an Aussie vehicle is incapacitated

and people are injured. The young bloke in the vehicle's turret was blown out of it while the other two occupants received minor injuries. The Bushmaster had taken the direct impact of the blast which immobilised it. It actually didn't look too bad; you could tell it was a Bushmaster but the blast had broken the axles and transmission and it had to be towed by another Bushmaster across the desert.

The Taliban moved on before the sun came up and after a hurried breakfast of MREs, we moved out from the compound, the scouts and recon guys going ahead, and the rest of us travelling in convoy. The Taliban were out there, according to the scouts, but there wasn't much contact during the day. The afternoon became hot and it dragged on.

For the first time in Afghanistan I ran more video than stills. I'd given 1080p helmet cams to 10 of the guys. There was just so much action, and I was getting out of the cars with the soldiers and moving around.

Once things calmed down and we withdrew from the Doan contact, the Taliban really raised the tempo. They'd originally been holed up on a hillside, shooting RPGs and rockets at us, and they eventually moved all the way up the hill and fortified themselves on top, and then they were really giving it to us. The Bushmasters set up, basically in the open but with some cover from a rock or an outcrop, and engaged the Taliban targets. The red and blue tracer lines were shooting across the desert, the diggers taking cover in the rocks and going after the buggers. I just got in behind these blokes, and kept my head down and my finger on the record button.

That night, we were still in the open and our commanders called for help from whoever was around. The response came back from the Americans and we were reinforced by US Special Forces who engaged the Taliban on the hill. Out in the desert, the Aussie soldiers I was with parked the incapacitated Bushmaster and waited for the American air force bombers to make a run at it, to put it out of its misery. Only on the second bombing did it disintegrate. The Bushmaster was one of the success stories of the Afghanistan war. It's so tough that no one has died in one yet. Everybody loves the Bushmaster.

One of the problems during the Doan contact, in my opinion, was the involvement of the ANA. They were led by a fool who wanted to mutilate the Taliban. So the Aussie unit leaders were having to play diplomat to the ANA soldiers, while leading their units in combat. I thought it put too much pressure on them and their diplomacy was sorely tested. In one sweep, during this gig, Macca and I returned to an Aussie forward operating base that had been garrisoned by the ANA for two weeks, and the disrespect with which those people had treated the latrine areas was appalling.

We returned to forward operating base Tinsley where I'd planned to do a video essay. The idea was the soldiers would write down the one thing they really missed from Australia. At the end of the interview they'd hold up the word on a little white board I'd bought in Officeworks. I'd been moved by the number of injured people I dealt with in the Dust-Off choppers during my last trip, and I wanted to humanise these blokes. The interview I remember most was with Lance

Corporal Luke Gavin, a nice young bloke. When I asked him what he missed the most about back home, he simply wrote 'Kids' on the board.

After returning to Australia I learned that Luke Gavin had been murdered along with Captain Bryce Duffy and Corporal Ashley Birt: all shot by an ANA soldier. It was a 'green on blue' incident, which means the people Luke was trying to help turned on him.

26

Stealth Work at Home

Back in Australia I slept for two days and tried to recharge the batteries. It was the lead-up to Christmas, I was busy at the Press Gallery and Ali and I were trying for a child. But I'd also put my hand up for another tour of Afghanistan with Macca, timed for ANZAC Day 2012.

Ali and I were both working hard but, in all honesty, I was going overboard a little. I can become very focused on work and I tend to take my eyes off the prize. In early 2012 we found out that Ali was pregnant and we were both incredibly happy. It had been a long time coming. But in March, on my Granny's birthday, Ali miscarried and we were both devastated. Ongoing complications meant that we could no longer have children. I felt a rage like nothing I'd felt before. I was angry at the world and at myself. I had no one to blame and it was ripping me apart from the inside out. I felt terrible about it – not that I was directly responsible but I spent a lot of time in

my work and a lot of time away and I wondered what could have happened if I'd pulled back a bit and been more available.

I withdrew from the Afghanistan trip and we took some time off. I tried to ease back on the throttle slightly, even though Ali didn't really want me to do that. She's always been very supportive of my work ethic. In November of that year I won the Walkley Award for Best Broadcast Camerawork. It was for my coverage of the contact at Doan and it was the first time a News Corp stills photographer had won the TV news cameraman award. I was stoked about the recognition. It occurred to me that I was sort of splitting into three professions: the political photographer, the manager and the conflict photographer. You can actually be all of these things, and more. Some photographers think they're artists, and you can never please them. But generally we're a pretty broad church, us photographers. A good shot's a good shot. I think the Walkley proved that point.

I was also tapped by the Australian War Memorial, in 2013, to be their Official War Photographer for a specific project. I photographed 19 ADF personnel before deploying to Afghanistan, during their deployment and post-deployment. It was a heartfelt project, and I felt I'd achieved a great milestone. It was something I had always dreamed of doing but never imagined I'd have the opportunity. The project took nearly fourteen months to complete.

The 2013 federal election came and went, and the workload didn't get any lighter for having done it twice before. If you're the chief photographer at Parliament House,

you not only cover the elections but you're on the phone all day troubleshooting back in Canberra. For the 2013 campaign I was on Abbott's plane; he knew me by name and as far as I knew I'd never had a problem with him photograph-wise. Even with the fatigue and the stress that goes with a campaign, I thought Tony Abbott was a pretty good guy, certainly one with a sense of humour.

But even as I burrowed further into the world of federal politics, Sydney still wanted me for my stealth work. In April 2014, Prince William and his wife Kate brought their son George to Australia. My bosses in Sydney knew there was going to be a rest day for the couple, and they'd spend it at Government House in Canberra. So they wanted me to cook up something special. I went into planning mode. I knew that Mike Bowers – *The Guardian*'s photographer at large – had once lugged a 1200mm lens to a secret place on Lake Burley Griffin that had a direct line of sight to the front lawn of Government House. The 1200mm lens is sometimes talked about, but never sighted on a working photographer's camera. Bowers had taken a shot of the then Governor-General, Peter Hollingworth, strolling on his lawn. I thought I could replicate the shoot, hoping that Will and Kate would cavort on that lawn with their son. My only problem was the 1200mm lens: they're very rare and expensive and I couldn't get hold of one. So instead I grabbed a 600mm F4 lens and screwed 1.4x and 2x converters onto the base of it.

When I got down to the spot, there was a Channel 7 crew there too, so we found our positions and set up. My lens

worked well; I could make out the detail on the pool fencing and see everything. I was happy with the set-up – now all I needed was some Wills-and-Kate action.

We waited almost two hours for them to show up, and when they did it was magic: a couple of royals walking around on a lawn in Canberra, and the Aussie photographer snapping away from the other side of the lake. It was a nice day, good light and I would have been happy with that. I had my stuff and I could have left and Sydney would have been happy. But then Kate disappeared, and out she came a few minutes later … with George. She was playing with him, ruffling his hair and giving him shoulder rides. It was wonderful and unique: the first shots of Kate playing with George, and the British press pack hated us for it. They leave the royals alone on the rest days.

That was strike two for Ramage, as far as the royals were concerned.

Not all my covert work is of a tabloid nature. Sometimes it has a political dimension. In late May 2014, I was chasing Clive Palmer, a new member of parliament with his own party, Palmer United. I had a tip-off that he was up to something but among the journos it was considered a non-story. I tend to follow my own counsel so I got onto the team in Sydney and they agreed to send down a journo.

I knew Palmer was going to start his evening at an event at the Great Hall in Parliament House, so I snuck in there to confirm there was a place set for him. I then called my colleague Ray Strange down to the hall, and he came down

with the Sydney journo. I wanted them to follow Palmer around the official dinner and keep an eye on him.

I placed Kym Smith outside Parliament House in her RAV4. I was rostered on PM-watch that night, and I couldn't stake out the hall myself. I wanted her to follow Palmer from the dinner and tell me where he went and who was there. I assumed a hotel meeting.

I kept on Abbott and then I got a call around 8 pm. It was Kym: she'd followed Palmer's Rolls-Royce and she was now outside the Red Duck restaurant in Kingston. She was excited and a bit confused: Palmer was in there with Malcolm Turnbull and the former Secretary of the Treasury, Martin Parkinson.

Essentially, if Turnbull was meeting with Palmer then it was probably a discussion about what could get done under a Turnbull prime ministership, given that PUP controlled some of the balance of votes in the Senate. The meeting was going down that night.

I dropped everything and raced to the restaurant, my mind spinning. We had a story about a couple of gazillionaires plotting how to run the country, but Parkinson? Why would you have a Treasury geek in a meeting with a mining magnate and a prime ministerial aspirant? I didn't understand it, but I loved this story.

I put Ray across the road with a 300mm lens, in a nice line to catch the trio leaving the restaurant. Meanwhile, Kym and I cased the place along the footpath — I didn't want to burst in and do an ambush: I wanted them to walk out and have the flashes go off.

When they realised they were busted, I just brought up the camera, walked to the door of the Red Duck and started shooting as they left the restaurant. Parkinson ran out the rear exit, Turnbull just smirked and sighed as he walked past my flashing camera, and Palmer was paying me off as he walked past to his waiting car. I stuck with Palmer while Kym followed Turnbull.

For a 'non-story' – as it was called by a high-profile Gallery hack – it ran on the front page of every newspaper for three days, and led the radio and TV news. Of course it did: we had the smoking gun. And the magician-like disappearance of Martin Parkinson? Well, he reappeared all over again when Turnbull deposed Abbott and assumed the prime ministership in 2015; Parkinson was Prime Minister Turnbull's Secretary of the Department of Prime Minister and Cabinet.

* * *

In July 2014, Prime Minister Tony Abbott launched *Afghanistan: Australia's War*, my photographic book – with accompanying words by Macca – at the Australian War Memorial. By all accounts it was well received. I was proud of that book and the stories it told. The destruction of my grandfather's military service records had left a big mark on me; now I wanted all stories of military service recorded.

It was in 2015 that I had one of the few real disappointments in my media career. I accompanied Tony Abbott to Turkey for the centenary of the ANZAC landings, and there were a

lot of functions with the Turks, and the British and Australian veterans groups. It was a beautiful part of the world, up there on the ridges, looking down on the Dardanelles and the ANZAC landing beaches. Abbott was due at the centenary dawn service. It was a big do, really flashed up with stages and flags and sound systems, and the media contingent and the PM's media staffers knew I wanted to stand with the guests and honour the flag. That morning I put on my great-uncle's and grandfather's World War I medals, along with my own service medals. I was very excited. I did my shoot of the Prime Minister meeting the Kiwi Prime Minister and then Prince Charles and his son Harry. The PM moved to his seat as the sun came over the horizon and I went to stand in the shadows, out of sight. But the government escort officers saw me and wouldn't let me stay. I was intent on standing my ground, but this was a special morning. So I bit my tongue and allowed myself to be sent to the media bus. I sat down, a cross between fuming and sad. I'd served and I wanted to honour our fallen at ANZAC Cove on the 100th anniversary. I wanted to honour my grandfather too, and every other service man and woman who had served.

I sat there for five minutes, on the bus, and suddenly snapped out of it. I went to the door, told the security I had to go to the loo, wandered down to the line of portable toilets and stood at a rise in the ground from where I could see the whole service. So I did get to spend my dawn service at ANZAC Cove, and honour all those fallen souls that had gone before me, from the best vantage point of all: standing beside a line of Portaloos.

27

Ice Nation

Back in Australia, I embarked on a really interesting project in the middle of 2015, which actually started as a misconception. News Corp's Network team wanted to put me and journalist Paul Toohey back together again for a special project. The Network division comes up with the big assignments, throws resources at sending journalists and photographers to do them, and then makes the results available to all the News mastheads

This one would be a series of articles on what they originally called the 'Ice Highway'. No, we weren't going to Canada; we were going to do a long-form journalistic work that traced the movement of crystal methamphetamine (ice) from its constituent chemicals to its manufacture, then its distribution to drug dealers and out to small towns in regional Australia. It was a great concept, but as soon as we went on the road to do it, it turned out there was no ice highway; there

wasn't even a road. Ice is made and consumed everywhere. It's easy to make – there are recipes on the internet – and you can do it in small, easy-to-conceal labs. Some of it is made in vans and garden sheds. So the story became 'Ice Nation' and it won me two Walkleys later that year.

When we first started working together, Paul and I didn't always see eye to eye. We were a couple of cranky middle-aged blokes, each with his own ways of doing things, and suddenly we were on a thirty-day road trip chasing a story which initially didn't exist, doing the kind of gig they'd usually throw to people twenty years our junior. But we became good mates and he's a great writer, especially good at connecting personal stories to larger political forces, and vice versa.

We met in Brisbane, hired a car and first headed west to Toowoomba. Then it was on to St George, Brewarrina, Walgett, Dubbo, Lightning Ridge, Wagga Wagga, Canberra, Jindabyne, Albury, Melbourne, Mildura, Mount Gambier, Millicent, Adelaide and then to Perth. All in a hire car. I was forty-eight and he was fifty-one, and there we were, humping up to hospital emergency wards and driving around poorer neighbourhoods, trying to find the relatives of ice addicts from court lists and looking for names in the White Pages. Paul was constantly on the phone, and filled several large notebooks. I was lugging my large Pelican in the back of the hire car, along with the lights and tripods and sound gear needed because I was supposed to be shooting material for an online video as well doing stills for the papers.

Just in case you need further proof that the photojournalist life is not necessarily glamorous, even as I was embarking on this epic journalistic road trip I was taking calls from Ali, in the UK; she was telling me off for forgetting to have the cats fed while I was away. I'd also torn down the back fence and left to do the assignment before I could erect a new one. So I was on the road, taking flak from the wife and not exactly feeling like an international glamour-puss photojournalist.

The 'Ice Nation' project became a monster because we decided to really get to the bottom of what this thing was about and do a thorough job, which meant interviewing all the people affected by the drug. We went from the criminal side of it to the user side, and of course to the families, the healthcare professionals and the police. In one of the most powerful series of images I've ever taken, we found an addicted Aboriginal boy in the Royal Perth Hospital emergency department, handcuffed to a gurney with a team of large security guards having to hold him down. The drug gave this small, skinny kid superhuman strength, and they were all wearing splatter masks because the kid was HIV positive and he was known to be a spitter when he was on ice.

The entire policing and healthcare system is changing to adapt to ice addicts. The Royal Perth Hospital now has a 'code grey' alert which calls the security guards and expert nurses and orderlies to an ice admission. The ice users are usually in a psychotic state and have to be handled in a way that is pushing many good people out of the hospital system. The

police have also had to develop protocols for apprehending ice users: they don't just spit – they bite and scratch, and with diseases like hepatitis and HIV always a concern, police put themselves in danger dealing with it. Doing a long-form piece, with a photo-essay component, was a first for me, and I really liked it. It gave us the chance to tell a bigger, more complex picture story.

When you're on the road, with one story to do, you have to find a way to make the two talents work together. So Paul would get someone talking about their child being addicted, and I'd do my stills shoot.

The journo has to get the talent to open up and then the photographer has to capture it, sometimes on two formats.

I don't just run a video camera in the corner while I take my stills; I have the camera mounted on a tripod, frame the

I asked if we could go over it again for the video camera.

shot, adjust my lights and run broadcast audio through radio microphones. This all takes time to set up.

If I'm shooting for an online production, I don't put my name to crap. So when the stills shoot was done and Paul had completed this extraordinary interview with a mother who was at the end of her tether, I asked if we could go over it again for the video camera.

I have the utmost respect for Paul as a serious journalist and I enjoy working with the bugger!

28

Three Days in the Hide

I'm seeing the prison so close that I can peer into the enclosed exercise yard and pick out the faces of the inmates. I'm dressed in a sniper's ghilli suit and hidden under a sniper's cammo netting, so the dog-walkers in the nature reserve don't bust me.

The gig started when I was at my desk in the Press Gallery one morning. The Network managers wanted me in Sydney for a confidential chat. I got up there and they told me they wanted to commemorate twenty years of Martin Bryant being behind bars at Tasmania's Risdon Prison. Martin Bryant murdered thirty-five people and injured twenty-three when he went on a shooting rampage at the Port Arthur tourist attraction in 1996. They wanted something special, on the twenty-year anniversary. They wanted Sarah Blake for the writer but they wanted Ramage to get an image of Bryant, now forty-eight.

When you do these special jobs you have to start with what's wanted, overlay it with what's possible and then explore all

options to get what's wanted without anyone losing an eye. It's not for everyone, but I find this work exciting and interesting, which is probably why they continue to tap me for it. The initial design of the operation had to account for the obvious: Bryant was not only in prison, but the Tasmanian government had a policy to not mention him or comment on the murderer – the worst in Australia's history. In the first instance there wasn't going to be a helping hand from the government.

Secondly, Bryant was in the maximum security section of Risdon Prison. The Network team provided me with a location as seen on Google maps and we decided on a location based on the topography opposite the prison as the best advantage point. I searched every image I could of Risdon. I also spoke with Sarah because she was down in Tasmania and she had an idea of the lay of the land and we had to know exactly where Bryant was to get the picture. Without Sarah's hard work prior to my arrival this picture would not have happened, because where he was in the prison would dictate where he could exercise; and his exercise spot would dictate where I would be able to shoot from and the quality of the shot.

In early September, Sarah worked out where Bryant was in the Risdon system. Risdon is made up different sections, dealing to varying prisoner-types. Bryant was in the maximum security section. I flew down to Tasmania and we found a bushy knoll almost one kilometre from the side of Risdon that housed a semi-outdoor exercise yard, that joined with the Tamar pod – Bryant's pod. It would give me a line of sight – across heavy bushland – into that exercise yard.

The shot would have to be taken through an outer chain-link fence, through the inner chain-link fence that delineates maximum security, and then there were thick bars enclosing the exercise yard. My biggest concern was the yard itself: yes, it was technically outdoor but the inmates milled around in an enclosed area that was dim in comparison to the real outdoors. To make the shot, I'd have to have a head-and-shoulders of Bryant. And it would have to be taken from around 900 metres. I would need a really special piece of glass to make it work. And given the angle, I'd need to shoot in the late afternoon so the sun was pushing as much light as possible into the exercise yard. The Sun Seeker app on my iPhone showed me where the sun would be through the afternoon, and which angle at every minute of the day, superimposed on an aerial shot of Risdon, my position and my line of sight.

I worked it out and came to a conclusion. I rang my manager in Sydney, Steve Moorhouse, and said I needed a 1200mm lens to make this shot. A 1200mm is a Black Swan lens; you hear mention of it, but no one ever sees or touches one. There are ten known 1200mm lenses in the world, and only one in the Southern Hemisphere. I knew News Corp had access to it, via its long commercial relationship with Canon. But that lens is worth $150,000 and Steve had to make sure the insurance was covered.

So I did my sums and came up with a converter kit for the lens, and we went down to Hobart.

You don't get one of these things immediately. In Sydney there were negotiations with Canon, discussions with

insurance brokers, and undertakings given by News to Canon. The first one was that the 1200 lens would be accompanied, and the second one was that it wouldn't travel on a plane as freight. So Steve Moorhouse traveled to Canon, picked up the 1200, and went down to Qantas where they had to put a team of engineers on the case. The Canon 1200 travels in a special padded box which looks like a filing cabinet and the lens alone – without the case – weighs 25kg. Steve had a seat on the flight to Hobart, and the 1200mm lens was rigged into the seat beside him, hence the engineers and their strapping that complied with air safety and with Canon's demands.

I met Steve at the airport because this lens really needs two people to manhandle it.

The next morning, we had to first park in the car park of what is a nature reserve and walking track. The park closes at 4.30 pm and the maximum security prisoners exercise between 1 and 4 pm. We got out of the car and as I was hauling all this gear out, the first person we interact with just walks up, points at my tripod case, and says, 'I hope that's not a gun.' I told him I was a bird watcher and I was looking for the rare Tasmanian yellow-throated honey eater. I am just lucky there is such a bird.

So we decided to lay low for a day or two. A few days later, Steve and I hauled all of this stuff back to my secret spot. Getting the right spot is crucial: if you have to spend a few days waiting for the shot, it needs to be secure and comfortable. I walked along looking for what I thought would be a good position to shoot from. I put on my ghilli suit as worn by Australian Army snipers. I draped woodland

cam netting across the camera and the lens. Once I was in place, I was hard to spot. I was disguised in the same way as a sniper would be in the field.

We got the tripod into place and fully adjusted the legs so it could be used on sloping and uneven ground. The tiniest vibration or movement would wreck a shot made on a 1200 lens so I took my time adjusting the legs and getting it absolutely level. When I attached the Canon camera to the lens, I used a 1.4x converter attached to a 2x converter to almost treble the focal length of the lens. This reduced the amount of light in the frame so I had to make adjustments to the ISO, shutter speed and aperture. I'd also need to shoot, from that angle, in the late afternoon so the sun was pushing as much light possible into the exercise yard. The Sunseeker app on my iPhone showed me where the sun would be through the afternoon, and which angle at every minute of the day, superimposed on an aerial shot of Risdon, my position and my line of sight. So I found the ground-to-ceiling grill that gave access to the exercise yard and focused on it. With the converters giving me as much performance as possible, I was still going to capture Bryant in a way that would make him about one-eighth of the frame.

We got more intel on which exercise yard Bryant was in. Turns out he was in a maximum security unit that houses the inmates who are a danger to the staff, to other inmates and to the good order of the prison. That would be Bryant, who Sarah discovered had attacked prison staff, broken someone's jaw and attacked nurses. We looked at the aerials of Risdon

and I knew the yard Bryant was in. I'd scoped it with my lens. It was another 200 metres away from where I'd initially shot. But now I knew where I was shooting.

With all of the converters on the camera, the distance to the subject and movement on the tripod this all added up to being a very difficult shot to make. That's why it was crucial for me to plan the sun's angle, so we had as much available light into that darkened enclosure as possible. The Sun Seeker app said 3.20 pm was my optimum time.

When I sat down behind the camera to begin, I realised the merest touch of the camera body was enough to adjust where the lens was pointing. That's how I would follow Bryant as he walked behind the bars of his cage. One millimetre of movement at my end behind the camera resulted in a few feet of movement at the other end of the lens where Bryant would hopefully be.

I sat in my hide for three days while the park was open to the public, on each day having a window of maybe ten to twelve minutes before the light in that enclosure was no good. I sat and waited and on the third day, at 3.22 pm, a balding behemoth dressed in prison greens wandered to where the bars separate inmates from the outside world, and I started shooting. I'd seen him through my lens in the preceding two days, and I'd decided that must be him. Sarah had briefed me on the state of the guy; her story would reveal that Bryant's weight was spiking to 160 kg, and his famous blond curls were gone, replaced by a chrome-dome. So I knew I was looking for fat and bald, and I'd tracked him from afar, but

Almost as soon as Bryant appeared, he was gone again. But I had my shots.

always seeing him deep inside the enclosure where there wasn't enough light to get the shot – certainly not enough for a front page pic.

Almost as soon as Bryant appeared, he was gone again and then the light faded and my moment was gone. But I had my shots.

The story ran big and Sarah's story was a cracker. It was a great piece of journalistic work considering the Tasmanian government had a ban on government employees and contractors discussing Martin Bryant.

From my perspective, I'd finally had a go on a 1200mm lens, a bit of gear so rare that most people's standard reply is, 'no such thing exists.'

In October I received a raucous phone call from my mate Craig Greenhill in Sydney, screaming down the line that I had won the Walkley. I had no idea what he was talking about at the time. I'd forgotten that the finalists of the most

prestigious media awards were announced that night in Sydney. Craig was now yelling, 'Fuck me, you have just been nominated for two more Walkley awards as well.'

Adam Taylor, a photographer and another *Telegraph* mate, then rang and said it was confirmed, I had won the Hero Image of 2015 with my 'Ice Nation' picture and had also been nominated as a finalist in the Feature category and for Photographer of the Year. My phone started ringing off the hook. I was a finalist for three Walkley awards!

In November Ali and I travelled to Melbourne for the awards gala dinner ceremony. Just as we got to the top of the escalator the sole of my old Army high-shine boot caught in the moving bits and was 99 per cent ripped from the upper. I couldn't believe it. It was 6.50 pm and only ten minutes before the ceremony started. I went into Ramage mode, and ran down the stairs of the Crown Casino to a shoe shop. I asked the young guy for a pair of black shoes. He said they would cost $559. I declined and asked for the location of another shoe shop. There was one about a kilometre away, he said. I bolted there, running through the casino in my tux with the sole flapping as I ran. I got to the shop, sat down and bought the first pair of shoes I tried on. Running back to the dinner, I was seated by 7.02 pm. A pretty good effort, if you ask me.

I was presented with two out of three awards: the Nikon-Walkley Press Photographer of the Year and the Photograph of the Year. It was a great moment.

EPILOGUE

I have a little voice at the back of my photographer's head, and from time to time the voice reminds me, *Sins of the photographer.*

The role of the press photographer is a privileged one: your access can be immense, your power in many cases is limitless and the insights you enjoy are ones the average person is not exposed to. So with this privilege comes responsibility, but how to exercise that? Do you impose your own morality? Your own aesthetic? Do you have a hard-and-fast set of rules?

I'm not the first photographer to ponder this, because when we shoot for media outlets, we don't do it for ourselves. We're professionals, we work for employers and, mostly, we work for the readers. The job is to record what happened – to tell the story to people who weren't there. So we're constantly pushing beyond our own bounds of taste and ethics just to do our jobs. Very few people can pursue a family from the airport terminal to their car, shooting pictures of them in their

faces. It's not a pleasant job. Yet millions of people will look at those shots on the front page of the newspapers, because they're following the trials of Schapelle Corby and they're interested in the fact her father has flown in to Denpasar. It's easy to call me a vulture, but you'll consume my pictures and not think about the abuse I had to endure to get those shots.

It doesn't concern me too much. It's my job.

But I do have a limit and I do exercise it. On that Dust-Off helicopter in Afghanistan, I did my utmost to ensure that the American soldier shot in the lung did not appear in my photographs in ways that could identify him. He was basically deceased – his body instinctively trying to go on – but I didn't think it right that he lose his dignity as well by having his naked self published in newspapers. In the end my main rule is the dignity one. Let me illustrate: during the 2007 federal election campaign, we followed Kevin Rudd to a primary school in Queensland where a bunch of awards was being presented for high achievers. It was a warm day and one of the girls fainted. She fell right in front of Rudd, and unfortunately, she fell so her skirt was up around her armpits. I refused to shoot the picture as I saw there was no story to it. I put down my camera, and told the other two photographers to do the same. The government photographer started to argue with me so I put him in his place. Why he thought the government needed a photo of a young girl in distress was beyond me.

I felt the same way about Peter Slipper in that bar in Canberra and I felt the same way about Lance Corporal

Shannon McAliney in Somalia. The actors in the drama provide us with the pictures and the story, and we put them on the front page and feel closer to the story. But once they've given us most of themselves, everyone retains something that no one else owns: their dignity.

I've gone over that line on occasions and kicked myself for it. I've also taken myself way too deep into a subject, a long way beyond the bounds of objective observer. That awful day in the Role 3 hospital in Kandahar and the morning on the Dust-Off helicopter stand out as times when I was too deep in the subject and I had the opportunity to stand back, but didn't. I've paid a price for this instinct, and as I get older it's a price I hope will not sabotage my marriage or my significant friendships.

In the end, we're telling stories. We can enlighten, educate, titillate, entertain and outrage. But if we don't tell a story, no one looks at the picture or reads the words. We use all of our skills, talent, access and experience to make you stop and look. And if I do my job right, you'll get the flavour of where I've been, and what I've seen, but endure none of the turmoil I endured to make that picture.

As all photographers know, with the power comes the responsibility ... and if you can't get that right, at least file a picture that runs on the front page.

AWARDS

2015	Walkley Press Photographer of the Year.
2015	Nikon–Walkley photo of the Year.
2014	News Corp Photograph of the Year finalist.
2012	Walkley Best Broadcast Camerawork.
2012/2013	AWM Official War Photographer.
2012	Walkley Slide Show winner.
2010	News Corp Photographer of the Year.
2009	Head On Portrait People's Choice Award.

ACKNOWLEDGMENTS

I'd like to acknowledge the men and women of the Australian Defence Force who took me under their wings and looked after me over the years; and the men and women of the US Army's Dust-Off crews and the 3/6 US Marines who kept me alive in some adrenaline-pumping situations. For all the words of wisdom and guidance over the years I'd like to thank my photographer and journalist friends, peers and bosses. And a special mention to my bosses at the Network — a huge 'thank you' for all the great assignments.

My great mate Trevor Bailey, for his friendship and support through the good times and bad, and my dear mate Ian McPhedran for his loyalty, friendship and great sense of humour when the chips were down. Thanks to Dave and Cath Munro for their great friendship over many years. Terry Dex gave me the greatest gift — his knowledge — and Mal Lancaster fine-tuned me in the art of telling the story with great pictures. Barry Buckley always had my back and words of wisdom and Lisa Keen had faith in me to always bring

home a result, and gave me a great nickname: 'Petal'. Bruce Johnson was always looking out for me and being the big brother I never had; Lieutenant Colonel Rob Barnes (retired), gave me friendship and the opportunity to lead men, and Lieutenant Colonel John Weiland for giving me a start as a young army photographer. A big thanks to Giles Penfound for his true professionalism, friendship and the inspiration that he oozes on making photographs; his wife Nicola and his two lovely daughters, have always welcomed me into their home.

Hilary and James have given me great friendship over the years and Mark 'Pup' Elliott must be thanked for his friendship and guidance and for leading me astray on more than one occasion.

Thanks go out to Lieutenant Colonel Michael Harris, an absolute professional with a true vision, and a great bloke; the CDF Air Marshal Mark Binskin and the previous Chiefs – Angus Houston and David Hurley – who allowed me to embed with our diggers in Afghanistan; the Director of the Australian War Memorial, Dr Brendan Nelson, and all the staff, for their great support.

A big thank you to Stephanie Boyle and Alison Wishart for friendship and guidance, and to my two little sisters, Gerri and Nicola, for always being there when their big brother became unstuck. My friends have stuck by me through the good and bad times, through the sorrow and heartache, through the laughter and memorable events, and I thank them all.

Thank you to Catherine Milne, Nicola Robinson and Mark Abernethy and the entire team at HarperCollins

for their guidance and patience. I can never thank them enough.

And finally, I must thank the woman I love more than life itself, my beautiful wife Alison. Without her encouragement, understanding, love, guidance and constant spelling corrections I would not be where I am now. She has tolerated my short notice assignments and endured the loneliness while I spent months away, covering the war in Afghanistan. No words can express my gratitude to her for sticking with me these past ten years.

AFGHANISTAN
Australia's War

Gary Ramage & Ian McPhedran

A photographic story of the nation's longest war and those who served

Featuring the stunning images of award-winning photographer Gary Ramage, and the words of best-selling defence writer Ian McPhedran, this book is an emotional, graphic, very moving and comprehensive record of Australia's war in Afghanistan. *Australia's War in Afghanistan* is an extraordinary visual record which recognises and celebrates the significant contribution that Australian troops have made to the conflict in Afghanistan.